HUDSON RIVER SCHOOL

HUDSON RIVER

MASTERWORKS FROM THE WADSWORTH ATHENEUM MUSEUM OF ART

Introduction by Elizabeth Mankin Kornhauser

Catalogue by Elizabeth Mankin Kornhauser and Amy Ellis,
with Maureen Miesmer

Yale University Press, New Haven and London
in association with the
Wadsworth Atheneum Museum of Art, Hartford

SCHOOL

(detail of cat. 10)

The exhibition was organized by the Wadsworth Atheneum Museum of Art, Hartford, Connecticut

Exhibition Itinerary: Iris & B. Gerald Cantor Center for Visual Arts at Stanford University, Stanford, California, October 8, 2003–January 18, 2004;
Carnegie Museum of Art, Pittsburgh, Pennsylvania, February 21–May 9, 2004; North Carolina Museum of Art, Raleigh, North Carolina, June 6–August 29, 2004;
Philbrook Museum of Art, Tulsa, Oklahoma, February 6–April 24, 2005; The Saint Louis Art Museum, St. Louis, Missouri, June–August 2005;
Frist Center for Visual Arts, Nashville, Tennessee, September 15–January 8, 2006.

Library of Congress Cataloging-in-Publication Data
Kornhauser, Elizabeth Mankin, 1950–
Hudson River school : masterworks from the Wadsworth Atheneum Museum of Art / introduction by
Elizabeth Mankin Kornhauser ; catalogue by Elizabeth Mankin Kornhauser and Amy Ellis, with Maureen Miesmer.
p. cm.
Exhibition catalogue.
Includes bibliographical references and index.
ISBN 0-300-10116-3 (cloth : alk. paper)—ISBN 0-918333-20-2 (pbk. : alk. paper)
1. Hudson River school of landscape painting—Exhibitions. 2. Landscape painting, American—Hudson River Valley (N.Y. and N.J.)—19th century—Exhibitions.
3. Hudson River Valley (N.Y. and N.J.)—In art—Exhibitions. 4. Art—Connecticut—Hartford—Exhibitions. 5. Wadsworth Atheneum Museum of Art—
Exhibitions. I. Ellis, Amy. II. Miesmer, Maureen. III. Wadsworth Atheneum Museum of Art. IV. Title.
ND1351.5.K67 2003
758'.1'0974730747463—dc21
2003009650

A catalogue record for this book is available from the British Library.
The paper in this book meets the guidelines for permanence and durability of the
Committee on Production Guidelines for Book Longevity of the Council on Library Resources.
10 9 8 7 6 5 4 3 2 1

Jacket/Cover: Asher B. Durand, View Toward the Hudson Valley, 1851. Oil on canvas, 33⅛ × 48⅛ in. (84.1 × 122.2 cm).
Wadsworth Atheneum Museum of Art. The Ella Gallup Sumner and Mary Catlin Sumner Collection Fund.
Title page: Frederic Edwin Church, Grand Manan Island, Bay of Fundy, 1852. Oil on canvas, 21¹³⁄₁₆ × 31¹⁵⁄₁₆ in. (53.8 × 79.5 cm).
Wadsworth Atheneum Museum of Art. Gallery Fund purchase.
pp. 18–19: William C. Bradford, Coast of Labrador, 1868. Oil on canvas, 25½ × 44 in. (64.8 × 111.8 cm).
Wadsworth Atheneum Museum of Art. Bequest of Elizabeth Hart Jarvis Colt.
Colophon: detail of cat. 26

SPONSOR'S STATEMENT

In the early years of the nineteenth century, the magnificent landscape of our young nation captured the imagination and inspired the creativity of a whole generation of American painters. Now, over 150 years later, we have a rare opportunity to admire and appreciate that world through the eyes of some of those artists. The Wadsworth Atheneum Museum has organized works by more than twenty artists from its renowned collection of American paintings into a traveling exhibition that will visit six cities. *Hudson River School: Masterworks from the Wadsworth Atheneum Museum of Art* offers a thought-provoking view of the American landscape.

Recognizing the arts' contribution to the vitality of our communities, MetLife Foundation is committed to making the arts more accessible to broader audiences. We are pleased to be the national sponsor of this historic exhibition. The accompanying catalogue promises to be a valuable addition to scholarship and an important educational resource.

Sibyl Jacobson

Sibyl Jacobson
President and Chief Executive Officer
MetLife Foundation

CONTENTS

FOREWORD

The first American school of painting emerged between 1825 and 1875, during which time two generations of artists created a distinctive style of landscape painting that became the premier focus of art in the United States. This group of painters, who came to be known as the Hudson River School, set their sights on the discovery, exploration, and settlement of the land.

With the opening of the Wadsworth Atheneum in 1844, Daniel Wadsworth shared with the nation's public his long-standing interest in American art and culture. As a member of the first generation of American citizens—like many of the artists of his day—Wadsworth saw the young country's vast wilderness landscape as a symbol of its potential to become a great nation. The themes embraced by America's contemporary artists—the Hudson River School—defined his vision as a collector and patron. His lifelong associations with its leading members, including Thomas Cole and Frederic Church, enabled Wadsworth to assemble one of the earliest and finest private art collections in the country. His collection became the core of the new Wadsworth Atheneum galleries. Over the past century and a half, the Hudson River School collection at the Wadsworth Atheneum has continued to grow in quality and breadth.

It is with pleasure that we share these extraordinary paintings with audiences across the United States, as the collection travels to six museums: Iris & B. Gerald Cantor Center for Visual Arts at Stanford University, the Carnegie Museum of Art, the North Carolina Museum of Art, the Philbrook Museum of Art, The Saint Louis Art Museum, and the Frist Center for the Visual Arts.

Willard Holmes
Director, Wadsworth Atheneum Museum of Art

PREFACE AND ACKNOWLEDGMENTS

The Wadsworth Atheneum's collection of Hudson River School paintings is arguably the greatest of its kind held by any museum, boasting thirteen paintings by Thomas Cole and eleven by Frederic Church. Daniel Wadsworth, the founder of the Wadsworth Atheneum, determined the quality and direction of the collection. His distinguished Puritan lineage and his ties to the American War of Independence endowed him with a profound reverence for his country's recent history. Wadsworth saw this history and his country's vast wilderness landscape as conjoined, symbolic of the nation's potential greatness, and these two themes defined his vision for the Wadsworth Atheneum.

In the early decades of the nineteenth century, Wadsworth's active involvement in the picturesque description of the country's wilderness—as both amateur artist and collector—helped bring the aesthetic qualities and historic associations of the northeastern landscape to the nation's attention. As one of the most important early patrons of American artists, Wadsworth met Thomas Cole in 1825, and the two maintained a lifelong friendship that influenced Wadsworth's own collection. He nurtured the careers of a number of major artists, including John Trumbull (to whom he was related through marriage), Alvan Fisher, and Frederic Church, whom he discovered in Hartford and introduced to Cole, resulting in Church's two-year apprenticeship in Cole's Hudson, New York, studio. His friendships with these artists helped to define Wadsworth's ambitions for the country's first permanent gallery of fine art. Months before the opening of the Wadsworth Atheneum, Cole, leader of the American landscape school, applauded Wadsworth's vision, writing, "I assure you that I shall feel proud of having a picture of mine in your Gallery & hope the example you are about to set, in form-

ing a permanent Gallery, will be followed in other places & be the means of producing a more elevated taste & a warmer love for beautiful Art than at present exists in the Country" (Thomas Cole to Alfred Smith [Wadsworth's lawyer], February 6, 1844, Archives, Wadsworth Atheneum).

Later acquisitions and gifts by donors such as Elizabeth Hart Jarvis Colt, widow of Hartford arms manufacturer Samuel Colt, added significant works by all of the major Hudson River School artists, including Albert Bierstadt, William Bradford, John William Casilear, Frederic Church, Jasper F. Cropsey, Asher B. Durand, and John F. Kensett. With Frederic Church as her adviser, Elizabeth Colt formed one of the finest private picture galleries in the United States. The collection, which was housed in her Hartford mansion "Armsmear," was formed during the Civil War era. Because many of the works in the collection were commissioned by these patrons, the Wadsworth Atheneum collection has a purity that reflects the major concerns of the young nation and its artists.

This catalogue of the Atheneum's Hudson River School paintings accompanies a major tour of the collection. It has benefited from the research done for previous publications on this collection, including Theodore E. Stebbins, Jr., *The Hudson River School: 19th-Century American Landscapes in the Wadsworth Atheneum* (Hartford: Wadsworth Atheneum, 1976), and Elizabeth Mankin Kornhauser with Elizabeth R. McClintock and Amy Ellis, *American Paintings Before 1945 in the Wadsworth Atheneum*, 2 vols. (Hartford: Wadsworth Atheneum; New Haven: Yale University Press, 1996).

The research, writing, editing, and publication of this catalogue have taken the considerable efforts of a great many people. On the staff of the Wadsworth Atheneum we are particularly grateful to Allen Phillips, director of collection imaging, who was ably assisted by Natalie Russo in

creating digital images of the works in this catalogue. In addition, thanks go to Maura Heffner, director of exhibition programs; Stephen Kornhauser, chief conservator; Ulrich Birkmeir, painting conservator; Zenon Ganzenic, conservation assistant; Amy Ellis, assistant curator of American painting and sculpture; Maureen Miesmer, curatorial assistant, American painting and sculpture; Mary Schroeder, registrar; Edd Russo, senior associate registrar; and Steve Winot, head preparator. We would also like to thank Inga Bing, Mary Busick, Amanda Cook, David Baxter, Jon Eastman, Andrew Fotta, Janet Heim, Jack Tracz, and Nicole Wholean for their assistance on this project.

At Yale University Press thanks are due to Patricia Fidler, publisher, art and architecture, who very ably guided us through the publication process; Mary Mayer, production manager; Jeffrey Schier, manuscript editor; John Long, photo editor; and Bruce Campbell, for his talented design work.

Elizabeth Mankin Kornhauser

NOTE TO THE READER

The entries are arranged alphabetically by artist. Works by a given artist are arranged chronologically, with those of the same date arranged alphabetically. A biography of the artist precedes each group of entries. Entries include the media for each work. The dimensions of the support are given in inches followed in parentheses by centimeters. Height precedes width.

INTRODUCTION

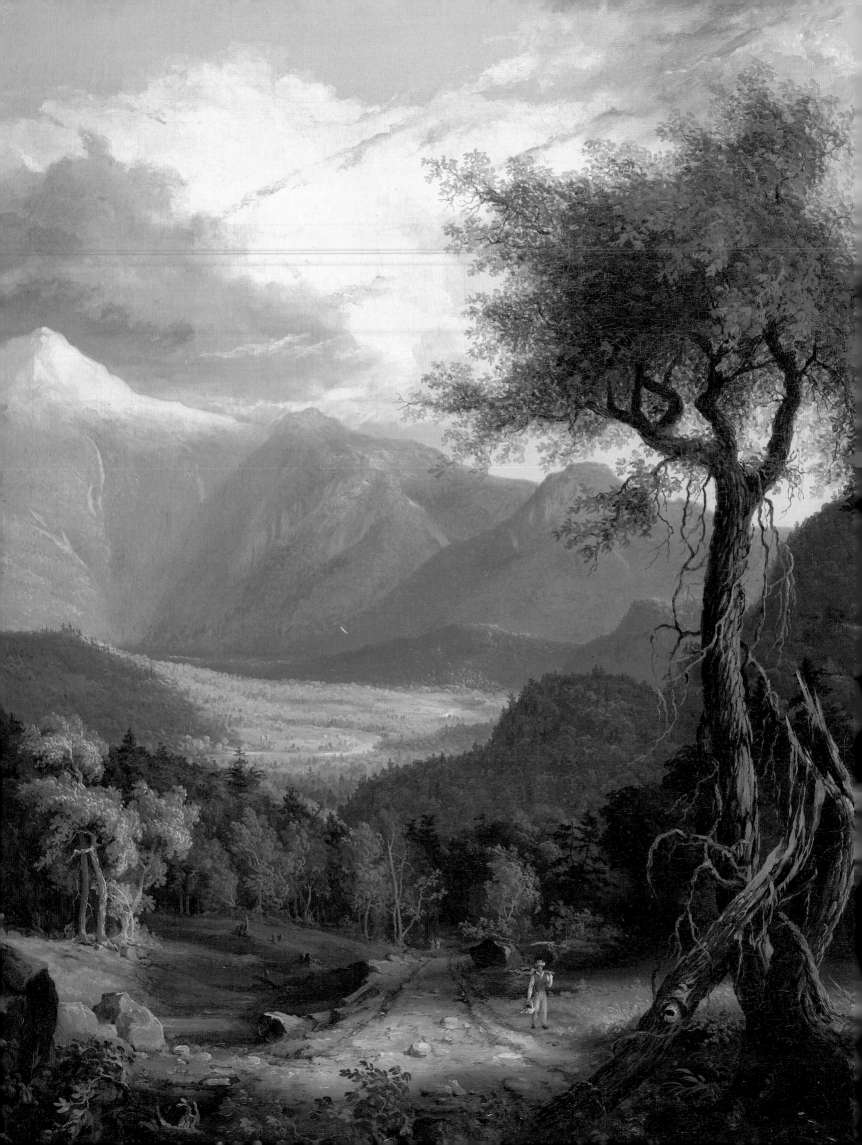

"ALL NATURE HERE IS NEW TO ART"

PAINTING THE AMERICAN LANDSCAPE IN THE NINETEENTH CENTURY

Elizabeth Mankin Kornhauser

The rise of a school of landscape painters in New York in the mid-nineteenth century has proven to be one of the most important cultural developments in the United States. Native-born, immigrant, and visiting European artists focused their attention on the terrain of this new world, often combining literalism and lyricism to represent the transformation of the land from wilderness to an industrialized, urban-based society. Their art reveals the changing relationship between humans and their environment, from dominance by nature's forces to a reversal of roles as the landscape was gradually integrated into human life by the century's end.

The collection of Hudson River School paintings at the Wadsworth Atheneum Museum of Art was formed largely by two important patrons of American artists of the era: the museum's founder, Daniel Wadsworth (1771–1848) (fig. 1), and Elizabeth Hart Jarvis Colt (1826–1905) (fig. 2), widow of the Hartford arms manufacturer Samuel Colt (fig. 3). Because many of the works in the collection were commissioned by these collectors for their personal enjoyment or for the museum itself, the Wadsworth Atheneum collection has a rare purity that reflects the major concerns of the young nation and its artists, as well as the aesthetic sensibilities of the Hudson River School. The collection has grown to become one of the largest and most comprehensive of its kind.

Opposite: detail of cat. 24

EMERGENCE OF LANDSCAPE CULTURE IN AMERICA

The groundwork for the emergence of the Hudson River School was laid in the eighteenth century. As in England and elsewhere around the globe, a growing fascination with native scenery fueled the development of landscape art and landscape culture in the United States in the form of prints, paintings, travel guides, travel literature, treatises on aesthetics, and tourism. By the end of the eighteenth century, prospective travelers in the New World could educate themselves about landscape culture by reading the works of prominent English writers whose books on landscape aesthetics were now widely available in America. The taste for landscape was largely restricted to the Northeast elite. They turned to England as a cultural model and were educated in the contemporary theories of English landscape aesthetics. The writings of William Gilpin, Uvedale Price, and Richard Payne Knight informed their ideas on the basic categories of the beautiful, the sublime, and the picturesque.[1]

By the 1820s, with settlement well under way, American writers, including Timothy Dwight, Benjamin Silliman, and Theodore Dwight, were publishing accounts of their travels through their own native landscape, celebrating wilderness and encouraging the rise of tourism among a broader public.[2] The collaboration of the painter John Trumbull, the art patron Daniel Wadsworth, who was an avid picturesque traveler seeking scenery in the northeastern

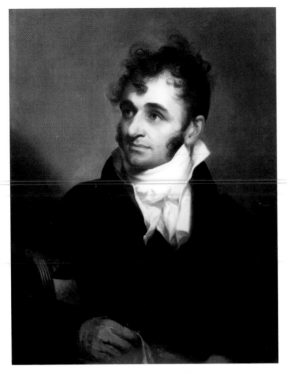

Fig. 1. Thomas Sully, *Daniel Wadsworth*, 1807
Oil on canvas, 28½ × 21⅞ in. (71.4 × 55.6 cm)
Wadsworth Atheneum Museum of Art
Gift of William P. Wadsworth, 1976.79

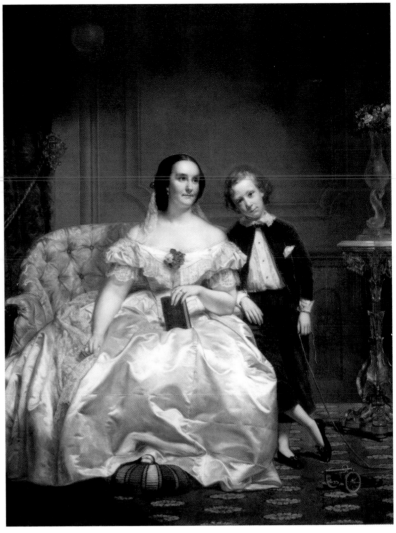

Fig. 2. Charles L. Elliott, *Portrait of Mrs. Elizabeth Hart Jarvis Colt and Her Son,
Caldwell*, 1865
Oil on canvas, 84 × 66 in. (213.4 × 167.6 cm)
Wadsworth Atheneum Museum of Art
Bequest of Elizabeth Hart Jarvis Colt, 1905.9

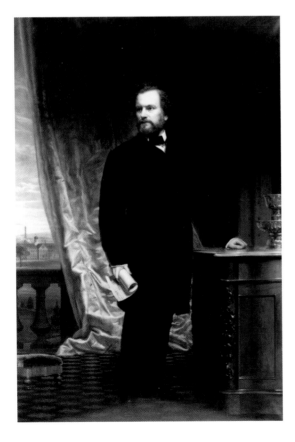

Fig. 3. Charles L. Elliott, *Portrait of Colonel Samuel Colt*, 1865
Oil on canvas, 84 × 64 in. (213.4 × 162.6 cm)
Wadsworth Atheneum Museum of Art
Bequest of Elizabeth Hart Jarvis Colt, 1905.8

United States, and the Yale College geologist and travel writer Benjamin Silliman (all well versed in the aesthetics of the picturesque—and friends, related through marriage) provides an apt example of the earliest developments of landscape culture in the United States. As arbiters of taste, these men drew attention to the virtues of the American landscape. Trumbull's *View on the West Mountain near Hartford*, c. 1791 (fig. 4), based on his sketches of the site, captures the picturesque possibilities of the land that Wadsworth later turned into his country estate. In 1805, working in partnership with Trumbull, Wadsworth began transforming the wilderness tract of land on the summit of Talcott Mountain, west of Hartford, into a carefully cultivated summer retreat with a neo-Gothic house, gardens, a boathouse, and a working farm. He named the estate Monte Video, completing it by about 1810 with the construction of its most distinctive feature, a seventeen-meter (fifty-five-foot) viewing tower that commanded a spectacular, sweeping view (fig. 5).

In 1819 Wadsworth and Silliman made a tour from Hartford to Quebec, which resulted in *Remarks Made, on a Short Tour, Between Hartford and Quebec in the Autumn of 1819* (New Haven, 1824), written by Silliman and with illustrations after Wadsworth's drawings. In the introduction Silli

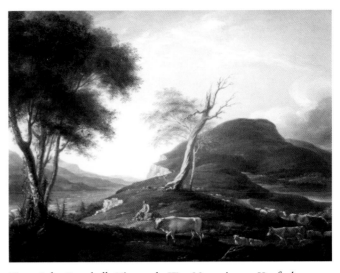

Fig. 4. John Trumbull, *View on the West Mountain near Hartford*, c. 1791
Oil on canvas mounted on wood, 19 × 24⅞ in. (48.3 × 63.2 cm)
Yale University Art Gallery
Bequest of Miss Marian Cruger Coffin in memory of Mrs. Julian Coffin
(Alice Church), 1957.24

man expressed the beliefs he shared with Wadsworth and others regarding the value of landscape for Americans: "National character often receives its peculiar cast from natural scenery. . . . Thus natural scenery is intimately connected with taste, moral feeling, utility and instruction."[3] A detailed description of Monte Video was included, with illustrations based on Wadsworth's drawings of the house and tower. Wadsworth later commissioned the artist

Fig. 5. Simeon Smith Jocelyn
(after Daniel Wadsworth),
Monte Video, from Benjamin
Silliman, *Remarks Made, on a Short
Tour, Between Hartford and Quebec
in the Autumn of 1819*, 1820
Engraving, 6¹³⁄₁₆ × 8⅞ in.
(7.3 × 22.5 cm)
Wadsworth Atheneum
Museum of Art
William F. Healy Fund, 1996.16

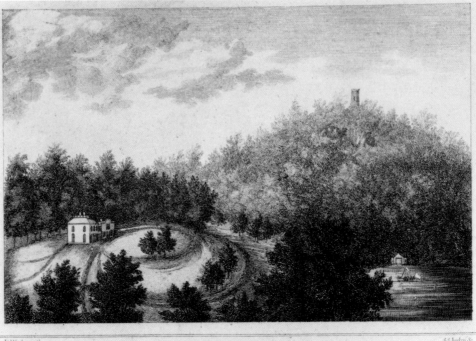

MONTE-VIDEO.
Approach to the House.
172

Thomas Cole to paint *View of Monte Video, the Seat of Daniel Wadsworth, Esq.*, 1828 (see cat. 26), a panoramic view from the base of the tower. While Trumbull's earlier painting of the site revealed his reliance on the compositional conventions of the Old World, Cole dispensed with these traditions in an effort to convey the visual mastery that this mountaintop locale afforded the viewer in its grand, panoramic sweep.[4] To elevate the taste of American citizens, Wadsworth opened the property to the public, encouraging visitors to enjoy his wilderness estate. In 1844 he established a public art museum in Hartford, the Wadsworth Atheneum, filled with contemporary American landscapes by the country's leading painters and featuring works by Cole and the young Hartford native Frederic Church.

The taste for landscape demanded that the individual not only admire images of landscape and read treatises on landscape aesthetics, but also experience it firsthand. While the thrill of sublime scenery, which offered the viewer a sense of overwhelming grandeur or irresistible power, was sought most often, picturesque views attracted travelers as well. Comparisons were frequently made between the Old World landscape and that of the New: the panoramic expanses of the Connecticut and Hudson River valleys, for example, lent themselves to favorable comparison with England and Europe. Of the Hudson, Cole wrote, "Its shores are not besprinkled with venerated ruins, or the palaces of princes; but there are flourishing towns, and neat villas, and the hand of taste has already been at work."[5] The taste for picturesque scenery was spurred on in the early decades of the nineteenth century by a proliferation of landscape engravings of American scenery.[6]

ENCOUNTERING THE WILDERNESS:
GREAT NATURAL WONDERS

As a new nation attempting to define itself, America celebrated in its art the novelties of its landscape—scale, freshness, and variety. The wilderness, which had been feared and loathed in the eighteenth century, was now considered to be America's most distinctive feature—a symbol of the nation's potential as well as its history. In the absence of cultural history so celebrated in European art, educated tourists sought spiritual renewal in the ruins of nature and monuments of their own sublime wilderness scenery. They delighted in the mysterious and uncontrollable aspects of nature, and in the sudden fear they experienced when confronting its power. In search of these sublime thrills, they traveled in increasing comfort to view America's unparalleled natural wonders—the waterfalls, mountains, and forests of the Northeast and, later, the West.

Geology reigned as the most important field of scientific inquiry at that time.[7] Theories of the creation of the world suggested that the Earth was far older than previously thought, and that it had been dramatically transformed by geological forces: the influential German geographer and scientist Alexander von Humboldt gained an international audience with his series of books about the physical history of the Earth; and fascination with geological time led travelers to seek natural phenomena both above and below the Earth's surface.

Along with the most exceptional features of the wilderness landscape, Native Americans served as an important symbol of the New World. In landscape art they are so fully integrated into the wilderness scenery that they seem one and the same. In an effort to justify their claim to this vast landscape, artists and the American public romanticized the indigenous presence while eliminating all signs of the Native Americans' actual relationship with the land. They appear in northeastern scenery as symbols of the original purity of God's wilderness; and later, as they are encountered in the western territories, they are documented with a sense of urgency that forecasts their threatened extinction—for example, Albert Bierstadt's *Toward the Setting Sun*, 1862 (see cat. 3).

For its scale, power, and sublimity, Niagara Falls achieved aesthetic preeminence during the first half of the nineteenth century, becoming the most frequently painted natural wonder in the United States. With the opening of the Erie Canal in 1825, Niagara became an annual tourist destination for thousands, and because it had no equal in the Old World, Americans could claim cultural prominence. Anticipating an emotional and religious experience, visitors to

the falls saw themselves as pilgrims on a spiritual journey to a sacred site.[8]

Nearly every landscape painter of the period accepted the challenge of capturing Niagara on canvas. John Trumbull painted several of the earliest views, including *Niagara Falls from an Upper Bank on the British Side*, 1807, and *Niagara Falls from Below the Great Cascade on the British Side*, 1808 (see cat. 52 and 53), which were acquired by Daniel Wadsworth for his collection in 1828. Alvan Fisher, also patronized by Wadsworth, was one of a number of native-born painters to specialize in paintings of the falls. Most were versions of two paintings based on sketches he made on his first trip to Niagara in 1820: *The Great Horseshoe Fall, Niagara* and *A General View of the Falls of Niagara* (coll: Smithsonian American Art Museum).[9] By that time various comfortable hotels existed on both the American and Canadian shores.[10] Early landscape painters such as Trumbull and Fisher adopted conventional compositional structures for their landscapes as one way of taming the wilderness. In Fisher's paintings of Niagara, including *Niagara Falls*, 1823 (see cat. 41), the artist's carefully composed views are taken from the Canadian side. He depicts visitors to the sites as separate from their surroundings, placed in the foreground in a stagelike setting that removes them from imminent peril.

Most leading artists of the time were based in New York City, the nation's cultural center. Cole's arrival there in 1825 has traditionally marked the beginning of the Hudson River School, which reigned as a national school of landscape art until about 1870.[11] Cole, the acknowledged founder of the school, was the premier landscape painter of the second quarter of the nineteenth century. He proved to be a far more cerebral landscape painter than those who had come before him, such as Fisher. Cole used landscape art as a means of upholding traditional beliefs, as he warned Americans of the dangers of material progress, unlimited democracy, and expansionism, which he believed to be rampant in the Jacksonian era.[12] John Trumbull, who was among the first to recognize Cole's genius, introduced the artist to Daniel Wadsworth in 1825. Wadsworth became Cole's most important early patron, and the two men remained close friends and correspondents until their deaths in 1848.

In a break from the European convention of landscape painting, which was dominated by pastoral views, wilderness became the primary subject of Cole's early landscapes. As the first artist to depict the Catskill Mountain region in New York State, Cole painted its most spectacular sites, including *Kaaterskill Falls*, commissioned by Wadsworth in 1826 (see cat. 22), in which he eliminated all signs of tourism and instead presented images of a pristine wilderness. This work epitomizes the romantic sublime—storms sweep across the sky, and natural rock formations and gnarled branches of dead trees assume anthropomorphic forms. Cole includes a Native American as sole witness to the purity of American wilderness. Native Americans had long since been removed from the Northeast, as white settlement and tourism claimed this region. Cole may have intended that the viewer comprehend the Catskill wilderness through the eyes of Native Americans, to see it as he imagined that they had seen it, unchanged since creation.

Years later, after returning from a trip to the Catskill region, Cole reflected on the role of the American landscape painter: "The painter of American scenery has indeed privileges superior to any other; all nature here is new to Art. No Tivoli's[,] Mont Blanc's, Plinlimmons, hackneyed & worn by the daily pencils of hundreds, but virgin forests, lakes & waterfalls feast his eye with new delights, fill his portfolio with their features of beauty and magnificence and hallowed to his soul because they had been preserved untouched from the time of creation for his heaven-favored pencil."[13] As Alan Wallach has noted, Cole exaggerated the "untouched" quality of the Catskill region's wilderness lands, by this time a tourist destination, but he did articulate "the central problem confronting early American landscapists—the problem of portraying a hitherto unrepresented nature."[14]

ENCOUNTERING THE AMERICAN WEST

When the French and English first settled Quebec, Plymouth Rock, and the James River estuary in the early 1600s, North America was not a virgin land but an "old

world" that had been inhabited by Native American tribes for millennia. As the European settlers cut their way through eastern forests and pushed the Native Americans westward and away from their lands, an image of a new European landscape emerged. From the start the French and English considered the Native Americans to be outsiders, without a legitimate claim to the land on which they lived. On the other hand, Spaniards, who had arrived in the 1500s and had explored the Southwest, acknowledged the presence of an indigenous culture and eventually assimilated Pueblo Indians into their own world, in part through intermarriage.[15]

In the early nineteenth century artists painted Native Americans as savages, as seen in John Vanderlyn's *The Murder of Jane McCrea*, 1804 (see cat. 54), and as romantic images of the noble Indian living on lands that were still beyond the frontier of advancing white settlement. Many artists, such as Titian Ramsey Peale (1799–1885), followed government-sponsored expeditions into the prairies, documenting the land and its inhabitants, while others used private funding for their trips. Inspired by the scientific spirit of the age and holding a romantic vision of his quest, George Catlin set out on his own to document the western landscape and the American Indian tribes that inhabited the land, along with the buffalo herds that sustained them, before all disappeared. Seeing himself as an ethnographer, Catlin described his mission:

> I have for many years past, contemplated the noble races of red men who have now spread over these trackless forests and boundless prairies, melting away at the approach of civilization. . . . I have flown to their rescue—not of their lives or of their race (for they are "doomed" and must perish), but to the rescue of their looks and their modes, at which the acquisitive world may hurl their poison and every besom of destruction, and trample them down and crush them to death; yet phoenix-like, they may rise from the stain of a painter's palette, and live again upon canvass, and stand forth for centuries yet to come, the living monuments of a noble race.[16]

CLAIMING THE LAND

Most landscape imagery of the first half of the nineteenth century celebrated human progress in transforming the landscape—that is, claiming and settling America's wilderness. In 1831 Alexis de Tocqueville observed this phenomenon: "In Europe people talk a great deal of the wilds of America, but the Americans themselves never think about them; they are insensible to the wonders of inanimate nature and they may be said not to perceive the mighty forests that surround them till they fall beneath the hatchet. Their eyes are fixed upon another sight: the American people views its own march across these wilds, draining swamps, turning the course of rivers, peopling solitudes, and subduing nature."[17]

The vast majority of Americans were too busy pursuing progress to admire their expansive wilderness landscape until after they had subdued it. The rapid expansion of the young nation was fueled by the American conviction that they were meant to establish a great empire. By the 1840s these beliefs led to the quasi religious doctrine of Manifest Destiny—that the United States was destined to expand westward across the continent. The discovery of gold in the American River, California, in 1848 provided the impetus to develop land in the West. Believed to be sanctioned by God, Manifest Destiny to some suggested expansion across the continent to the Pacific; to others it included the whole North American continent; while to many the entire hemisphere was considered fair game.[18]

In addition to the emergence of a few native-born landscape artists in the early years of the Republic, an influx of British artists to the United States came in search of new artistic opportunities, often portraying imagery that would compare favorably with familiar scenes at home. They painted domesticated landscapes that also highlighted the progress of America. William Birch, for example, with his son Thomas, settled in Philadelphia, where, following English models, they produced and published a series of landscapes titled *The Country Seats of the United States of North America* (1808). In addition, they painted landscapes of countryseats and of settled lands, including Thomas Birch's *Landscape with Covered Wagon*, 1821 (fig. 6).

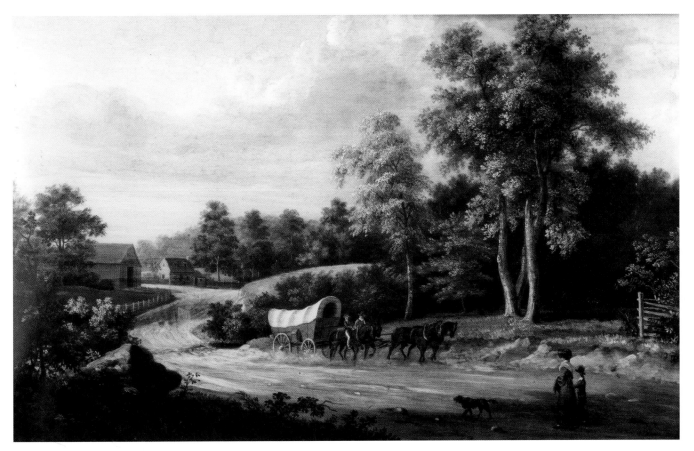

Fig. 6. Thomas Birch, *Landscape with Covered Wagon*, 1821
Oil on wood panel, 15¾ × 25 in. (40 × 63.5 cm)
Wadsworth Atheneum Museum of Art
Bequest of Clara Hinton Gould, 1948.207

LANDSCAPES OF ASSOCIATION

Many middle-class Americans, admiring European land-scapes for their associations with the past, felt a sense of inferiority when they attempted to compare their recent history and culture to that of Europe. At the same time they proclaimed their exceptional status as citizens of a new world destined to prosper. In the early decades of the nineteenth century, American landscape painters, in part-nership with travel writers, novelists, and poets, sought to provide local associations for the American landscape. The question arose, however, as to the nature of the associa-tions—should they refer to America's past, present, or future? Cole reveals this sense of ambivalence in his "Essay on American Scenery" (1835), proclaiming that "American scenes are not destitute of historical and leg-endary associations—the great struggle for freedom has sanctified many a spot, and many a mountain, stream, and rock has its legend, worthy of poet's pen or the painter's

pencil," while also declaring in the same essay that "Amer-ican associations are not so much of the past as of the pres-ent and the future. . . . Where the wolf roams, the plow shall glisten; on the gray crag shall rise temple and tower—mighty deeds shall be done in the now pathless wilderness; and poets yet unborn shall sanctify the soil."[19]

Reflecting Cole's ambivalence, American landscape painters incorporated a variety of associations in allegori-cal landscapes, often evoking a sequential narrative that charted a progressive transformation from wilderness to pastoral and settled land.[20] Their responses to this chal-lenge ranged from the pessimism of Cole's series *The Course of Empire*, c. 1836 (figs. 7–11), which rejected American nationalist pride by predicting its inevitable decline, to the optimism portrayed in the series of great national images painted by Cole's pupil, Church, which reinforced America's imperial ambitions. The son of a

Fig. 7. Thomas Cole, *The Course of Empire: Savage State*, 1834
Oil on canvas, 39¼ × 63¼ in. (99.7 x 160.6 cm)
Collection of The New-York Historical Society, 1858.1

Fig. 8. Thomas Cole, *The Course of Empire: Arcadian State*, 1834
Oil on canvas, 39¼ × 63¼ in. (99.7 × 160.6 cm)
Collection of The New-York Historical Society, 1858.2

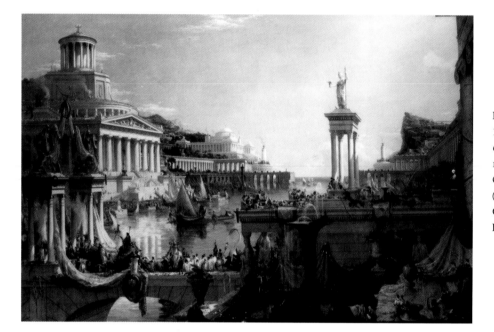

Fig. 9. Thomas Cole,
*The Course of Empire:
Consummation of Empire*,
1835–36
Oil on canvas, 51¼ × 76 in.
(130.2 × 193 cm)
Collection of The New-York
Historical Society, 1858.3

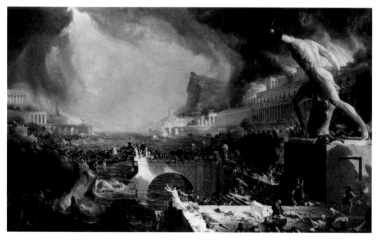

Fig. 10. Thomas Cole, *The Course of Empire: Destruction*, 1836
Oil on canvas, 33¼ × 63¼ in. (84.5 × 160.6 cm)
Collection of The New-York Historical Society, 1858.4

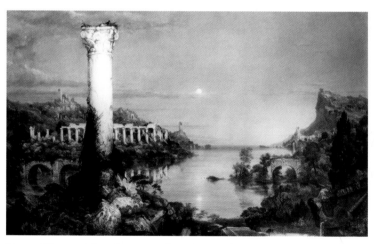

Fig. 11. Thomas Cole, *The Course of Empire: Desolation*, 1836
Oil on canvas, 39¼ × 63 in. (99.7 × 160 cm)
Collection of The New-York Historical Society, 1858.5

Hartford businessman, Church was first discovered by Daniel Wadsworth, who convinced his friend Cole to take him on as a student in his Catskill, New York, studio. From 1844 to 1846 Church absorbed the lessons Cole imparted, including a love of nature and an ambition to embrace elevated historical and moralistic themes for his landscape paintings.

Cole and other members of the urban-based Hudson River School used contemporary literature as well as the Bible for their pictorial themes. They worked in concert with such leading writers of the day as Washington Irving, William Cullen Bryant, and James Fenimore Cooper, using landscape as a vehicle to develop American historical themes and narratives. Cole's Scene from "The Last of the Mohicans," Cora Kneeling at the Feet of Tamenund, 1827 (see cat. 25), uses landscape to convey psychological meaning. The artist's representation of a scene drawn from recent American literature (Cooper's popular novel of the same title) reflects American settlers' attitudes toward Native Americans as savages. The scene took place in the vicinity of Lake George in upstate New York. In the composition, real and idealized imagery are combined. Cole includes both a faithful rendering of New Hampshire's White Mountain scenery (which he considered the finest he had ever beheld) at upper left, and idealized geological features enhancing the minute narrative scene in the foreground.[21] The sexual tension in Cooper's novel is evoked by a rocking stone atop a huge phallic pinnacle and by a dark cave, which provide a backdrop for the narrative scene of the young girl pleading for her sister's and her own life in front of the Indian chief.[22]

Church's earliest works followed Cole's precept to paint a "higher style of landscape." In his first ambitious composition, Hooker and Company Journeying Through the Wilderness from Plymouth to Hartford, in 1636, 1846 (see cat. 13), Church chose to paint a heroic event drawn from colonial history—the migration of a band of religious dissidents led by the Puritan preacher Thomas Hooker to found Hartford, Connecticut. This was a natural subject for Church, a sixth-generation Connecticut Yankee whose ancestor had been a member of Hooker's party. Like Cole, Church used human and spiritual drama to define the landscape; the figures evoke the Holy Family. The brilliant light that illumines their passage through the wilderness completes the allegory of divine providence at work in the Connecticut valley. Diverging from his teacher's pessimism, Church embraces the theme of Manifest Destiny in this work, which is one of the earliest representations of westward expansion. Landscape features such as the historic Charter Oak Tree, seen to the left, and the anthropomorphic forms of the gnarled trees and rocks in the foreground, along with the stylized rays of sunlight symbolic of divine light, enhance the meaning of the painting.

IN AWE OF THE LAND

By mid-century New York had become the base for the promotion of a national artistic culture, and most leading landscape painters were associated with the Hudson River School. The artistic community flourished through such forums as the National Academy of Design, the journal The Crayon, the American Art-Union, the opening of the Tenth Street Studio Building, the Artists' Fund Society, and the Century Club. Artists sought to come to terms with their nation's landscape by transcending pictorial tradition to capture the essence of nature, and by including new scientific understandings regarding nature's processes and new ideas of the sublime. Challenged by the competitive climate for patronage in New York, artists strove to develop new, more painterly techniques to convey romantic landscape images, focusing on water, forest interiors, mountains, and other such subjects that evoked the deeper meanings of nature. They employed bigger canvases to capture their expanding notions of landscape; the entrepreneurial spirit among leading painters resulted in "the great picture." Exhibitions of single works on a grand scale, such as Church's Heart of the Andes, 1859 (coll: The Metropolitan Museum of Art), were presented to the public for a fee. Artists honed their marketing skills, seeking patronage among America's railroad magnates and robber barons, as well as looking to London and Europe in search of an international audience.

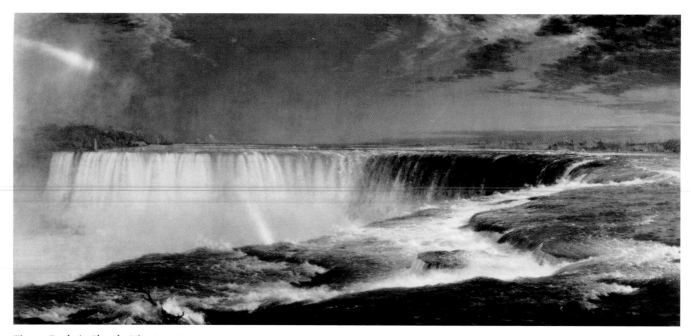

Fig. 12. Frederic Church, *Niagara*, 1857
Oil on canvas, 42½ × 90½ in. (108 × 229.9 cm)
In the Collection of the Corcoran Gallery of Art, Museum Purchase, Gallery Fund, 76.15

Church reigned at mid-century as the New World's most talented landscape painter. In 1850, upon reading the German naturalist-explorer Alexander von Humboldt's *Cosmos*, he was inspired by the descriptions of the world, particularly the tropics, which the scientist portrayed as an ideal, natural world. Church retraced von Humboldt's early travels through South America, making two trips there in the 1850s. In search of creation's origins, and fascinated by the processes of nature, he painted a series of major South American landscapes, including *Mountains of Ecuador*, 1855 (see cat. 15).[23]

In 1856, between his trips to South America, Church read volumes three and four of *Modern Painters* by the influential English art critic John Ruskin, and he was so impressed that he reread the earlier volumes. Ruskin's discussion of water as "to all human minds the best emblem of unwearied, unconquerable power," likely led Church to make water the central subject of two of his most important landscapes, *Niagara*, 1857 (fig. 12), and *Coast Scene, Mount Desert*, 1863 (see cat. 17).[24] Church broke new ground with these two paintings, employing innovative techniques for his daring compositions. It was shortly after reading Ruskin that Church traveled to Niagara Falls for the first time, embracing its aesthetic challenge. And fol-lowing von Humboldt's advice he produced color oil sketches for use in his studio—oil sketches being a relatively new approach to landscape painting. Church produced over seventy sketches, including *Niagara Falls*, 1856 (see cat. 16), in preparation for his final canvas.

The final conception for the grand-scale painting encompasses a view on the brink of the western edge of Horseshoe Falls. By eliminating the foreground altogether, Church creates the psychological sensation that the viewer is suspended over the torrent itself. *Niagara*, his first "great picture," gained for him an international audience. The technical brilliance of this work and its extraordinary illusionism made him the most famous painter in America and succeeded in impressing a British audience as well, including J. M. W. Turner and Ruskin.[25] In painting a North American landscape with nationalist overtones, Church presents the falls as a symbol of the power and energy of the New World. Water as subject, in conjunction with ideas concerning the erosion of the earth, continued to attract Church, as seen in such technically brilliant works as his seascape *Coast Scene, Mount Desert* (see cat. 17). Once again eliminating the foreground, Church places the viewer in direct confrontation with the sea and its sublime power.

Church later served as an adviser to the collector Elizabeth Hart Jarvis Colt, assisting her in creating one of the most impressive private picture galleries in the United States during the decade of the Civil War. One of the most important commissions for her gallery was Church's *Vale of St. Thomas, Jamaica,* 1867 (see cat. 18), a breathtaking stormy tropical scene that references the legacy of slavery on the island of Jamaica. Church also arranged for Elizabeth Colt to meet his colleagues, the major Hudson River painters who, along with Church, had studios in the Tenth Street Studio Building in New York. Colt would commission and acquire works from Albert Bierstadt, William Bradford, John Kensett, and Sanford Gifford, among others.

In addition to influencing Church's art, Ruskin's *Modern Painters* also had a profound effect on a small band of New York–based artists who called themselves The Association for the Advancement of Truth in Art, and who became strict disciples of Ruskin and the Pre-Raphaelite movement. William Trost Richards, a member of the group, demonstrates a mastery of the Pre-Raphaelite manner with his *On the Wissahickon,* 1880 (fig. 13), which adheres to Ruskin's call for "truth to nature" as seen in the brilliance of local color and profuse botanical detail in the foreground. This landscape commands a response completely different than that of the more conventional grand panoramas of the Hudson River School. *On the Wissahickon* inspires the kind of reverential response toward the forest interior as a natural sanctuary, or primeval cathedral, as is also found in such paintings as Asher B. Durand's *In the Woods,* 1855 (The Metropolitan Museum of Art), and expressed in such poems as William Cullen Bryant's "A Forest Hymn."

In addition to the influence of the English sublime found in Ruskin's writings, many American landscape painters sought training at mid-century in Düsseldorf, where their exposure to German Romantic idealism was later demonstrated in romantic sublime paintings of the American landscape. Mountains of the Northeast as well as the newly discovered mountains and valleys in the West persisted as favorite subjects of these artists until late in the century.

Sanford Gifford's *A Passing Storm in the Adirondacks,* 1866 (see cat. 42), was painted for the private picture gallery of Elizabeth Colt at a considerable price that demonstrated the artist's entrepreneurial talents.[26] Gifford depicts a scene in the Adirondack Mountains that includes two themes of central interest to him during the Civil War era—storm imagery and the pioneer in the wilderness. Between 1859 and 1868, Gifford employed storm imagery, perhaps as a symbol of civil discord, painting a series of "coming," "approaching," and "passing" storm scenes that may have related to the effects of the Civil War.[27] *A Passing Storm in the Adirondacks* was painted in the war's aftermath, ironically commissioned by Elizabeth Colt, who oversaw the management of Colts Arms Manufactory, which had supplied both the North and South with guns during the conflict.[28]

As the leading painter of the American West, with an entrepreneurial spirit that rivaled that of Church, Bierstadt not only aligned himself with the railroads, but in order to

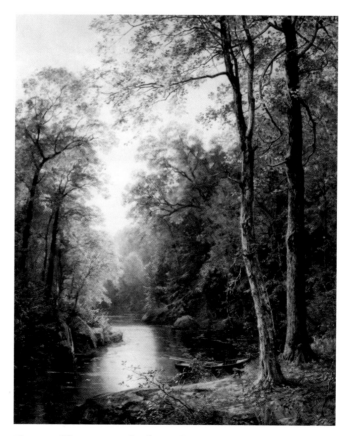

Fig. 13. William Trost Richards, *On the Wissahickon,* 1880
Oil on canvas, 24⅛ × 20⅛ in. (61.3 × 51.0 cm)
Wadsworth Atheneum Museum of Art
Bequest of Ambrose Spencer, 1901.6

Introduction

13

gain national recognition he also went so far as to rename the mountains in his western paintings for leading patrons. Bierstadt had exhibited a painting titled *Mountain Lake*, which was typical of his epic western landscapes, at the National Academy of Design in 1877. He renamed the work *Mount Corcoran* (coll: The Corcoran Gallery of Art) in order to attract the patronage of William Corcoran, who placed it in the Corcoran Art Gallery, a cultural institution that he opened in the nation's capital in 1874. Bierstadt was also commissioned to paint a western landscape for Elizabeth Colt's Hartford picture gallery, *In the Yosemite Valley*, 1866 (see cat. 4).

Landscape of Contemplation

American landscape painters who established their careers after mid-century continued to explore familiar scenery in the Northeast, but their landscapes demonstrated new aesthetic concerns. In the 1860s and 1870s Americans, who traveled in greater numbers to Europe, became more cosmopolitan in their tastes. Artists sought training and inspiration in Europe as American patrons supported the large-scale importation of European art. Several new trends rooted in European art began to have an impact on art in America, including French Barbizon landscape painting, the Munich School, and the British-inspired Aesthetic movement. The term *Hudson River School* was first introduced in the 1870s—pejoratively, in fact—to describe the panoramic vision and precise detail of such artists as Durand, Church, and Bierstadt, among many others whose works began to appear conservative in the face of new stylistic concerns.[29] Additionally, advancements in photography threatened the landscape painters' hegemony over this newer, more "truthful" medium.[30] These changes signaled in landscape art a transitional phase that was resolved by the end of the century, when the figure replaced nature as the prominent subject of the landscape.

Beginning in the 1860s, some Hudson River School painters, most notably Gifford and Kensett, painted light-infused atmospheric landscapes that demonstrate their shift in artistic priorities. Paintings such as Gifford's *Sunset on the Hudson*, 1876 (see cat. 43), and Kensett's *Coast Scene with Figures (Beverly Shore)*, 1869 (see cat. 51), in which detail and spatial effects have been starkly reduced, came to be called "luminist" paintings in the twentieth century.[31] New understandings of the scientific theories of natural law, including Charles Darwin's *On the Origin of Species* (1859), which described the evolution of nature as a process of natural selection marked by random variations, and Charles Lyell's theories of geology, which held that changes in the Earth's surface occurred slowly over extremely long periods of time, added to the modifications in landscape art. Widespread in his writing, Ruskin expressed the new response to nature: "It is not in the broad and fierce manifestations of the elemental energies, not in the clash and hail, nor the drift of the whirlwind, that the highest characters of the sublime are developed. God is not in the earthquake, nor in the fire, but in the still small voice."[32]

While Gifford favored atmospheric spaces over massive mountains, Fitz Hugh Lane and Kensett depicted local shoreline scenery, evoking a similar, contemplative sublime emotion in which the coastline is seen as quietly mysterious. Kensett's *Coast Scene with Figures (Beverly Shore)* (see cat. 51) is a mature work and one of his largest canvases. The tightly controlled brushwork, subtle palette, and emphasis on delicate atmospheric effects, combined with a reductive composition made up of two large masses of land and water and harmoniously balanced against the larger mass of the sky, are distinctive characteristics of his later work. Humans on the shoreline contemplate a benign setting, disturbed only by the giant breakers about to crash on the shore.

More typical of the intimate scale favored by artists at this time is Martin Johnson Heade's *Winding River, Sunset*, c. 1863 (see cat. 46). Heade produced more than one hundred landscapes investigating the haystacks that could be seen along the coastal marshes of the Northeast. In these works he explores the evanescent effects of light and weather. Salt marshes made for interesting subjects because, neither wild nor domesticated, they are beyond human control; the grass grows without cultivation, and, despite harvesting, little change is made to the marshes.[33]

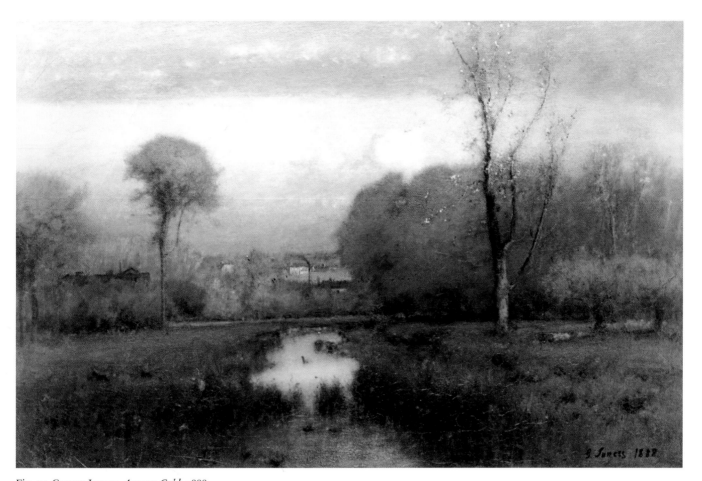

Fig. 14. George Inness, *Autumn Gold*, 1888
Oil on canvas, 30 × 45 in. (76.2 × 114.3 cm)
Wadsworth Atheneum Museum of Art
Purchased through the gift of Henry and Walter Keney, 1897.4

During the 1870s and 1880s artists favored tamed landscapes rather than the wilderness of Cole and Church. The evocative, romantic style of tonalism emerged in 1880s landscape art, in which painters used a limited range of colors, often a single tone, to create softly lit scenes in which detail is obscured. These works were strongly influenced by the lyrical nocturnes of James McNeill Whistler and, like Whistler himself, inspired in part by Asian art, particularly Japanese prints.

George Inness proved to be one of the most dynamic American landscape painters of the third quarter of the century. Inspired by Barbizon painting, which emphasized mood and expression over topography, he sought the local, more civilized landscape that he felt was "more worthy of reproduction than that which is savage and untamed."[34] Inness worked from memory and imagination, distancing himself from the immediate experience of

nature and often painting over earlier canvases. In his mature landscapes, such as *Autumn Gold*, 1888 (fig. 14), he produces a breadth of effect, focusing on the formal qualities of the autumn landscape. Painting his favored local New Jersey landscape, he strove "to awaken an emotion with the composition's fragile beauty and restrained harmonies of color.[35]

By the end of the century the American frontier was declared "closed" by the young historian Frederick Jackson Turner. In 1893, four years after the Oklahoma Territory—the last tract of western American Indian land—was opened to non-Indian settlement, Turner delivered his lecture "The Significance of the Frontier in American History." He declared that "frontier is gone and with its going has closed the first period of American history." As one recent historian has noted, however, Turner's frontier thesis rested on a single point of view: "It required that the

observer stand in the East and look to the West," interpreting the western frontier as a process rather than as a place that continues to have a history.[36] American artists returning home from European sojourns in the 1870s and 1880s found that the earlier agrarian society had rapidly shifted by the final decades of the century to an industrialized and increasingly urban culture. They began to explore urban subjects and scenes of modern life.

Over the course of the nineteenth century, landscape painters in the United States investigated the transformation of the wilderness forests to cultivated fields, as European settlement took hold from the eastern to the western edges of the North American continent. In their aesthetic inquiries these artists explored the nation's geography, including its picturesque river valleys and sublime natural wonders; wilderness mountains and forests; and swamps and vast deserts. As Americans laid claim to the land, inscribing it with property lines, artists painted the newly built houses, recently settled towns, and flourishing cities. At the same time, artists imbued their landscapes with uniquely American historic associations. Moving westward, artists documented the imminent extinction of Native Americans as they were forced off their lands. Scientific and religious knowledge provided deeper meanings for landscape and nature at mid-century, and painters expressed them in ever-larger canvases. As the century progressed, landscape and landscape painting served as a vehicle for therapeutic retreat from an increasingly industrial, urban-based society. By the end of the century, the transformation process was seemingly complete. Humanity's changed relationship to nature—from subject to master—was revealed in landscape art, and figure painting effectively replaced landscape as the leading artistic genre.

NOTES

1. For much of the eighteenth century Edmund Burke's definitions of the beautiful, meaning the harmonious, sensual, feminine aspects of nature, and the sublime, which he associated with the harsh, masculine, horrific aspects of nature, were widely accepted. See Edmund Burke, *A Philosophical Inquiry into the Origins of Our Ideas of the Sublime and Beautiful (1757–1759)*, ed. James T. Boulton (Notre Dame and London: University of Notre Dame, 1968). With the growing interest in landscape painting and tourism by century's end, the category of the picturesque was defined in the writings of Gilpin, Price, and Knight. For a discussion of their writings, and for the changing definitions of the picturesque, see Malcolm Andrews, *The Search for the Picturesque* (Stanford, Calif.: Stanford University Press, 1989).

2. Timothy Dwight, *Travels in New England and New York 1769–1815*, 3 vols., ed. Barbara Miller Solomon (1822; reprint, Cambridge, Mass.: Harvard University Press, 1969); Benjamin Silliman, *Remarks Made, on a Short Tour, Between Hartford and Quebec in the Autumn of 1819* (1820; reprint, New Haven: Converse, 1824); Theodore Dwight, *Northern Traveler* (New York: Wilder and Campbell, 1826); Theodore Dwight, *Sketches of Scenery and Manners in the United States* (New York: Goodrich, 1829); and Theodore Dwight, *Things as They Are; Notes of a Traveler Through Some of the Middle and Northern States* (New York: Harper, 1834).

3. Silliman, *Remarks Made*, 18.

4. As Alan Wallach notes, Cole's painting hints at the experience of what he calls the "panoptic sublime" that was afforded by the view from the tower, providing both panoramic or visual mastery of the scene with telescopic vision resulting in "a sudden loss of boundaries." See Alan Wallach, "Wadsworth's Tower: An Episode in the History of American Landscape Vision," *American Art* 10(3) (Fall 1996): 8–27, esp. 22.

5. Thomas Cole, "Essay on American Scenery" (1835), in John W. McCoubrey, *American Art 1700–1960* (Englewood Cliffs, N.J.: Prentice-Hall, 1965), 98–109.

6. Edward J. Nygren, with Bruce Robertson et al., *Views and Visions: American Landscape Before 1830*, exh. cat. (Washington, D.C.: The Corcoran Gallery of Art, 1986), 42–57.

7. Rebecca Bedell, *The Anatomy of Nature: Geology and American Landscape Painting, 1825–1875* (Princeton and Oxford: Princeton University Press, 2001).

8. John F. Sears, *Sacred Places: American Tourist Attractions in the Nineteenth Century* (New York: Oxford University Press, 1989), 13.

9. Fred Barry Adelson, *Alvan Fisher (1792–1863): Pioneer in American Landscape Painting*, vol. 1 (Ann Arbor, Mich.: University Microfilms International, 1985), 167–88.

10. Jeremy Elwell Adamson et al., *Niagara: Two Centuries of Changing Attitudes, 1697–1901*, exh. cat. (Washington, D.C.: The Corcoran Gallery of Art, 1985), 35n.90.

11. "Hudson River School" was originally intended as a derogatory label first used in the late 1870s to call attention to the provinciality of the painters; see Kevin J. Avery, "A Historiography of the Hudson River School," in John K. Howat et al., *American Paradise: The World of the Hudson River School*, exh. cat. (New York: The Metropolitan Museum of Art, 1988), 3–20; see also Angela Miller, *The Empire of the Eye: Landscape Representation and American Cultural Politics, 1825–1875* (Ithaca and London: Cornell University Press, 1993), 21–65.

12. See Christine Startsell and Sean Wilentz, "Cole's America," in *Thomas Cole: Landscape into History*, ed. William H. Truettner and Alan Wallach, exh. cat. (New Haven and London: Yale University Press, for the National Museum of American Art, 1994), 3–23.

13. Marshall Tymn, ed., *Thomas Cole: The Collected Essays and Prose Sketches* (St. Paul, Minn.: John Colet Press, 1980), 131.

14. Truettner and Wallach, eds., *Thomas Cole: Landscape into History*, 51.

15. Karl W. Butzer, "The Indian Legacy in the American Landscape," in *The Making of the American Landscape*, ed. Michael P. Conzen (1990; reprint, New York and London: Routledge, 1994), 27.

16. George Catlin, *Letters and Notes on the Manners, Customs, and Condition of the North American Indians*, vol. 1 (London, 1841; reprint, New York: Dover, 1973), 16.

17. Alexis de Tocqueville, *Democracy in America* (1835, 1840; reprint, New York: Vintage Books, 1954), 2.

18. In 1844 the growing popular sentiment for expansionism, including the annexation of Texas, led to the election of James K. Polk as president of the United States. The phrase that captured this expansionist spirit became "Manifest Destiny," first used in 1845 in a speech by the New York Democratic journalist John L. O'Sullivan, who wrote of "our manifest destiny to overspread and to possess the whole of the continent which Providence has given us for the development of the great experiment of liberty and federative self-government entrusted to us." See Frederick Merk, *Manifest Destiny and Mission in American History* (1963; reprint, Cambridge, Mass.: Harvard University Press, 1995), 32. The term was widely embraced at mid-century to justify western expansion.

19. Quoted in Truettner and Wallach, eds., *Thomas Cole: Landscape into History*, 53–54; Thomas Cole, "Essay on American Scenery," in Tymn, ed., *Thomas Cole: The Collected Essays*, 16–17.

20. Miller, *The Empire of the Eye*, 83.

21. Thomas Cole to Daniel Wadsworth, 4 August 1827, in J. Bard McNulty, ed., *The Correspondence of Thomas Cole and Daniel Wadsworth* (Hartford: Connecticut Historical Society, 1983), 12.

22. Richard Slotkin, introduction to *The Last of the Mohicans*, by James Fenimore Cooper (New York: Penguin, 1988), ix–xxviii.

23. Katherine Emma Manthorne, *Tropical Renaissance: North American Artists Exploring Latin America, 1839–1879* (Washington and London: Smithsonian Institution Press, 1989).

24. John Ruskin, quoted in David C. Huntington, *The Landscapes of Frederic Edwin Church: Vision of an American Era* (New York: Braziller, 1966), 65–66.

25. Adamson et al., *Niagara*, 15–17.

26. Elizabeth Mankin Kornhauser et al., *American Paintings Before 1945 in the Wadsworth Atheneum*, vol. 2 (New Haven and London: Yale University Press, 1996), 26.

27. A convincing argument concerning Gifford's response to the Civil War is presented in Ila Weiss, *Poetic Landscape: The Art and Experience of Sanford R. Gifford*, American Art Series (Newark: University of Delaware Press, 1988), 260.

28. Kornhauser et al., *American Paintings Before 1945 in the Wadsworth Atheneum*, vol. 1, 22–30; vol. 2, 404–7.

29. Doreen Bolger Burke and Catherine Hoover Voorsanger, "The Hudson River School in Eclipse," in Howat et al., *American Paradise*, 71–98, esp. 71–73.

30. Ibid., 74–75.

31. Although scholars have tended to define this mode as a unified approach to landscape art, carried out by a second generation of Hudson River School painters whose quiet, simplified style emerged after the Civil War (and perhaps in response to that conflict), the term *luminist* as well as the concept of luminism remains controversial. The major works on luminism include: John I. H. Baur, "Early Studies in Light and Air by American Landscape Painters," *Bulletin of the Brooklyn Museum* 9 (Winter 1948): 1–9; John I. H. Baur, "American Luminism: A Neglected Aspect of the Realist Movement in Nineteenth-Century American Painting," *Perspectives USA* 9 (Autumn 1954): 90–98; Barbara Novak, *American Painting of the Nineteenth Century: Realism, Idealism, and the American Experience* (1969; rev. ed., New York: Harper and Row, 1979); and John Wilmerding, ed., *American Light: The Luminist Movement, 1850–1875*, exh. cat. (Washington, D.C.: National Gallery of Art, 1980). More recently, scholars have offered new, more contextually and psychologically based interpretations for this mode, exploring new definitions of the sublime in nature, as seen in artists focusing on nature's "feminine" characteristics—voids displace mass, and silent process displaces noisy manifestations of natural force. See Miller, *The Empire of the Eye*, 243–89.

32. Quoted in ibid., 251.

33. Diana J. Stazdes, entry for Martin Johnson Heade, *Newburyport Meadows* (c. 1872–1878), in Howat et al., *American Paradise*, 177–78.

34. Quoted in Howat et al., *American Paradise*, 79.

35. [George Inness], "A Painter on Painting," *Harper's New Monthly Magazine* 56 (February 1878): 458.

36. Patricia Nelson Limerick, *The Legacy of Conquest: The Unbroken Past of the West* (New York and London: W.W. Norton, 1987), 25–26.

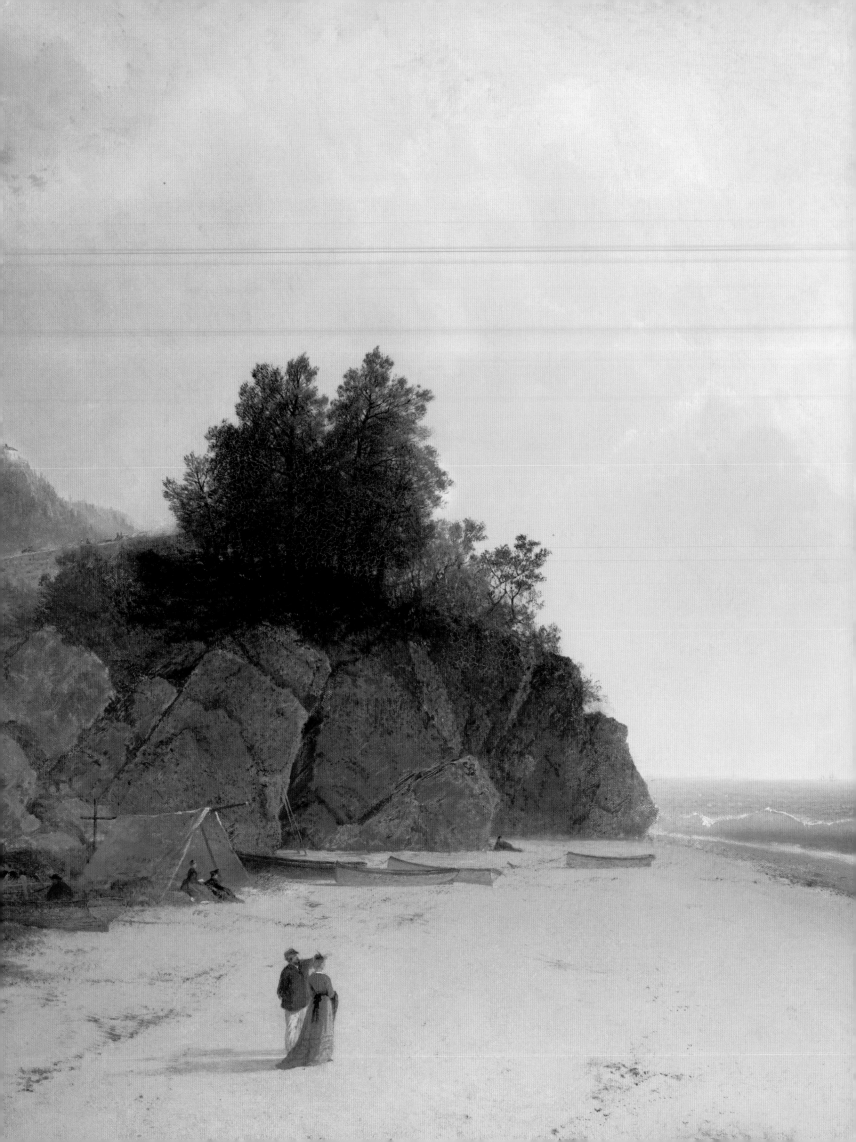

CATALOGUE

WILLIAM HOLBROOK BEARD

Born 1824, Painesville, Ohio;

died 1900, New York City

THE CENTURY ASSOCIATION, NY

William Holbrook Beard was a specialist in animal painting, but, like many artists, he began with portraiture. He was not a successful portraitist, however; he made little effort to flatter his sitters and often exaggerated their unfortunate characteristics to the delight of all but the subjects themselves.

At around age twenty-five, Beard moved to Buffalo, New York, where he set up a studio. There, Beard made a number of acquaintances, including artist Thomas LeClear (1818–1882), who became his father-in-law in 1863. In 1856 Beard traveled to Europe, visiting Düsseldorf, Switzerland, and Rome, and met a number of American artists, among them Sanford Gifford, Worthington Whittredge, and Albert Bierstadt.

Beard returned to Buffalo in 1858 and began sending his animal and fantasy pictures to the National Academy of Design in New York City. During this period he also exhibited at Snedicor's Art Gallery on Broadway. The following year, he married his first wife, Flora Johnson, the granddaughter of the first mayor of Buffalo. She died only months after their marriage, and this tragedy may have prompted Beard to leave Buffalo for New York City the following winter. He moved into the Tenth Street Studio Building,

remaining there for the rest of his career, continuing to exhibit at the National Academy and Snedicor's, as well as at Samuel P. Avery's and William and Everett's galleries. He also exhibited at the Boston Athenaeum and at the Pennsylvania Academy in Philadelphia. In 1873 he exhibited in Hartford at the Connecticut School of Design.

Beard was elected an academician at the National Academy in 1862. He wrote two books, Humor in Animals (1885) and Action in Art (1893), and a long poem, The Spade (1894). In 1866 he traveled to Colorado with writer Bayard Taylor, but this trip had little effect on his choice of subject matter for painting. In 1871 he designed a series of animals, sculpted out of rock, which was to have been part of an underground entrance to a museum planned for the site where the Museum of Natural History in New York City now stands. He also completed some small models of animals in preparation for his paintings and designed at least two large sculptural monuments that were never executed.

Although he was best known as an animal painter, Beard also painted such diverse subjects as Native Americans, scenes from fairy tales and Charles Dickens stories, and, particularly in his later years, religious and allegorical subjects.

Beard

1 · *Mountain Stream and Deer,* 1865

Oil on canvas, 37 × 29 in. (94 × 73.7 cm)
Signed at lower left on rock: W. H. Beard / 1865
Ex coll.: Elizabeth Hart Jarvis Colt, Hartford, to 1905
Gift of Elizabeth Hart Jarvis Colt, 1905.16

Mountain Stream and Deer is typical of the type of animal paintings American academic painters were making in the nineteenth century, and it draws on the American landscape painter's use of animals to help convey mood and idea. When pictured singly, deer symbolized solitude; in conjunction with such elements as a mountain stream and unspoiled forest wilderness, communion with nature.[1] Beard's painting, which includes two bucks, may suggest interrupted solitude.

Beard painted a few landscapes early in his career, and this painting is as much about the vivid autumn landscape as it is about the animals in it. Given the popularity of landscapes at this time, it is likely that he painted this work with the intention of selling it quickly. Elizabeth Colt, who gave this painting to the Atheneum, bought a number of paintings from artists in New York City for her private picture gallery and may well have purchased this work at Beard's Tenth Street Studio.

(detail)

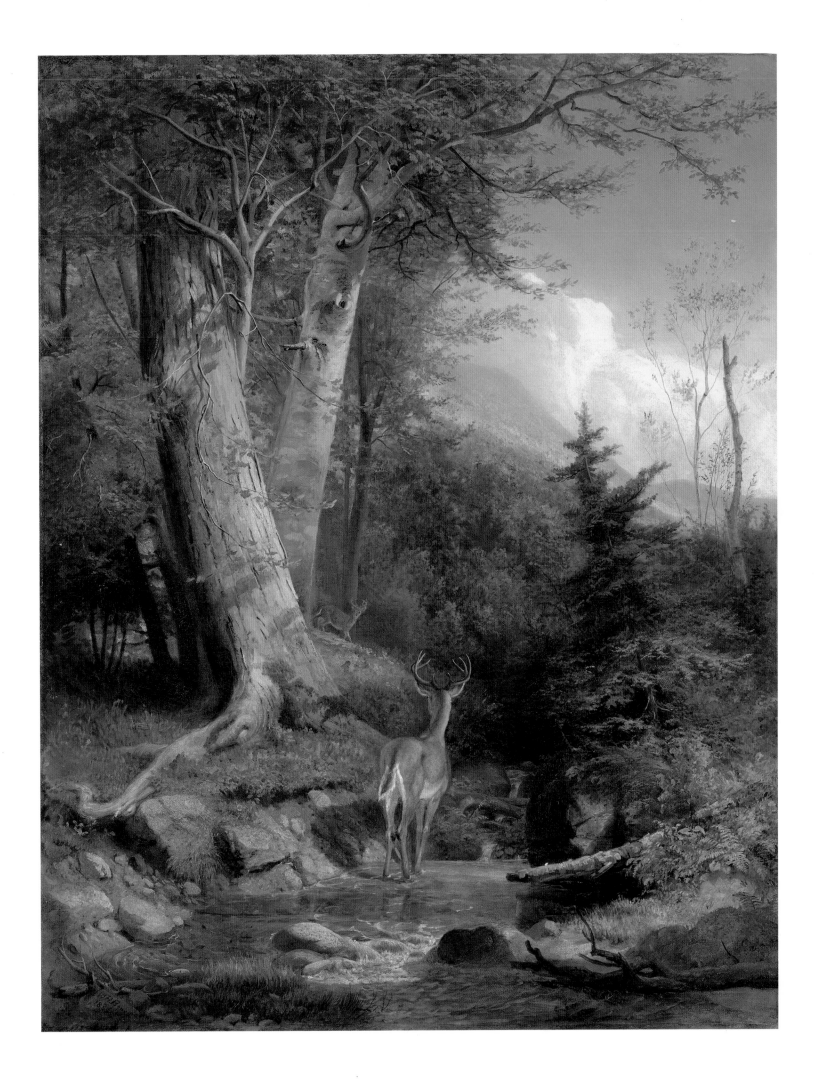

ALBERT BIERSTADT

Born 1830, Solingen, Prussia;
died 1902, New York City

Albert Bierstadt was born near Düsseldorf, Germany. At age two, he immigrated with his family to America. Apparently self-taught, he advertised in 1850 as an instructor in monochromatic painting in New Bedford, Massachusetts. For the next three years, he worked with a daguerreotypist, producing theatrical presentations of American scenery, an experience that initiated a lifelong interest in photography.

In 1853 Bierstadt returned to Europe to study at the Düsseldorf Art Academy, and he traveled extensively. In Düsseldorf he met American artists Emanuel Leutze (1816–1868) and Worthington Whittredge, as well as the contemporary German painters Carl Friedrich Lessing (1807–1880) and Andreas Achenbach (1827–1905), who inspired the highly finished style of his mature work. In 1856 he traveled with Whittredge to Rome and to the mountains of Germany, Switzerland, and Italy. Returning to New Bedford in July 1857, Bierstadt began organizing an exhibition of paintings, including fifteen of his own works based on his European sketches; it opened the following March and brought him national attention. In April 1859, with the intention of making sketches for a series of large-scale landscapes of the American West, Bierstadt joined a United States government survey expedition, headed by Colonel Frederick W. Lander, to the territories of Colorado and Wyoming. With the spectacular scenery of the Alps still fresh in his mind, he wrote to the journal The Crayon *from the Rocky Mountains: "The mountains are very fine; as seen from the plains, they resemble very much the Bernese Alps, one of the finest ranges in Europe, if not in the world. They are of a granite formation, the same as the Swiss mountains and their jagged summits, covered with snow and mingling with the clouds, present a scene which every lover of landscape would gaze upon with unqualified delight."[2]*

On his return to New York City in the fall, he moved into the Tenth Street Studio Building and began to paint a series of landscapes that secured his position as America's leading painter of Western scenery. The success of The Rocky Mountains, Lander's Peak *(1863, The Metropolitan Museum of Art), exhibited at the art gallery of the Metropolitan Sanitary Fair in New York City in 1864, established the artist as a major rival of Frederic E. Church. In 1863, accompanied by the writer Fitz Hugh Ludlow, he undertook another, more extensive western trip that provided material for his paintings of California's Yosemite valley.*

Bierstadt enjoyed enormous success for the next decade. In 1863 he married Rosalie Ludlow and completed building Malkasten, an impressive mansion overlooking the river at Irvington-on-Hudson, New York. From 1867 to 1869 he toured Europe, continuing to paint western scenery, paintings of which he exhibited in the United States and abroad. Praised by critics in America and England for their detail and grandeur, Bierstadt's depictions of the little-known scenery of the American West appealed to the new industrial upper middle class, who valued their great size and virtuoso workmanship as well as their celebration of America's seemingly limitless natural resources. In 1867 the artist received a commission to paint two landscapes for the Capitol; he completed The Discovery of the Hudson *in 1875.*

Bierstadt was among the most productive and internationally honored American artists of the nineteenth century. In the post–Civil War era, however, his paintings began to receive negative criticism, and by 1880 his reputation had declined. The artist also suffered a series of misfortunes, including the destruction of Malkasten by fire in 1882 and the death of his wife in 1893.

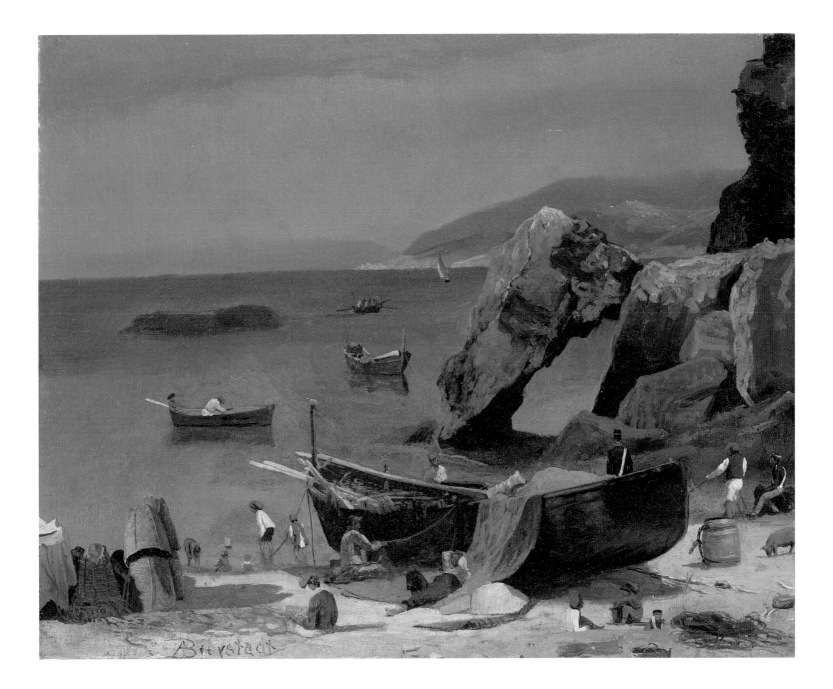

2 · *Capri Beach,* c. 1857

Oil on composition board, 10¾ × 13 in. (27.3 × 33 cm)
Signed at lower left (partial monogram): *ABierstadt*
Ex coll.: purchased from the artist's estate by Rholfs Gallery, Brooklyn,
New York; with John Nicholson Gallery, New York City, by 1947
The Ella Gallup Sumner and Mary Catlin Sumner Collection Fund, 1947.112

Bierstadt executed this oil study while he was on the island of Capri from May 30 until June 26, 1857, during his first visit to Italy. In the company of Sanford Gifford, Bierstadt journeyed to Capri and the Amalfi coast. Gifford's letters, journals, and sketches document the trip, which took place under spartan conditions, with the two artists sketching and at times camping outdoors.[3]

Capri Beach shows a beached fishing boat with canvas sails pulled over it. The representations of the fisherfolk and their animals are cursory, with the most attention paid to the colorful costumes, baskets, and nets. Children play with a toy boat at the water's edge, a man seated at left repairs baskets, and two soldiers observe the work going on around them. The detailed scene is set against a brilliant

Bierstadt

blue and aqua sea, with an interesting arched rock formation at the right.

One of many oil studies remaining in the artist's studio at the time of his death, *Capri Beach* shares related details and a similar provenance with that of the related work *Fishing Boats at Capri*, inscribed "Capri / june 14 1847 / A Bierstadt" (Museum of Fine Arts, Boston), which was also acquired by Rholfs Gallery in Brooklyn and later by John Nicholson Gallery in New York City in 1946. Its subject matter also relates to that of *Capri* (c. 1857, Garzoli Gallery, San Rafael, California), which bears a similar signature of questionable origin.[4]

Bierstadt produced a large number of color studies in oil on paper (with slight pencil underdrawing) of the landscape and people of the Amalfi coast. His attentiveness to the details of the landscape provided preparatory models for what he "would later see on California's Pacific shore."[5] Based on the many sketches he made of Capri, Bierstadt produced a major studio painting in 1859, *The Marina Piccola, Capri* (Albright-Knox Art Gallery, Buffalo, New York), which he gave to the Buffalo Fine Arts Academy.[6] Several details in *Capri Beach*, including the fishing nets and round-bottom baskets, also appear in the Albright-Knox painting.

3 · *Toward the Setting Sun*, 1862

Oil on paper mounted on canvas, 7¾ × 14 in. (19.7 × 35.6 cm)
Signed and dated at lower left (partial monogram): ABierstadt / 62
Ex coll.: Cassius Welles, 645 Prospect Avenue, Hartford; to his wife, Susan Russell Welles, Hartford; to her nephew, William B. Russell, Hartford; to his daughter, Edith Russell Wooley, Hartford; to J. Harold Williams, Hartford, by 1977
Gift of Mr. J. Harold Williams, in memory of Edith Russell Wooley, 1977.74

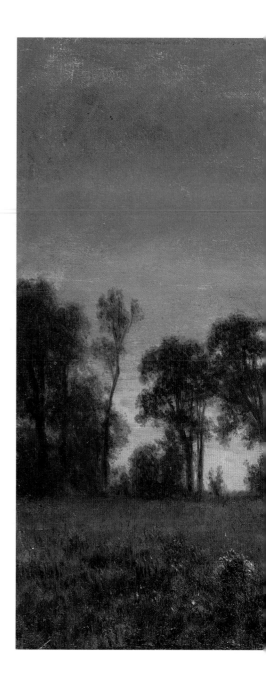

In January 1859 the artist's hometown paper in New Bedford reported that Bierstadt was about to start for the Rocky Mountains "to study the scenery of that wild region, and the picturesque facts of Indian life, with reference to a series of large pictures."[7] The artist joined Frederick W. Lander's survey party bound for the Rocky Mountains, and he completed studies of the Wind River, the Wasatch ranges, and the Black Hills. In an oft-quoted letter he wrote from the Rocky Mountains on July 10, 1859, which was published in *The Crayon*, Bierstadt expressed his desire to record the Native American people while it was still possible to do so.[8]

Bierstadt returned to New York City in September 1859 with a sizable number of drawings and sketches, stereopticon photographs of Native Americans and western landscape, and an impressive collection of Native American artifacts. Within three months he had moved into the Tenth Street Studio Building in New York City, where he placed his artifact collection on display and began to paint large canvases of the West.

Unlike many of his sketches of Native Americans, which document their physiognomy and dress, *Toward the Setting Sun* was painted three years after the artist's return from his

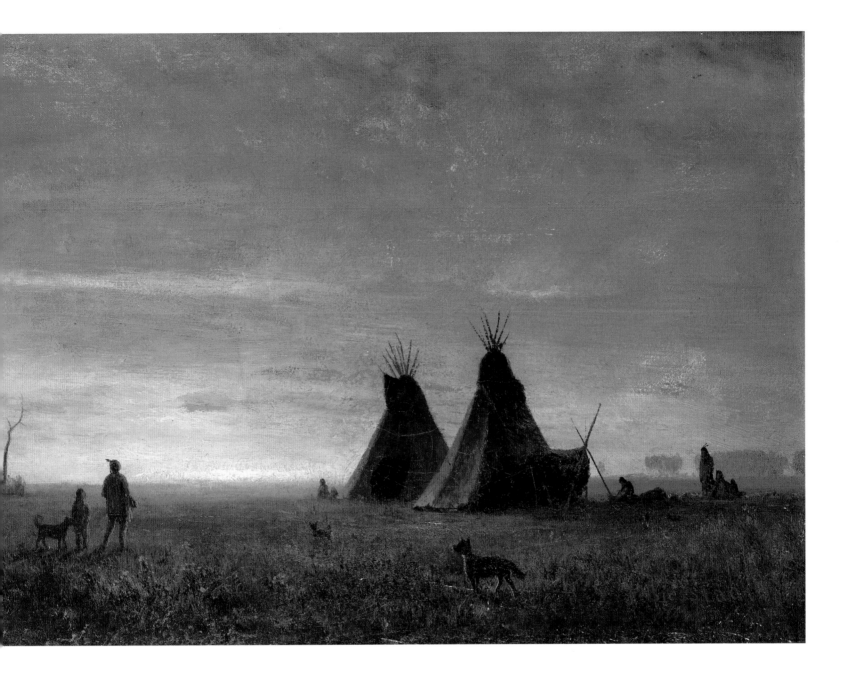

trip and carries a sentimental message of impending extinc-
tion. In a suffusion of golden red light, the Native Americans
and their dogs are placed in dark shadow in a flat plains land-
scape. With their backs to the viewer, the Native Americans
gaze at the setting sun in the distance.

Although after his 1859 trip Bierstadt painted other pic-
tures that have Native American figures in them, his claim
of being "a figure-painter" is suspect. Bierstadt knew his gifts
did not lie in this area but rather in landscape. Of the paint-
ings he produced as a result of this trip, *Indians Traveling
near Fort Laramie* (1861, Manoogian Collection) was his most

ambitious work to include Native American figures. Unlike
Toward the Setting Sun, in which the figures are placed at a
distance, making them indistinct, the Fort Laramie scene
includes a detailed figural group in the foreground of the
canvas. In his important work *The Rocky Mountains, Lander's
Peak* (1863, The Metropolitan Museum of Art), Bierstadt
included a detailed Native American "frieze" in the fore-
ground. Here, for the first time, the artist's early interest in
Native Americans and his developing interest in grand land-
scape are joined, although after this work Native American
figures serve largely as staffage for his grand landscapes.[9]

Bierstadt

4 · *In the Yosemite Valley*, 1866

Oil on canvas, 35⅛ × 50 in. (89.2 × 127 cm)
Signed and dated at lower right (partial monogram): A Bierstadt, 1866
Canvas stamp on back: 56 50 / Prepared by / Edw. Dechaux / New York
Ex coll.: purchased from the artist by Elizabeth Hart Jarvis Colt, Hartford,
probably in 1866
Bequest of Elizabeth Hart Jarvis Colt, 1905.22

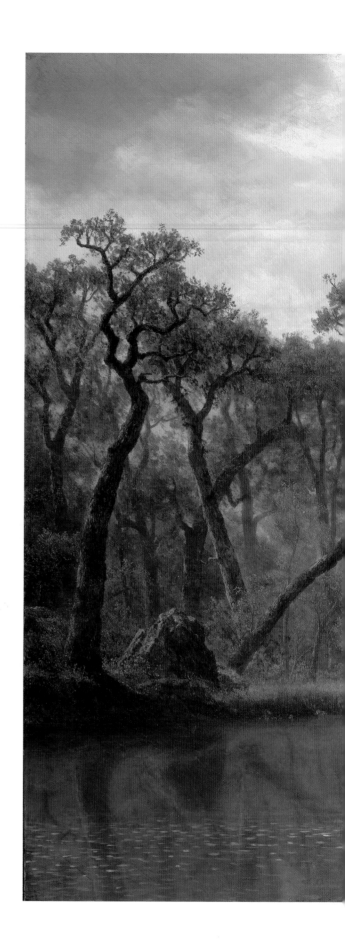

Traveling with Bierstadt to California in the spring of 1863,
the New York writer Fitz Hugh Ludlow chronicled the jour-
ney in a series of letters and articles, and in a book, *The Heart
of the Continent*, in 1870.[10] In San Francisco, Ludlow and Bier-
stadt were joined by the artists Virgil Williams (1830–1886)
and Enoch Wood Perry (1831–1915) on their trip to Yosemite.
The men stayed at Yosemite for approximately seven weeks,
spending their days on sketching expeditions. Bierstadt wrote
of the beauty of his surroundings: "We are now here in the
garden of Eden I call it. The most magnificent place I was
ever in, I employ every moment painting from nature. . . .
We camp out altogether, get no news, and do not care for
any for we are perfectly happy with the fine scenery, trout,
ducks, deer, etc."[11]

Bierstadt correctly predicted that scenery of the Yosemite
valley would be popular, and on his return to New York City,
working from his portfolio of drawings and sketches, he
began to depict the grandeur of the valley in a series of major
oil paintings. He offered his first Yosemite painting, *Valley of
the Yosemite* (1864, Museum of Fine Arts, Boston), a small
work (11¾ × 19¼ in. [29.8 × 48.9 cm]), at the fine art auction
held at the Metropolitan Sanitary Fair in New York City in
1864. The painting went to a "Mr. Davis" for sixteen hundred
dollars—the highest price paid for a painting at the sale—the
proceeds going to the Sanitary Commission.[12]

Elizabeth Colt, who served as the head of the Hartford
Table at the Metropolitan Sanitary Fair, later acquired or
commissioned *In the Yosemite Valley*, a similar but larger
work, for her private picture gallery, for which construction
began in 1865 and was completed in 1868. The painting,
finished in 1866, depicts an afternoon scene along the Merced
River, looking southwest rather than toward the east, which
was more typical for this artist. In this work, Bierstadt placed
a greater emphasis on the picturesque foreground details—
the deer and the fallen tree trunk—diminishing the impact
of the distant mountains.

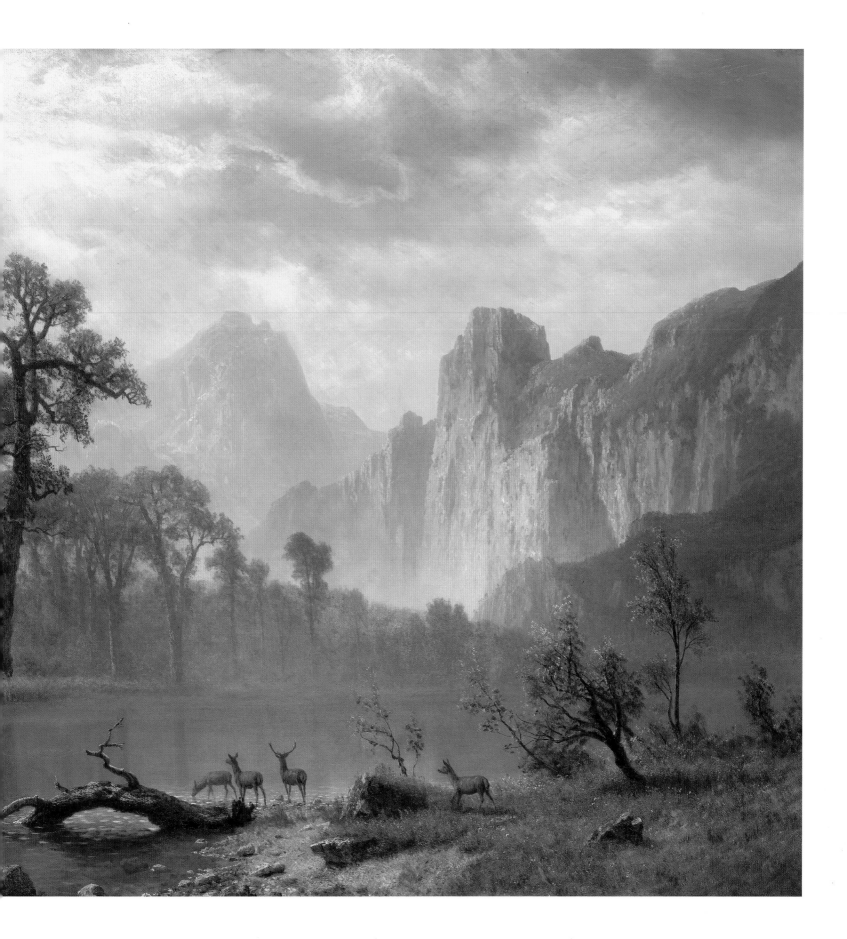

Colt hung her Yosemite landscape opposite a much larger, tropical scene, *Vale of St. Thomas, Jamaica* (cat. 18), which she had commissioned from Frederic Church, thereby re-creating the juxtaposition of the works of these two great rivals that she had earlier seen at the art gallery of the Metropolitan Fair.

5 · *In the Mountains*, 1867

Oil on canvas, 36³⁄₁₆ × 50¼ in. (91.9 × 127.6 cm)
Signed and dated at lower right: A Bierstadt 67.
Ex coll.: probably Junius Spencer Morgan, London, until 1890; to his daughter, Juliet Pierpont Morgan, in 1890; to her son, John Junius Morgan, in 1923
Gift of John Junius Morgan in memory of his mother, Juliet Pierpont Morgan, 1923.253

In June 1867 Bierstadt left for Europe, probably in order to attend the recently opened Exposition Universelle in Paris, where his work *The Rocky Mountains, Lander's Peak* (1863, The Metropolitan Museum of Art) was on view.[13] The artist traveled to Rome, London, and Paris during his two-year trip in an effort to establish an international reputation and to garner new commissions.

In the Mountains was painted either just before Bierstadt crossed the Atlantic or shortly after his arrival abroad, where he sought and found a buyer for the painting. The work is a smaller version of *Among the Sierra Nevada Mountains, California* (1868, Smithsonian American Art Museum, Washington, D.C.), which was painted in Rome in the winter of 1867–68. The larger canvas may have been painted as a traveling demonstration piece for the artist's European tour.[14] It received positive reviews when shown in London with two other important works in the summer of 1868.[15] Bierstadt's reputation in England reached its height when he was granted a royal interview with Queen Victoria and the Prince of Wales in July 1868. He exhibited *Among the Sierra Nevada Mountains* a second time in London and again in 1868 in Berlin, at the Royal Academy, where it received a gold medal. It was sold to the Boston collector Alvin Adams for a reported sum of fifteen thousand dollars shortly after Bierstadt's return to the United States in 1869.

In the Mountains and *Among the Sierra Nevada Mountains* differ markedly in size. Another striking difference is the absence of foreground detail in the Atheneum painting;

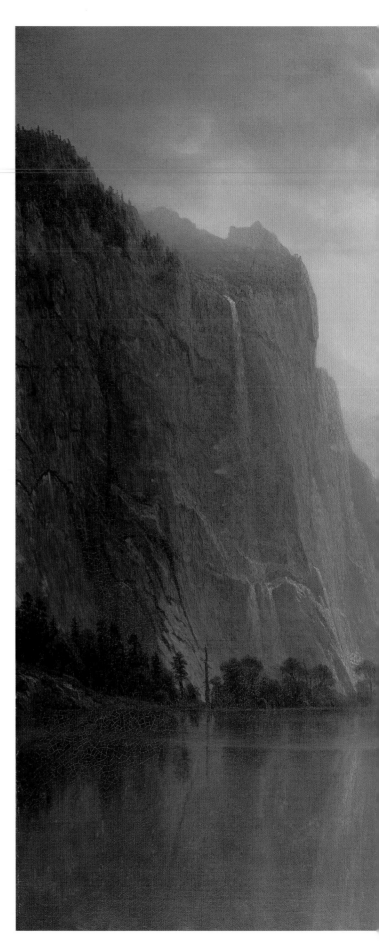

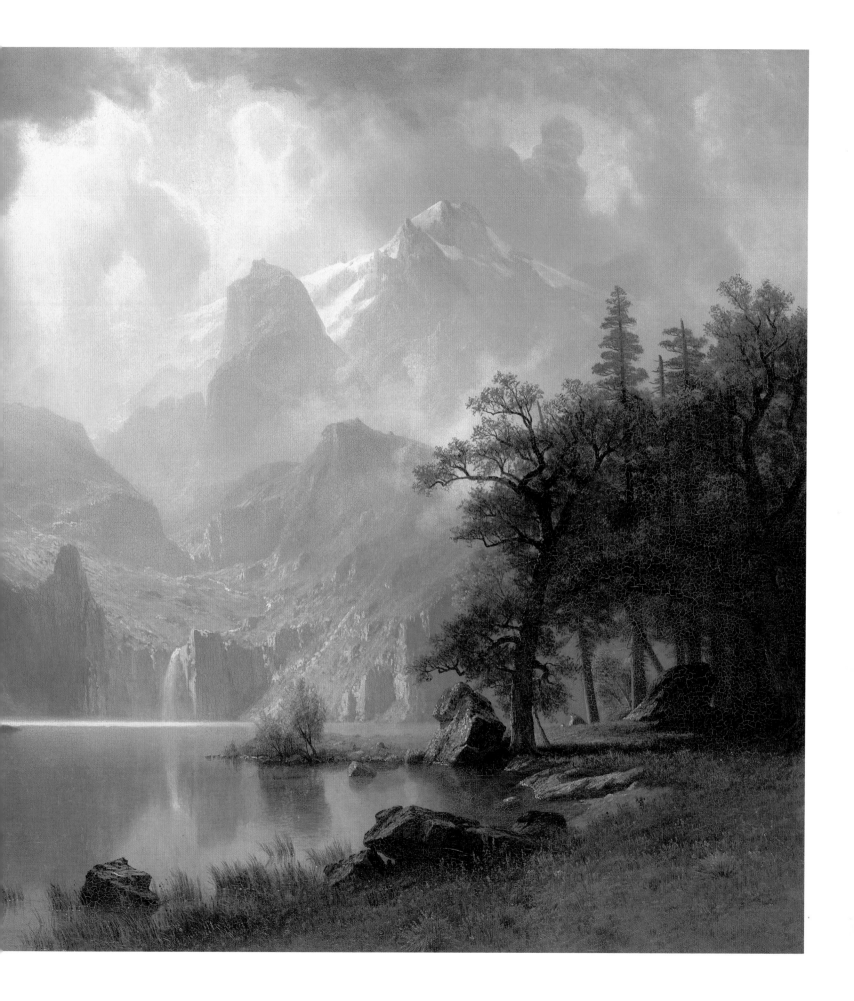

the flock of ducks landing on the water and the herd of deer present in the grand-scale painting are not found in the smaller work. Otherwise, the cool, silvery tones, dense trees at the right, reflections on the water, majestic snowcapped mountain peaks, and billowy storm clouds in the sky are found in nearly identical formations in both. It is possible that *In the Mountains*, firmly dated 1867 by the artist, served as a preliminary work for the larger and more complex landscape dated 1868 and was intended as a "Great Picture" for public exhibition.[16] The large painting in turn inspired several other canvases.

The massive cliff that appears at the left in both *In the Mountains* and *Among the Sierra Nevada Mountains* is a reconfiguration of Yosemite's El Capitan, which appears in a number of the artist's paintings. Some critics faulted the artist for not producing a topographically accurate portrait of the landscape, while others praised him for his "power of combination . . . an ideal union of the most splendid and characteristic features of our western mountains . . . a perfect type of the American idea of what our scenery ought to be, if it is not so in reality."[17]

The Atheneum's painting was formerly titled *Yosemite Valley*, but the name was changed when scholars were unable to identify the exact site.[18] We now know that this work is a composite drawn from various sources, intended by the artist not to be topographically faithful to any one site but to capture the essence of the landscape.

6 · *The Hetch-Hetchy Valley, California,* c. 1874–80

Oil on canvas, 37�5/16 × 58�5/16 in. (94.8 × 148.1 cm)
Signed at lower left: A Bierstadt
Ex coll.: with Eckhardt's Art Gallery (in business from 1872 to 1903), Hartford; purchased by Theodore Lyman, Hartford, before 1920; to his wife Laura M. (Sherman) Lyman, Hartford, in 1920
Bequest of Laura M. Lyman, in memory of her husband, Theodore Lyman, 1925.618

The Hetch Hetchy valley, once located in Yosemite National Park on the Tuolumne River, no longer exists as a valley. In 1938, the O'Shaunessy Dam, built in 1923, was enlarged, turning the valley into a lake about 9 miles long for supplying San Francisco with water via a 156-mile aqueduct. The valley

first came to public attention in 1867 when geologists provided descriptions and stereoscopic views of what was described as a "new Yosemite," by a writer for the *San Francisco Bulletin*. Because the West was so closely identified with Bierstadt's renditions of the landscape, this newspaper writer correctly predicted that "as Bierstadt visited and painted Yosemite, so he will doubtless visit and paint Hetch-Hetchy."[19] Bierstadt, his wife, and three friends spent six weeks camping in and about the Hetch Hetchy valley in the summer of 1873, during an extended trip in California that

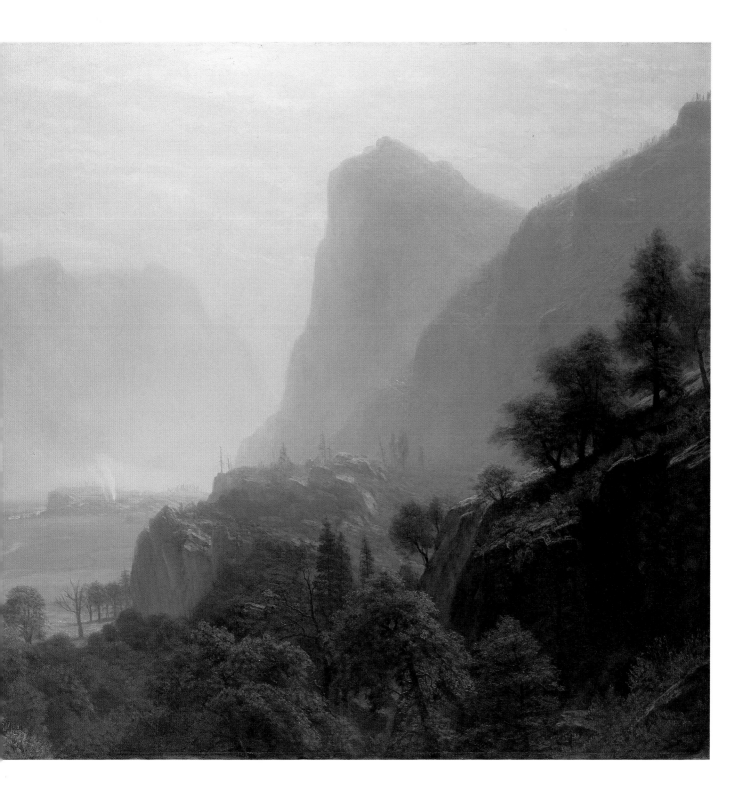

began in July 1871.[20] The *San Francisco News Letter and California Advertiser* of August 23, 1873, reported that Bierstadt had returned "laden with sketches, from a spot which as yet is almost untrodden soil, the Hetch-hetch-y Valley, twelve miles from Yosemite."[21]

The Atheneum's painting is one of the largest views of Hetch Hetchy valley produced by Bierstadt. In the landscape Bierstadt includes the figure of a man, probably the artist himself, holding what appears to be a sketchpad. The figure stands on an elevation at the left, behind a rock, and looks out toward the distant smoke of an Indian encampment. The Tuolumne River flows through the center of the valley. The artist conveys the autumn season with high-keyed autumnal foliage and a thick haze that pervades the lower valley region, making the distant mountain forms indistinct. The work was accompanied by a printed pamphlet describing the painting.

Bierstadt's depictions of the Hetch Hetchy valley have not received any in-depth scholarly attention, thus dating the known works, none of which was dated by the artist, is difficult.

GEORGE CALEB BINGHAM

Born 1811, Augusta County, Virginia;
died 1879, Kansas City, Missouri

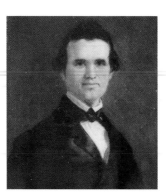

SMITHSONIAN INSTITUTION, NPG

As one of the foremost American genre painters of the nineteenth century, George Caleb Bingham is celebrated for his renderings of frontier life, which were informed by his active participation in Missouri politics.

When he was a boy, his family moved from Virginia to the frontier town of Franklin, Missouri, where his father became a prominent local businessman and politician. After the death of his father, Bingham served an apprenticeship to a cabinetmaker in Booneville, Missouri, in 1827 and 1828. He developed an interest in painting at this time, first painting ship signs and then, by 1833, executing portraits. For much of his career, Bingham earned his living as a portrait painter. In 1838 he went to Philadelphia, where he studied at the Pennsylvania Academy of the Fine Arts. There he saw the works of the Old Masters as well as those of contemporary American artists, including portraits by Gilbert Stuart (1755–1828) and Thomas Sully (1783–1872), and genre paintings by William Sidney Mount (1806–1868).

Bingham's painting improved significantly after his brief experience in Philadelphia. From 1841 to 1844 he lived in Washington, D.C., where he painted portraits of such national figures as John Quincy Adams. His growing interest in genre painting then led him to return to his native region, where he spent a decade recording and interpreting life along the Missouri and Mississippi rivers. His depictions of fur traders, boatmen, and politicians quickly found a market among eastern collectors. Works such as Fur Traders Descending the Missouri (1845, The Metropolitan Museum of Art), The Jolly Flatboatmen (1846, private collection), and The County Election (1851–52, Saint Louis Art Museum) established the artist's reputation.

In the late 1850s Bingham made several trips abroad to Düsseldorf, Germany, where he absorbed some of the academic teachings of the Düsseldorf Academy. His later works, which include history paintings and historical portraits, are thought to lack the freshness of his more celebrated earlier genre paintings and have not received the same acclaim.

Bingham's involvement in Missouri politics led to his election to the state legislature in 1848 and to his appointment as state treasurer in 1862. In the final years of his life, he served as professor of art at the University of Missouri.

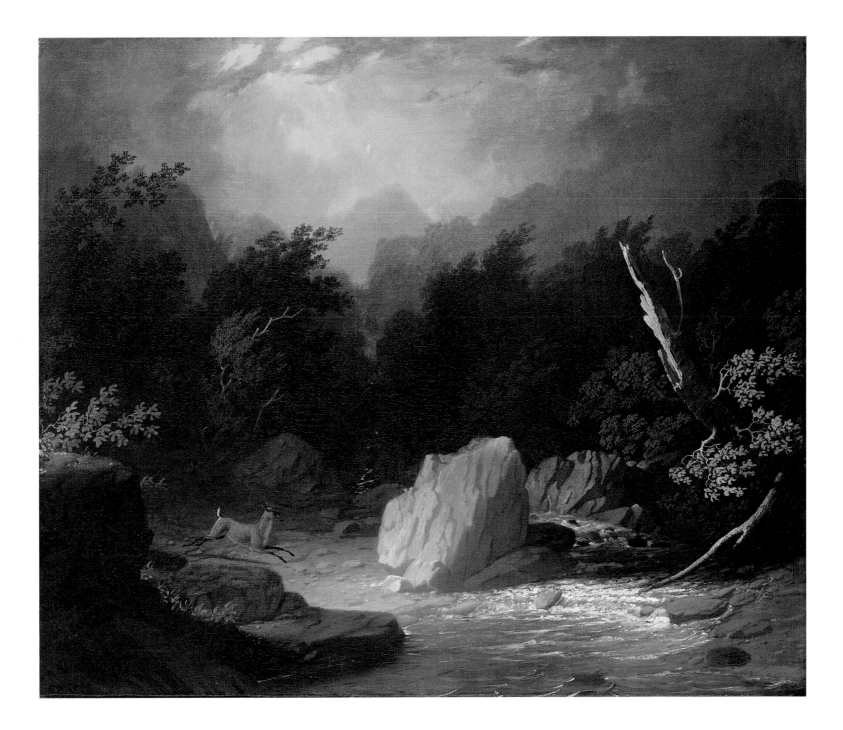

7 · *The Storm,* c. 1850–53

Oil on canvas, 25$\frac{1}{16}$ × 30$\frac{1}{16}$ in. (63.7 × 76.4 cm)
Ex coll.: private collection, St. Louis, Missouri; Antiques Shop, St. Louis;
to Oscar Thalinger by 1934; to Meyric Rogers, St. Louis, in 1934; with
M. Knoedler and Co., New York City, in 1944; purchased by Henry
E. Schnakenberg, New York City, in 1944
Gift of Henry E. Schnakenberg, 1952.74

From about 1840 to the early 1850s, when, at mid-career, he extended his artistic interests to include genre painting, Bingham also created a sizable number of landscapes. His interest in landscape was likely first ignited during his stay in Philadelphia in 1838, when he saw the works of Thomas Cole, among others. His interest probably increased during the time he spent in the East, when, in an effort to gain patrons, he pursued the most popular art form of the day in America—landscape.

He began sending his landscapes and genre paintings to New York City for exhibition beginning in 1845. Although his landscapes were not viewed as exceptional, paintings such as *The Jolly Flatboatmen*, which he exhibited in 1847 and which was engraved and widely distributed by the American Art-Union, gained the artist his greatest recognition.[22]

Around 1852 or 1853, Bingham honored the memory of the recently deceased artist Thomas Cole by painting the landscapes *The Storm* and *Deer in Stormy Landscape* (The Anschutz Collection, Denver, Colorado). These paintings were inspired by such sublime landscapes as Cole's much earlier *Lake with Dead Trees* (1825, Allen Memorial Art Museum,

Oberlin College, Ohio).[23] *The Storm* is a dramatic scene of untamed nature, containing the blasted tree, stormy sky, and sharp contrasts of light and dark that Bingham undoubtedly observed in the works of Cole. A deer frightened by the storm runs toward the rushing waters of a river. In the companion painting *Deer in Stormy Landscape* the storm has cleared, and the sky has opened up to reveal in the distance a majestic mountain just perceptible in *The Storm*.

These two sublime works are among the last landscapes Bingham painted; he executed only a few more over the course of his career. It is not known if he painted them for a client or for his own interest.

WILLIAM C. BRADFORD

Born 1823, Fairhaven, Massachusetts;
died 1892, New York City

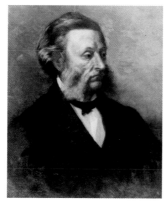

NATIONAL ACADEMY OF DESIGN, NY

William C. Bradford grew up in a small town across the harbor from New Bedford, Massachusetts. His father ran a dry goods store catering to the shipping trade, where Bradford worked as a young man. He began his career as a painter in 1855, setting up a studio in Fairhaven, Massachusetts, where he specialized in ship portraiture and harbor scenes. He received formal training from the Dutch marine painter Albert Van Beest (1820–1860), who was in Fairhaven in 1855 and 1856. He also knew the work of Robert Salmon (1775–c. 1844) and Fitz Hugh Lane (1804–1864). Like them, he pursued the tradition of English and Dutch marine painting, working in a linear and precise style and focusing on the effects of light and atmosphere. Between 1854 and 1857 he was influenced by the writings of arctic explorer Elisha Kent Kane (1820–1857) to take several trips to Labrador, where he sketched the arctic landscape.

After maintaining a studio in Boston for several years, Bradford moved to New York City in 1860. The following year he was working in the Tenth Street Studio Building, where he remained a tenant until 1877. There he came in contact with the leading artists of the day, including fellow New Bedford artist Albert Bierstadt. Inspired by his contemporaries, particularly Frederic Church, who had made expeditions to the Arctic and South America, Bradford became an artist-explorer. He would become best known for his depictions of arctic subjects. In 1861 he spent four months off the coast of Labrador photographing and sketching icebergs, and (with one exception) he repeated the voyage each summer for seven years. His most famous trip took place in 1869, when he chartered a steamer and traveled to Greenland with Dr. Isaac I. Hayes, a noted arctic explorer, and two photographers. The trip resulted in the publication of Bradford's The Arctic Regions (1873), which contains 125 photographs.

Like Bierstadt, Bradford attracted important patrons in both America and England. In 1872 he settled in London for two years, completing an important commission for Queen Victoria, The Panther off the Coast of Greenland Under the Midnight Sun (1873, H.R.H. Queen Elizabeth II, London), which was exhibited at the Royal Academy in 1875.

In the later years of his career, Bradford came to rely on his photographs and sketches of the Arctic for his paintings. In the 1880s he also turned his attention to the American West, maintaining a studio in San Francisco and painting in the Yosemite valley and the Sierra Nevada. He continued to paint in New York City until his death in 1892.

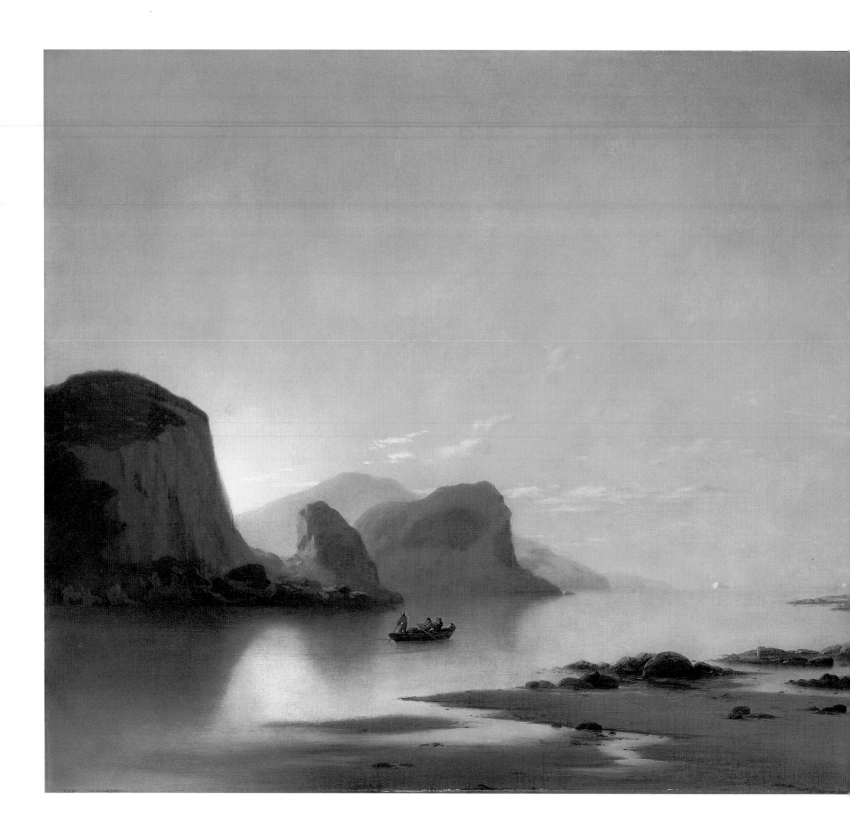

8 · *Coast of Labrador,* 1868

Oil on canvas, 25½ × 44 in. (64.8 × 111.8 cm)
Signed and dated at lower right: Wm Bradford 1868
Ex coll.: purchased by Elizabeth Hart Jarvis Colt, Hartford, in about 1868
Bequest of Elizabeth Hart Jarvis Colt, 1905.18

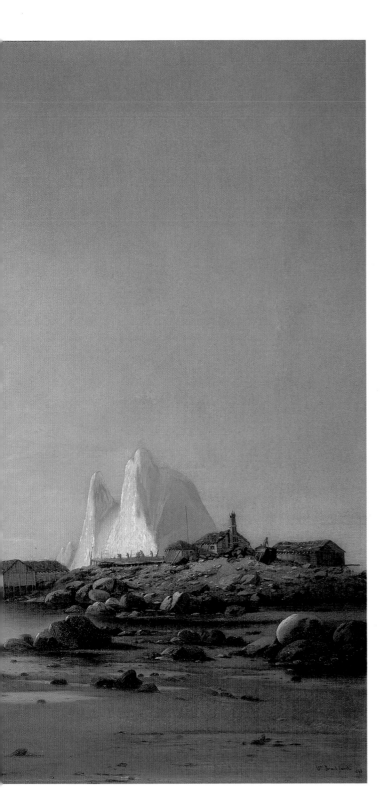

Working from a large inventory of drawings and wash and oil sketches, as well as from photographs, Bradford created vivid representations of the beauty as well as the ever-present danger of the frozen landscape. In *Coast of Labrador* Bradford explored the special effects of northern light, portraying the arctic sun's rising (or setting), casting shadows across the calm water, backlighting the glaciers at left, and illuminating the iceberg at right. Using a low horizon line, Bradford conveys the vastness of this cold climate of floating icebergs, emphasizing scale by the small vessel on the water and the detailed rendering at the right of the huts and beached vessels belonging to fishermen, whom he encountered on his trips to the region. The buildings pictured in *Coast of Labrador,* as in Bradford's other paintings of the subject, make up a summer fishing station: a house, wharves, and outbuildings for storing small boats in the winter and for processing fish.[24]

This work was acquired by Elizabeth Hart Jarvis Colt for her newly completed picture gallery in her mansion, Armsmear, in Hartford. Colt may have first seen Bradford's work while she served as head of the Hartford Table at the Metropolitan Sanitary Fair, held in New York City in 1864. Bradford was the Tenth Street Studio Building's arctic specialist, and his studio was accessible to clients such as Colt. As one New York paper described his studio in 1865: "Esquimaux [*sic*] harpoons, snow shoes, seal-skin dresses, and walrus teeth" served as a backdrop to "several chilling but picturesque paintings of icebergs."[25] Colt also purchased a work by James Hamilton, who had illustrated *Arctic Explorations in the Years 1853, 1854, 1855,* the popular book by Elisha Kent Kane, that Bradford had studied as a young artist, sparking his interest in the Arctic. Mrs. Colt owned copies of Kane's arctic writings.

JOHN WILLIAM CASILEAR

Born 1811, Staten Island, New York;
died 1893, Saratoga Springs, New York

John William Casilear trained as an engraver, beginning an apprenticeship with Peter Maverick in New York City in 1827. When Maverick died in 1831, he continued his training with one of Maverick's former partners, Asher B. Durand. Casilear went on to form his own engraving firm with his brother. This firm later joined with several others, becoming the American Banknote Company.

Casilear made his "first real attempt at a landscape painting" at age twenty and noted that "Durand, when he saw it, examined it carefully, and then turning to me, said: 'Why you're a painter!'" (unidentified clipping, artist file, The Metropolitan Museum of Art). The National Academy of Design in New York City elected Casilear associate in 1833 and academician in 1852. By 1857 the artist had made enough money to retire from engraving and focus on painting.

Casilear lived with artists John F. Kensett and Louis Lang (1814–1893) at Waverly House, 697 Broadway, in

THE METROPOLITAN MUSEUM OF ART

New York City from 1854 until 1859, when he was one of the first artists to move into the Tenth Street Studio Building, where he lived until his death. Every summer Casilear and artist friends took sketching trips together, traveling to the Catskills, the Adirondacks, the White Mountains, and the Genesee valley in New York. Casilear traveled to Europe twice. He made his first trip in 1840 with Durand, Kensett, and Thomas P. Rossiter (1818–1871), spending three years in England and Continental Europe, primarily France. While abroad, Durand introduced Casilear to the work of Claude Lorrain. During this trip, Casilear went on a number of sketching tours with Kensett, and that artist replaced Durand as an important influence after their return from Europe. Casilear took a second trip to Europe in 1858, spending most of his time sketching in Switzerland. These sketches became the basis for his paintings of Swiss landscapes, and he drew on them until well into the 1880s.

Casilear died of a stroke at age eighty-three.

9 · Lake George, 1860

Oil on canvas, 26¼ × 42½ in. (66.7 × 108 cm)
Signed (monogram) and dated lower right: JWC'60
Inscribed on back stretcher: Mr. Casilear 10th St. Building
Canvas stamp: Prepared / by / Edwd. Dechaux / New York
Ex coll.: Clara Hinton Gould, Santa Barbara, California, by 1948
Bequest of Clara Hinton Gould, 1948.183

Remarks made fifteen years after Casilear painted *Lake George* could well describe the Atheneum's painting:

> *Mr. Casilear is a great lover of pastoral scenes, and some of his most notable pictures of this character have been drawn from the neighbourhood of Lake George, and the Genesee valley in Western New York. His work is marked by a peculiar silvery tone and a delicacy of expression which is in pleasant accord with Nature in repose, and of his own poetically-inclined feelings. He finishes his canvases with great care, and in that respect shows the influence of his early training.*[26]

The influence of John F. Kensett, a sketching companion and a neighbor at Waverly House, is unmistakable in the treatment of the water and the light in the Atheneum's *Lake George*. Casilear's own background as an engraver and perhaps the influence of another friend and former engraver on the trip, Asher B. Durand, is reflected in the highly finished quality of the canvas and the attention to detail in the foreground foliage and middle-ground hills.[27] The foreground of the painting, a series of beautifully rendered nature studies, compares with those by other artists working in the middle of the nineteenth century and may reflect, in part, the influence of the growing American Pre-Raphaelite movement.[28]

Henry Tuckerman wrote in 1867 about a painting by Casilear very similar to *Lake George*: "One of his most congenial and successful American subjects. . . . The glassy surface of the lake, its smoothness disturbed only by the ripples caused by leaping trout, spreads beyond and across to the opposite hills. A small boat, propelled by one person, leaves a slender wake behind it. A few light clouds hover above the hill-tops, and summer's peace seems to pervade the scene."[29] This peace was characteristic of American landscape paintings that predate the Civil War.

THOMAS CHAMBERS

Born 1808, London, England;
died after 1866

ittle is known about the early life of Thomas Chambers beyond the fact that he was born in London and immigrated to America in 1832. He is listed in the New Orleans directory for 1834 (printed in 1833) as a painter. He is next found in New York, listed in the New York City directories as a marine or landscape painter for the years 1834–40. By 1843 he was in Boston, where he lived until 1851, after which he moved to Albany, New York, remaining in that city until 1857. He next revisited New York City, where he is listed in the directories for the years 1858–59, then he lived in Boston in 1860–61, and finally he resettled in New York City from 1862 to 1866. After this point, no record of the artist exists.

Chambers produced imaginative marine paintings and landscapes that were often based on print sources. Rather than adhering strictly to the prints, he departed in quite original ways, employing a highly individual sense of design, a striking palette, and a bold, distinctive treatment of landscape and seascape features. Chambers relied particularly on the views produced by William H. Bartlett

(1809–1854) for Nathaniel Parker Willis's American Scenery *(London, 1840). He is also known to have used Asher B. Durand's and Jacques Gerard Milbert's prints for his landscapes. He based at least four views of George Washington's birthplace on one or more engravings after an oil painting by John Gadsby Chapman (1808–1889), and several of his paintings of naval battles during the War of 1812 are based on prints after the paintings of Thomas Birch (1779–1851).*

Although approximately seventy paintings have been attributed to Chambers, only five works are signed or dated. The artist first received attention in 1942. That year, the art dealers Norman Hirschl and Albert Duveen brought together eighteen works, including the Atheneum's Niagara Falls, *all of which they attributed to "T. Chambers" based on one signed painting in their exhibition* T. Chambers: First American Modern, *held at the Macbeth Gallery in New York City. Since that time, many attributions have been made based on the few additional signed works that have surfaced and on the limited knowledge of the artist's life.*

10 · *Niagara Falls*, c. 1835

Oil on canvas, 22 × 30¹⁄₁₆ in. (55.9 × 76.4 cm)
Ex coll.: T. A. Larremore; with Arnold Seligmann, Rey and Co., New York
City, by 1943
The Ella Gallup Sumner and Mary Catlin Sumner Collection Fund, 1943.99

Chambers's known landscapes tend to depict popular sites;
many are of American scenery, based on widely circulated
prints of the day. His reliance on print sources indicates that
he probably did not travel extensively. Chambers based the

composition of *Niagara Falls* on a print by Isidore-Laurent
Deroy after Jacques Milbert's *Niagara Falls from the American
Side* (c. 1828, The New-York Historical Society), published
in *Itinéraire pittoresque du fleuve Hudson et des parties latérales*

de l'Amérique du Nord (Paris, 1828–29).[30] The view was taken from Porter's stair tower, a wooden tower erected in 1818 by Augustus Porter, who owned much of the land on the American side of the falls.[31] Chambers altered the original by replacing the two minute figures of tourists seen in the print source with an overly large figure of an American frontiersman holding a rifle and gazing at the scene before him. In addition, he placed disproportionately large houses on the upper bank of the fall to point up the settled regions that had sprung up near this popular tourist site. Finally, he adhered to his distinctively bold use of bright color and two-dimensional forms and included his particular treatment of foliage and sharp, jutting tree forms, one of which emerges from the fall itself.

This work successfully incorporates Chambers's bold design and romantic vision of the American landscape.

FREDERIC EDWIN CHURCH

Born 1826, Hartford, Connecticut;
died 1900, New York City

OLANA STATE HISTORIC SITE

The only surviving son of Joseph Edward (1793– 1876) and Eliza Janes Church (1796–1883), Frederic Edwin Church had two sisters, Elizabeth Mary (1824–1886) and Charlotte Eliza (1832–1862). A successful businessman, jeweler, and silversmith, Joseph Church served on the board of several Hartford banks and an insurance company. A neighbor of Daniel Wadsworth, he was one of the original subscribers of the Wadsworth Atheneum in 1841 and served on a committee to raise additional funds for the Atheneum building in 1842 (Record Book, archives, Wadsworth Atheneum).

As a young man in Hartford, Frederic received artistic instruction from Alexander Hamilton Emmons (1816–1884) for six months in 1842 and from Benjamin Hutchins Coe (1799–after 1883). Although his father preferred that his son pursue a career in business, in 1844 he let Daniel Wadsworth arrange an apprenticeship for Frederic with Thomas Cole. Church was to become Cole's most illustrious pupil.

At Cole's studio in Catskill, New York, from 1844 to 1846, Church mastered his teacher's methods of sketching outdoors, developed a love of nature, and adopted Cole's style of landscape painting. Aware of the genius of his young student, Cole noted that Church had "the finest eye for drawing in the world."[32]

In 1846 Church returned briefly to Hartford but soon moved on to New York City. He completed his first major works in 1846 and 1847, in the type of historical landscape advocated by Cole, for exhibition at the National Academy of Design in New York City. Hooker and Company Journeying Through the Wilderness from Plymouth to Hartford, in 1636 (1846) (cat. 13), among other works, established his reputation as one of America's leading young artists.

By the fall of 1847 Church had set up his studio in the Art-Union Building in New York City; he was elected to the National Academy of Design the following year, becoming its youngest associate. Cole's teachings remained central to Church's art, but by the early 1850s the works of the English artists John Martin and J.M.W. Turner, and the writings of the English critic John Ruskin, as well as those of the German naturalist-explorer Alexander von Humboldt, affected the development of Church's mature style.

In 1853, following the scientific writings and explorations of Humboldt, Church became the first American artist to paint in South America. He continued to paint North American landscapes but returned to South America in 1857, traveling to Ecuador, accompanied by the landscape painter Louis Remy Mignot (1831–1870). In his oil paintings resulting from these expeditions, Church attempted to produce works that were both scientifically accurate and spiritually uplifting.

Church made trips to Labrador in 1859 to prepare for his enormous painting Icebergs (1861, Dallas Museum of Art), as well as sketching trips to Jamaica in 1865, which resulted in such masterworks as Vale of St. Thomas, Jamaica (cat. 18). He traveled to Europe and the Near East in 1867–68. The important works that resulted from these trips were composites of botanical, geological, and meteorological renditions of landscape as well as poetic and spiritual impressions of the exotic locales the artist visited.

By 1870 Church, whose reputation had suffered in the post–Civil War era, became preoccupied with the creation of Olana, his architecturally eclectic mansion designed by the architect Calvert Vaux. Situated on a mountaintop in Hudson, New York, the house overlooked the Hudson River, facing Cole's earlier studio on the opposite bank. Inspired by his travels in the Near East, Church and his wife, Isabel Carnes Church (whom he married in 1860), filled the house with exotic furnishings and bric-a-brac, as well as with a wide-ranging collection of paintings. A fusion of Persian and Moorish styles, the house became a retreat in which to raise his family.

Church

Despite the declining interest in Hudson River School paintings resulting from the influx of European art and styles, Church continued to exhibit major works. He was also involved in the cultural activities of New York City, including the founding of The Metropolitan Museum of Art in 1870. By the final decades of the century, however, Church's health was failing and the decline in interest in the *Hudson River School began affecting his productivity. With the exception of trips to Mexico, where he began spending the winter in 1882, he spent most of his time at Olana. He died at the age of seventy-three in New York City. He was buried next to his wife, two of his children, and his parents in Spring Grove Cemetery, Hartford.*

11 · *View of Quebec*, 1846

Oil on canvas, 22³⁄₁₆ × 30³⁄₁₆ in. (56.4 × 76.7 cm)
Signed and dated at lower left: F. Church / 10 / 1846
Ex coll.: with the artist in 1846; acquired by the Wadsworth Atheneum by 1850
Source unknown, 1850.8

Church painted *View of Quebec* in 1846, possibly while in his native city of Hartford.[33] He based his composition on an engraving by Simeon Smith Jocelyn (1799–1879) after at least three drawings (Wadsworth Atheneum) by Daniel Wadsworth.[34] The engraving appears as plate 9, *Quebec from the Chaudière, Setting Sun* in Benjamin Silliman's *Remarks Made, on a Short Tour, Between Hartford and Quebec in the Autumn of 1819*, published in 1820.[35]

Daniel Wadsworth and Benjamin Silliman set off on a five-week tour of upstate New York and the cities of Montreal and Quebec in the fall of 1819. The trip was made at Wadsworth's suggestion, stemming from his concern for his friend's mental state.[36] During the journey, Wadsworth sketched and painted in watercolors on small cards, taking a number of views of Quebec (Wadsworth Atheneum), while Silliman kept notes on the geology and mineralogy of the region. Church would have had access to Wadsworth's sketches as well as to Silliman's book while in Hartford, certainly from Wadsworth's library.

In his landscape, Church followed the engraved model faithfully, depicting Quebec to the left, built on Cape Diamond; in the distance on the right is Point Levi, with the hills around Montmorency beyond. The artist did, however, enhance the picturesque aspect of the scene by heightening the contrast of light and shadow. Church consulted Silliman's description of the scene recorded by Wadsworth: "This scene, which we thought not to be exceeded in beauty by anything that we saw in Canada, was sketched from the left bank of the Chaudière river, at its mouth. . . . It was seen by the mildest, softest light, of an Indian summer afternoon—not more than two hours before sun-setting; and there was a mellowness in the tints . . . which . . . excited still stronger perceptions of beauty. These impressions were heightened by contrast, with the deep black gulf, immediately below the observer."[37] Church interpreted the notations of color and light made by Silliman and followed the compositional forms recorded by Wadsworth, enhancing the landscape by rendering the rocks in greater detail and by adding foliage at the lower left.

The region was of historic significance to many Americans as the site of the death of General James Wolfe in 1759 following his victorious battle against the French army, an important moment in pre-Revolutionary history. Benjamin West's *Death of General Wolfe* (The National Gallery of Canada, Ottawa) made this region famous.[38] John Trumbull's *Death of General Montgomery in the Attack on Quebec* (1834), which hung in the Wadsworth Atheneum beginning in 1844, made this site famous.

12 · *Rapids of the Susquehanna*, c. 1846

Oil on canvas, 22¼ × 30³⁄₁₆ in. (56.5 × 76.7 cm)
Ex coll.: with the artist, Hartford, in 1846; acquired by the Wadsworth
Atheneum by 1850
Source unknown, 1863.8

Church executed *Rapids of the Susquehanna* while apprenticed to Thomas Cole, whose influence was pervasive in the artist's earliest works. Church probably based this landscape on an undated drawing by Daniel Wadsworth titled *Ferry at Columbia—Pens on the Susquehanna* (Wadsworth Atheneum).[39] He likely painted *Rapids of the Susquehanna* at the same time as his *View of Quebec* of 1846 (cat. 11), which was also based on one or more drawings by Wadsworth or on engravings after them.

Church greatly enhanced the dramatic effects of Wadsworth's scene. On the shoreline in the foreground he included the lone figure of a man who looks out toward the tiny ferry carrying a horse-drawn carriage. The ferry seems to be at the mercy of the fast moving white-water rapids. A line of birds flying between the shore and the raft further emphasizes the perspective. The atmospheric effects of the stormy dark clouds overhead—reminiscent of those found in works by his teacher, Cole—complete the scene, adding to the theatrical effect. The meticulous rendering of the foliage is representative of Church's developing style.

Beginning in 1799 Wadsworth began taking small, topographical sketches of scenery he encountered on his travels throughout North America. All are nearly identical in size and similar in style. Wadsworth recorded his observations of the sites he visited, which he then inscribed on the back along with the title, often a date, and his signature.[40] Wadsworth undoubtedly let Church view his sketches, and Church may

have executed this work at Wadsworth's suggestion, although the title does not appear in Wadsworth's probate inventory or will. Alternatively, Church could have painted it for the new Wadsworth Atheneum gallery, which opened to the public in 1844 through the generous contributions of the Hartford subscribers, including Joseph Church, the artist's father. This painting was on view in the Atheneum gallery by 1850 and hung with Church's *View of Quebec* (cat. 11) and *Hooker and Company* (cat. 13).

In all three works, Church treated subjects of historical significance that deal with the colonial history of America. *Rapids of the Susquehanna* depicts a region with historic associations for Connecticut citizens, particularly those who participated in the long battle with Pennsylvania settlers in the Wyoming valley over land claims dating back to the seventeenth century. The conflict began with the first attempt at a permanent settlement by inhabitants from Connecticut in 1769 at Forty Fort and which led to the Pennamite Wars, followed by the Wyoming Massacre of 1778. It was finally settled by the Compromise Act of 1799, which secured a means of legal settlement for Connecticut claimants who created a flourishing settlement in the valley in the first decades of the nineteenth century.[41] In his landscape, Church, following Wadsworth's drawing, depicted the point where the ferry crossed the Susquehanna River in Columbia County, a short distance southeast of the earliest Connecticut settlement at Forty Fort.

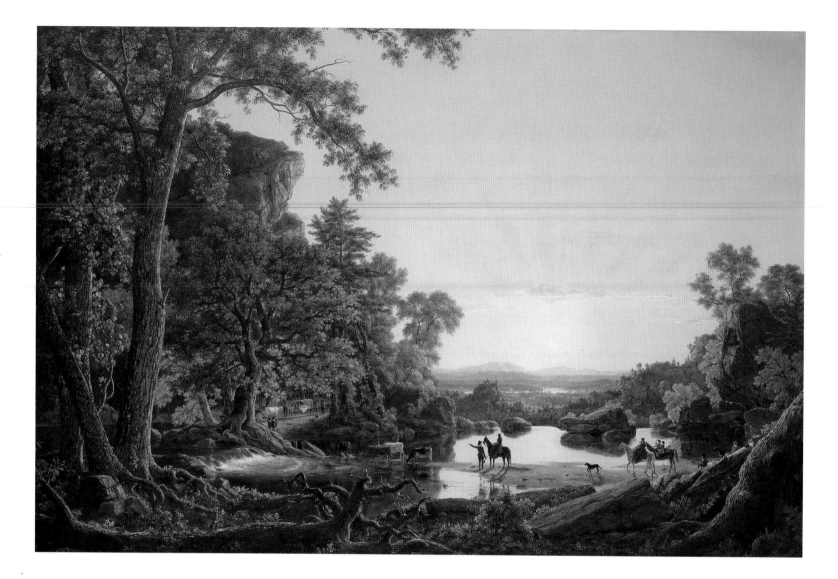

13 · *Hooker and Company Journeying Through the Wilderness from Plymouth to Hartford, in 1636,* 1846

Oil on canvas, 40¼ × 60³⁄₁₆ in. (102.2 × 152.9 cm)

Signed and dated at lower left: F. Church / 8 / 1846

Ex coll.: purchased by the Wadsworth Atheneum in 1846 from the artist

Museum purchase, 1850.9

After completing nearly two years of study with Thomas Cole in his Catskill, New York, studio from 1844 to 1846, Church returned briefly to his native Hartford. There, he painted his first ambitious landscape composition, following Cole's precept to paint the "higher style of landscape."[42] The work was exhibited in the spring of 1846 at the National Academy of Design with the title listed here.[43]

The large size of this work and its ambitious subject clearly made it one of the most important works in the artist's early career (he was twenty when he painted it). The subject, an event drawn from colonial history, was probably suggested by Cole, who himself had included it on a working list of possible subjects, as no. 74, "The migration of the settlers from Massachusetts to Connecticut—through the wilderness—see Trumbull's history of Connecticut—history of the U.S."[44] This was a natural subject for Church, a native of Hartford and sixth-generation Connecticut Yankee whose ancestor Richard Church had been a member of Hooker's party.

Thomas Hooker, a freethinking Puritan preacher, arrived in Massachusetts in 1633 and was elected pastor of the New-

town parish. In May 1636 he led members of his congregation from Newtown (now Cambridge) through the wilderness to found an independent settlement in Hartford.[45] Taking Cole's suggestion, Church may well have consulted Trumbull's history of Connecticut (readily available to him while in Hartford), which contained a detailed description of the historic event, providing the necessary information on which to base his painting.

Church's title, *Hooker and Company Journeying Through the Wilderness from Plymouth to Hartford, in 1636,* which is factually inaccurate (as Hooker left from Newtown, not Plymouth), may have been intended to carry a larger meaning. Church wanted his audience to grasp the nationally significant theme of Manifest Destiny, relating the first arrival of the Pilgrims in Plymouth to the settlement of Hartford.[46] When this painting was presented to the American public in the 1840s, the legend had achieved epic proportions "as an archetypal American experience embodying religious principles, moral courage, and the drive to settle the vast unexplored reaches of the country."[47] Like Cole, Church used human and spiritual drama to

define the landscape: the figures evoke the flight of the Holy Family. The brilliant light that illumines the party's passage through the wilderness completes the allegory of divine providence at work in the Connecticut valley. The painting is one of the earliest representations of western expansion.

This historical landscape became the first of a thematic triptych in which the artist explored the roots of American democracy as manifested in the landscape and history of Connecticut.[48] The second work is *The Charter Oak* (1847, Olana State Historic Site, Hudson, New York), of which there is a second version, *The Charter Oak, at Hartford* (1846–47, Florence Griswold Museum, Old Lyme, Connecticut). The third work is *West Rock, New Haven* (1849, New Britain Museum of American Art, New Britain, Connecticut).[49] Although the others represent contemporary views of historic sites, *Hooker and Company* represents the actual historical event. In this painting, Church portrayed the Charter Oak from the view opposite to that seen in *The Charter Oak.*[50] It appears at the left middle ground, with Hooker pointing toward it.

(detail)

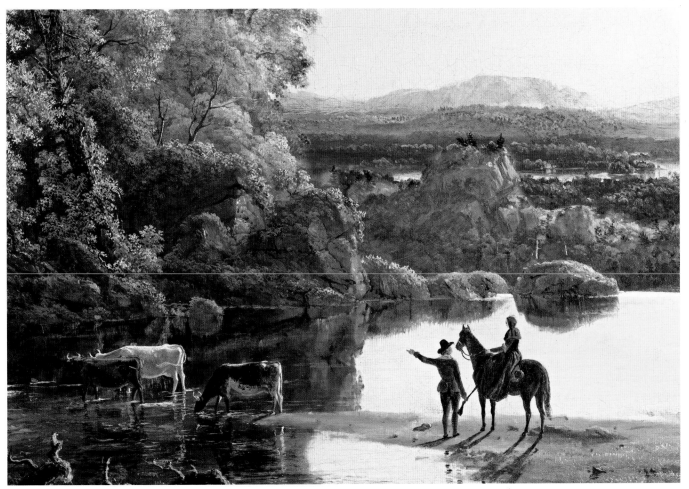

14 · *Grand Manan Island, Bay of Fundy*, 1852

Oil on canvas, 21¹³⁄₁₆ × 31¹⁵⁄₁₆ in. (53.8 × 79.5 cm)

Signed and dated at lower right: F Church / 52

Canvas stamps on the reverse: G. ROWNEY & Co. / MANUFACTUR-
ERS / 51 [] PLACE / LONDON [oval] and WILLIAMS & S[] / 353 /
BROADWAY / NEW YORK [oval]

Ex coll.: with William Kemble, New York City, by 1853, to 1881;
purchased for the Wadsworth Atheneum at James P. Silo Auction House
(Fifth Avenue Art Galleries), in 1898

Gallery Fund purchase, 1898.6

Church made his first summer visit to the coast of Maine in
1850; he would return frequently to his favorite sketching
sites in the state over the next thirty years. In 1878 he pur-
chased land and built a permanent camp on the shores of
Lake Millinocket. He was following in the footsteps of a
number of important artists, including Thomas Cole, who
sought the dramatic and rugged scenery of the Maine coast.[51]
The seascape by Andreas Achenbach, *Clearing Up-Coast of
Sicily* (1847, Walters Art Gallery, Baltimore) was on view at
the 1849 American Art-Union exhibition and, according to a
contemporary account, "seems to have directed the attention
of our younger men to the grandeur of Coast scenery."[52]

In addition to sketching in the region of Mount Desert
Island, Church sought even more remote scenery, sailing to
the island of Grand Manan, Canada, located twenty miles
offshore of the easternmost point in Maine, making two trips
in the summers of 1850 and 1851. In August 1851 he made a
series of geological studies of the rugged cliffs and shoreline.
Grand Manan Island, Bay of Fundy is based on at least two of

Church's sketches of this northern coastal site, *Sharp Rocks
off Grand Manan* (1851–52, Cooper-Hewitt, National
Museum of Design, Smithsonian Institution, New York City)
and *Cliffs at Grand Manan* (Cooper-Hewitt, National
Museum of Design).[53] These and other sketches Church
made on the island indicate that he chose to work on clear
days when the sea was calm.

In the finished painting, the artist created a view of this
remote scenery characterized by rough forms, broken sur-
faces, and jagged contours. The scene is dramatically lit by
the setting sun, an early attempt at this effect, with shadows
cast by the clouds in the upper sky. In the foreground Church
introduced the somewhat awkward figure of a fisherman,
who looks away from the spectacular vista behind him. The
viewer stands apart from the scene, the foreground diminish-
ing the immediacy of the rugged coastline in the distance.
Eleven years later, Church's mature vision thrust the viewer
into a far more spectacular and immediate seascape in *Coast
Scene, Mount Desert* (cat. 17).

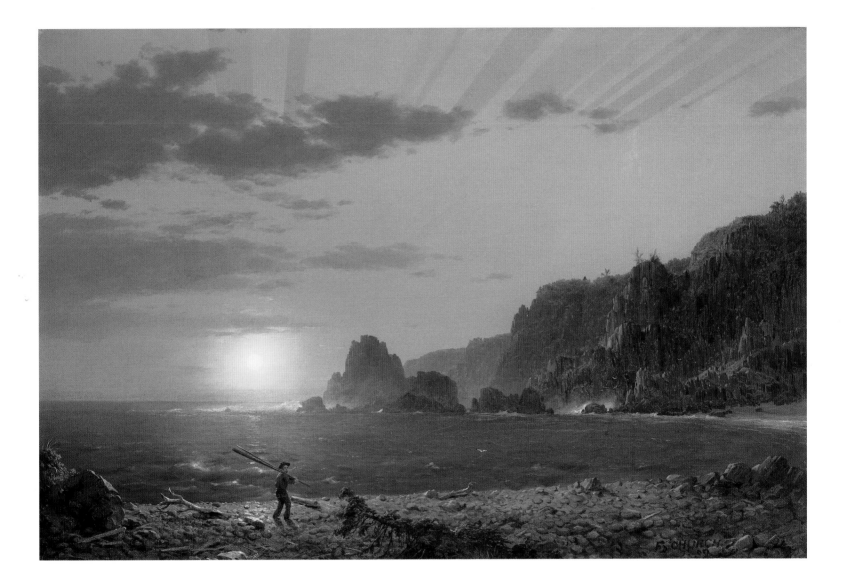

15 · *Mountains of Ecuador,* 1855

Oil on canvas, 24⁵⁄₁₆ × 36⁵⁄₁₆ in. (61.4 × 92.2 cm)
Signed and dated at lower left: F. Church. -55-
Ex coll.: with the family of Clara Hinton Gould (Mrs. Frederick
Saltonstall Gould), Santa Barbara, California, by the 1880s
Bequest of Clara Hinton Gould, 1948.177

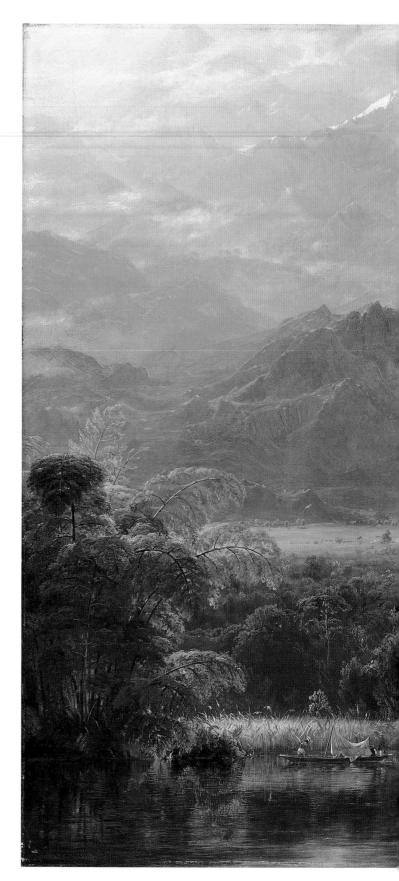

In search of ever-grander subjects, Church was drawn at
mid-century to the immense mountain peaks and exotic
vegetation of South America. In spring 1853 Church
traveled with his friend Cyrus Field to Colombia and
Ecuador.[54] The trip was inspired, in part, by the German
scientist Alexander von Humboldt (1769–1859), who had
explored the South American tropics between 1799 and
1804 and later wrote colorful narratives of his travels.
Church responded to Humboldt's call for an artist to
journey to "the humid mountain valleys of the tropical
world, to seize . . . on the true image of the varied forms
of nature."[55]

During his six-month journey, Church produced many
sketches he would later use as the basis for a series of trop-
ical landscapes. *Mountains of Ecuador* reveals the grandeur
and majesty of nature, including brilliant tropical birds
and vegetation in the foreground, civilization represented
by the village with its domed church in the middle ground,
and the immense snowcapped mountain peaks in the dis-
tance. A glowing sun and atmospheric mists unify the
landscape and suggest a spiritual presence.

Mountains of Ecuador is likely a composition drawn
from a variety of sketches, two of which have been
located. A detailed oil study for this landscape includes
most of the foreground, middle ground, and background
details, which are rendered in nearly finished forms. A
second oil study contains several elements that relate to
Mountains of Ecuador—for example, the arched stone
bridge over the river in the foreground and the configura-
tion of buildings in the village in the middle ground. The
title *Mountains of Ecuador* implies that the scene represents
Ecuadorian mountains, however, Church inscribed the
Cooper-Hewitt Museum oil study "Zipaquira, Colombia"
(1853, Cooper-Hewitt, National Museum of Design,
Smithsonian Institution, New York City).

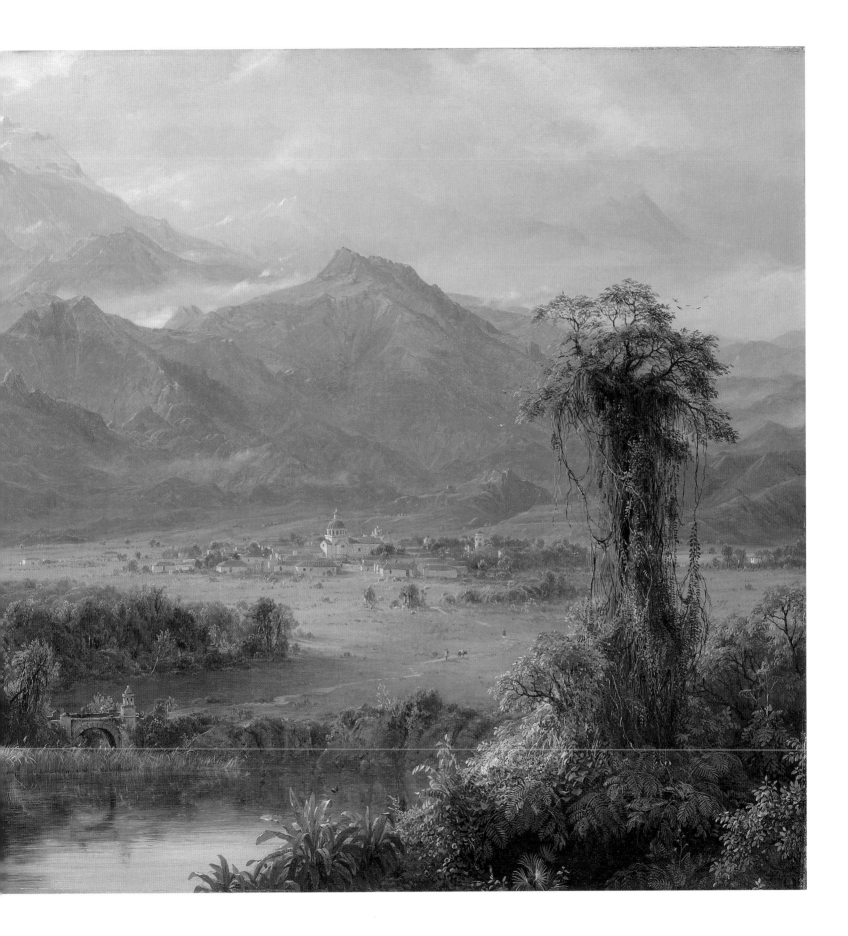

16 · *Niagara Falls*, 1856

Pencil and oil on paper mounted on canvas, 11$\frac{15}{16}$ × 17$\frac{7}{8}$ in. (30.4 × 44.8 cm)
Signed and dated at lower right: F. Church 56
Ex coll.: with the artist to 1900; to his niece, Mrs. George L. (Harriet
Osgood) Cheney; to her daughter, Barbara Cheney, New York City, by 1971
Gift of Miss Barbara Cheney, 1971.78

In 1857, Church produced what was considered at the time to be the finest depiction of Niagara Falls painted by European or American artists in the one hundred sixty years of pictorial explorations of America's greatest natural wonder. His creation of *Niagara* (1857, Corcoran Gallery of Art, Washington, D.C. [see Introduction, fig. 12]) has been thoroughly explored in recent years by a number of scholars.[56] Following its public exhibition in New York City and, in the same year, its tour in England, *Niagara* made Church internationally famous. The English critics proclaimed *Niagara* "the greatest realization of moving water in the world."[57]

Church's first documented sketching trip to Niagara Falls occurred in March 1856.[58] He returned twice more that year, first in July and later in August and September. In that same year, Church read the third and fourth volumes of John Ruskin's *Modern Painters* and reread the two earlier volumes. He was impressed by Ruskin's discussion of water as a subject: "Of all inorganic substances acting in their own proper nature, water is the most wonderful. . . . It is to all human minds the best emblem of unwearied, unconquerable power."[59] On his visits to the falls, Church explored many viewpoints of the cataracts in his numerous sketches, as well as detailed aspects, including the sheer power of the rushing water.[60]

The Atheneum's *Niagara Falls*, one of only a few self-sufficient studio works Church completed in 1856, depicts Horseshoe Falls from the American side. The artist chose a traditional vantage point below the falls, emphasizing the height and force of the rushing water, concerning himself with the downward plunge of the cataract and its changing qualities of light and density. A brilliant rainbow links the sky and water, and three tiny houses dot the far shore.

The artist's final conception for his grand-scale *Niagara* would be much more spectacular, encompassing a view on the very brink of the western edge of Horseshoe Falls, with the viewer suspended over the torrent itself.

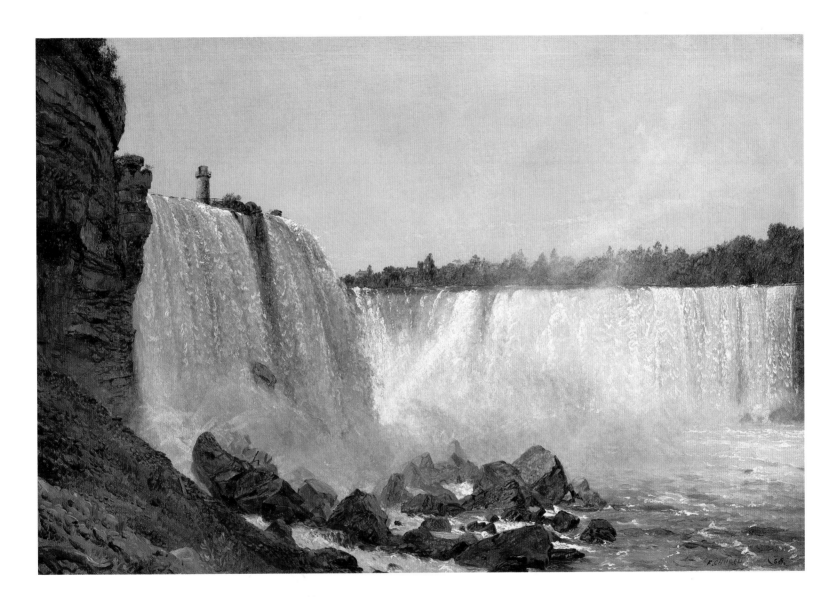

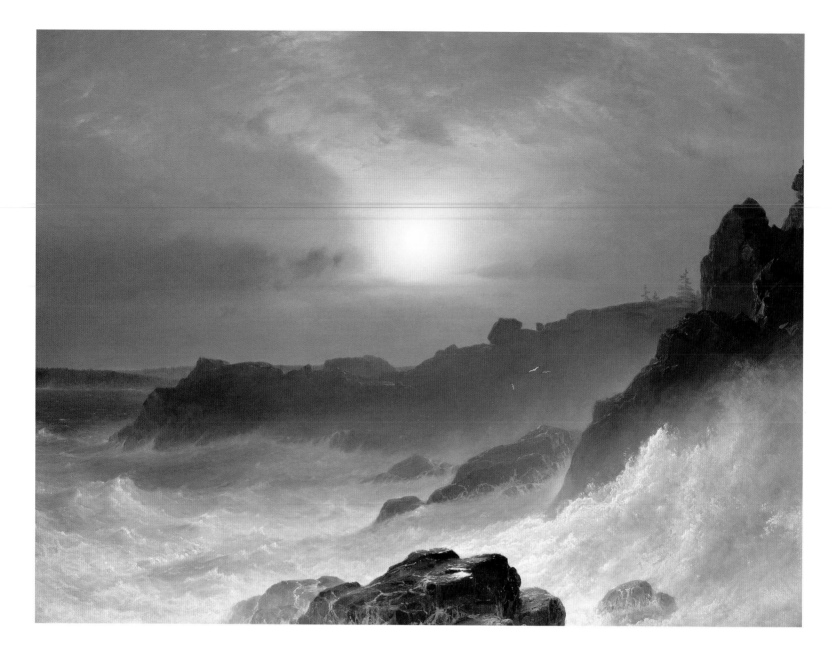

17 · *Coast Scene, Mount Desert*, 1863

Oil on canvas, 36⅛ × 48 in. (91.8 × 121.9 cm)
Signed and dated at lower right center: F. E. Church / 1863
Ex coll.: purchased from the artist by Marshall O. Roberts, New York City,
in 1863, to 1880; to Clara Hinton Gould, Santa Barbara, California, by 1948
Bequest of Clara Hinton Gould, 1948.178

Church first painted northern coastal scenery in the early 1850s, producing light-filled, expansive vistas. By the end of the decade, he had become a national figure, winning popular recognition, financial gain, and critical acclaim for his spectacular wilderness views of the Northeast as well as of more exotic South American locales. During the Civil War, Church returned to the depiction of northern coastal scenery for the first time since the early 1850s, painting his masterly seascape *Coast Scene, Mount Desert*.

Both the influence of J.M.W. Turner, as well as the memory of the Düsseldorf-trained artist Andreas Achenbach's *Clearing Up, Coast Of Sicily* (1847, Walters Art Gallery, Baltimore), which had been on view at the American Art-Union in New York City in 1849, may have inspired his return to this subject.[61] In this mature work, Church continued to investigate qualities of light and atmosphere and the power of the sea against the rocky coast, which he had explored eleven years earlier in such works as *Grand Manan*

Island, Bay of Fundy (cat. 14). *Coast Scene* is set apart from his earlier efforts at seascape, however, by its compelling sense of drama and energy; the viewer directly confronts the sea and its sublime power.

The emotional impact of the painting was appreciated by critics of the day, who gave it generally favorable reviews after its National Academy of Design showing in the year of its completion. One reviewer proclaimed it "among the best instances of Church's power. . . . Here is magnificent force in the sea; we give ourselves up to enthusiasm for it, regarded as pure power; when it dies its final death in mad froth and vapor, tossed quite to the top of the beetling barrier crags on the right foreground, we feel ourselves in an audacious actual presence, whose passion moves us almost like a living fact of surf. We value the light effects separately, and the fine reck-lessness of color by itself."[62] A writer for the *Albion* praised the work for its "luminous quality of light," declaring it, for the most part, a "noble work," and he went on to discuss at

length Church's choice of frame design, concluding that "the material [black walnut] being excellent, but the detail most unfortunate."[63] Henry Tuckerman wrote of the painting that "the peculiar yeasty waves and lurid glow [are] incident to a dry autumnal storm in northern latitudes," relating it to John Ruskin's discussion of "yesty [*sic*] waves" in *Modern Painters*.[64]

The painting is largely based on a plein-air oil sketch executed at Mount Desert (c. 1851–52, Cooper-Hewitt, National Museum of Design, Smithsonian Institution, New York City), which includes the dark brown silhouettes of the cliffs. The vantage point is looking out across the surf and rocks, with the spray crashing up at the lower right, seem-ingly at the viewer's feet.[65] Church turned the sketch into a finished work almost without change, adding to the oil the spectacular effects of the yellow sun burning through the mist, an atmospheric pink and blue sky, and the pine trees on the right horizon. He succeeded in preserving the immediacy and emotional impact of the sketch in his finished oil painting.

18 · *Vale of St. Thomas, Jamaica*, 1867

Oil on canvas, 48�5⁄16 × 84⅝ in. (122.7 × 214.9 cm)
Signed and dated at lower left: F. E. Church / 1867
Ex coll.: commissioned by Mrs. Samuel (Elizabeth Hart Jarvis) Colt,
Hartford, in 1867
Bequest of Elizabeth Hart Jarvis Colt, 1905.21

In March 1865 the Churches' two young children died of diphtheria. The artist memorialized the tragedy in two small works, *Sunrise* and *Moonrise* (1865, Olana State Historic Site, Hudson, New York). Needing a change of scenery, the cou-ple sailed for Jamaica in late April of 1865 with friends, includ-ing the young artist Horace Wolcott Robbins (1842–1904).[66] While in Jamaica, the Churches dealt with their sorrow indi-vidually, as Robbins noted in a letter to his mother: "Poor Mr & Mrs. Church I feel ver[y] sorry for them. She is often very sad and speaks to Sarah [a friend] about her children. He is very singular about that never likes to speak of his feelings— . . . He works away as if for dear life—& seems to be trying to forget his trouble by always keeping himself occupied."[67] *Vale of St. Thomas, Jamaica*, the painting Church conceived

on this trip for his friend and patron Elizabeth Colt, embod-ied the artist's emotional state at the time.

During his nearly five-month stay on the island, Church focused on the topography, botany, and meteorology of the tropical landscape and produced one of his greatest series of oil sketches.[68] Tuckerman noted the diversity of subjects that resulted: "The studies which he brought home . . . are ad-mirable effects of sunset, storm, and mist, caught in all their evanescent but characteristic phases; the mountain shapes, gorges, plateaus, lines of coast, and outlines of hills: besides these general features, there are minute and elaborate studies of vegetation—the palms, ferns, canebrakes, flowers, grasses, and lizards; in a word, all the materials of a tropical insular landscape, with every local trait carefully noted."[69]

Church

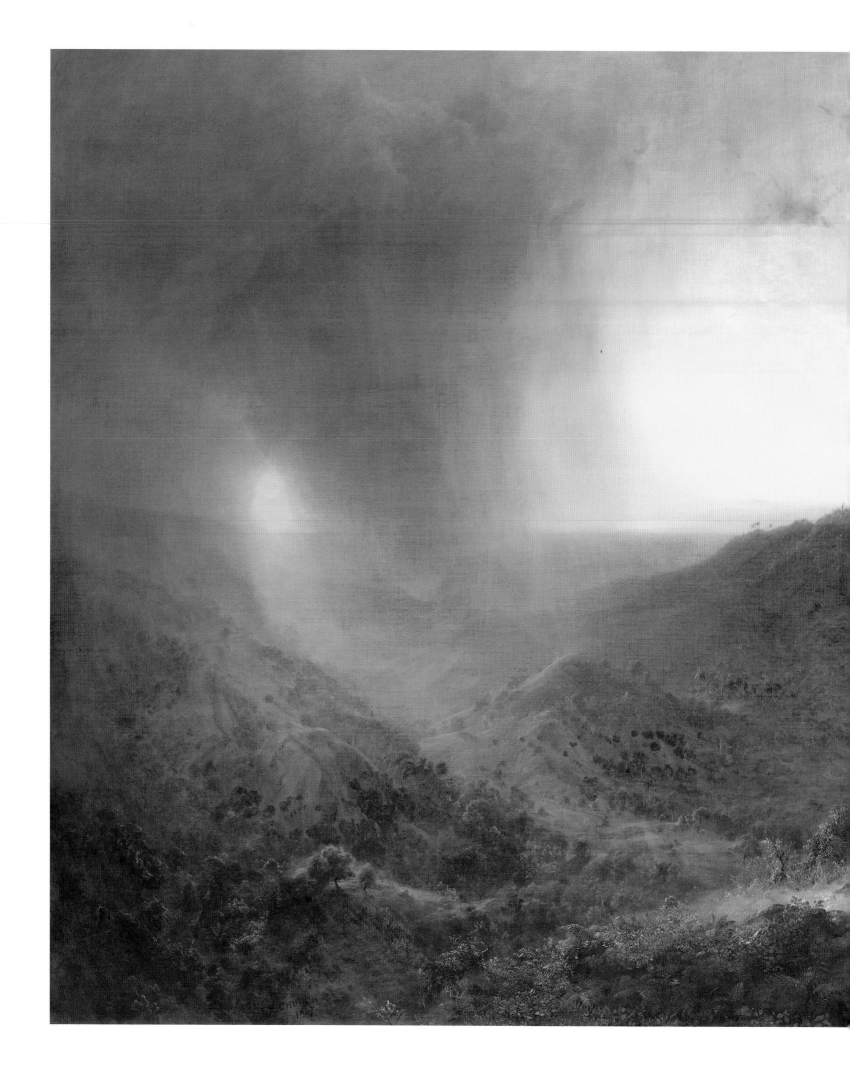

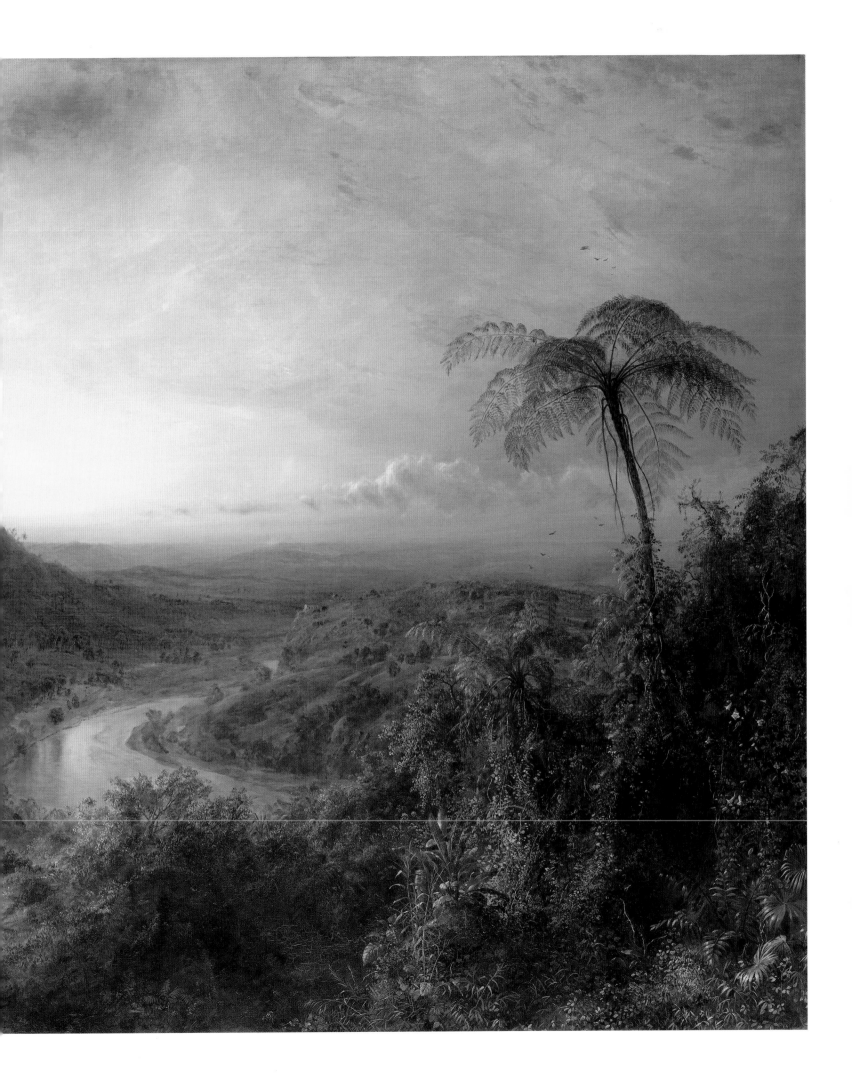

After an arduous journey across the island by train, on horseback, and on foot, Horace Robbins described in detail the moment the two artists first laid eyes on the landscape that would inspire *Vale of St. Thomas*: "Reaching the highest elevation [of Mount Diablo] we had one of the sweetest & finest views I have yet seen on the island—In the far distance was the long blue range of Blue hills and near the thickly wooded hills and down the valleys—great mosses & clouds of fogs wh[ich] seemed like lakes whilst here & there above it peeped out some tall palms.—It was a sight never to be forgotten[.] So beautiful and grand—We overlooked the Parish of 'St Thomas in the Vale' wh[ich] is one of the sweetest of them all—We remained sometime enjoying the view."[70] Church took spectacular oil studies from atop Mount Diablo, looking across St. Thomas in the valley to the Blue Mountains in the distance. The sheer number and beauty of these oil studies (now in the Cooper-Hewitt Museum in New York City) indicates that he was preparing to produce a large canvas of this site when he returned to his studio.

Elizabeth Hart Jarvis Colt had commissioned Church to paint an important work for a picture gallery she was creating in her Hartford mansion. The close ties between the Church and the Colt/Jarvis families of Hartford went back several generations, and, more recently, Elizabeth Colt and Church had shared the grief of family deaths. (Between 1857 and 1860, Colt suffered the deaths of two infant children, her daughter, and her husband, Samuel Colt.) With a controlling interest in the Colt arms manufactory, Mrs. Colt was one of the wealthiest women in the country. She planned an elaborate picture gallery that would serve as a memorial to her husband and, at the same time, would assert her financial and social authority in Hartford.

Aware that the painting would serve as an important focal point of the new gallery in his own native city, Church took care in imbuing his tropical landscape with a deeply spiritual meaning. He chose to depict the moment just after a storm, when the landscape glows in a lush, steamy atmosphere. The brilliant light of the rising sun emerges from behind a passing rain cloud, creating a swirling vortex of light and atmosphere reminiscent of J.M.W. Turner. In this idealized landscape, a tiny monastery is placed high on the horizon, overlooking the river, symbolic of divine presence in the tropics.

It is significant that at this late date in his career, Church created a large-scale landscape that is site specific, rather than drawn from a variety of sources, as was more typical of his large-scale tropical paintings, such as *Heart of the Andes* (1859, The Metropolitan Museum of Art). In addition to the beauty of the site, as evidenced by the many oil studies the artist took, Church's decision to paint this subject may also have been influenced by an important historical event. Weeks after his return from Jamaica (toward the end of August), violence broke out between Jamaican blacks and British colonials in the parish of St. Thomas. The event quickly escalated into a bloody conflict that led to the massacre of hundreds of Jamaicans. The clash was the subject of newspaper and journal articles in New York and London, which described it as the worst insurrection on the island since the emancipation of slaves in the 1830s.

After Church returned to New York in 1866, Colt wrote to him concerning progress on her picture gallery and concluded, "I want very much to see your picture for me & am sure it will be a never ending delight."[71] Church began the painting in 1866 and was still working on it the following year.[72] Although the artist finished the painting in 1867, Colt evidently did not receive it until after its public exhibition as "Jamaica" in 1870 at Goupil Art Gallery, New York City.[73] The work received favorable reviews, one critic noting that it "combined the effect of storm and sunshine . . . with the most vivid and startling power."[74] It was loaned to the artist's memorial exhibition at the Metropolitan Museum in 1900 and is listed in Elizabeth Colt's will with the title "Vale of St. Thomas, Jamaica."[75]

While volunteering at the Metropolitan Sanitary Fair of 1864 in New York City, Elizabeth Colt had seen Church's *Heart of the Andes* (The Metropolitan Museum of Art, New York) on exhibition. Its grand scale and dramatic presentation in a large black walnut frame hung with drapery would influence her own commission from Church. *Vale of St. Thomas, Jamaica* was given central prominence in Colt's gallery, including an elaborate shadow-box frame designed by the artist.

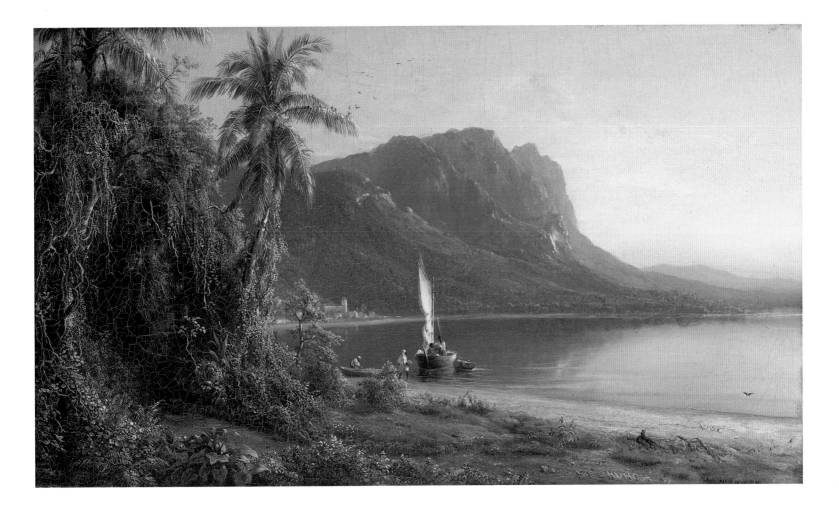

19 · *Jamaica*, 1871

Oil on canvas, 14¼ × 24¼ in. (36.2 × 61.6 cm)

Signed and dated at lower right: F. E. Church 71

Ex coll.: E. Hart Fenn, Wethersfield, Connecticut, by 1873

Gift of E. Hart Fenn in memory of his mother, Mrs. Frances Talcott Fenn, 1910.17

Church painted *Jamaica* in 1871, six years after his visit to that tropical island. He had recently returned from a tour of Europe and the Near East and was immersed in the construction of his villa, Olana, in Hudson, New York. The small scale and diminished impact of this work contrasts sharply with the epic proportions and panoramic vista of his monumental *Vale of St. Thomas, Jamaica* (cat. 18), painted four years earlier. The latter had become by 1870 a focal point of the private picture gallery of Mrs. Elizabeth Hart Jarvis

Colt in Hartford. Church may have received a request from E. Hart Fenn, the Wethersfield, Connecticut, state senator, to paint a more modest landscape of this tropical island.

Church consulted the numerous sketches and oil studies taken during his trip to Jamaica in 1865 for this later painting. He chose a coastal scene that includes tropical vegetation and a palm tree at the left, and native fishermen in boats dominating the foreground.[76] A village is visible in the middle distance, and there are mountains beyond.

20 · *Evening in the Tropics,* 1881

Oil on canvas, 32½ × 48⁹⁄₁₆ in. (82.6 × 123.3 cm)

Signed and dated at lower right: F. E. Church / 1881

Ex coll.: Julia Parmly Billings and Frederick Billings, New York City and
Woodstock, Vermont, 1881 to 1890; Julia Parmly Billings, from 1890 to 1914;
in the Billings family estate to 1922; in "American and Foreign Paintings,"
American Art Association, February 27, 1922, no. 58, as "Waterside
Landscape with Figures," property of the Billings Estate Corporation;
acquired by Clara Hinton Gould, Santa Barbara, California, before 1948

Bequest of Clara Hinton Gould, 1948.176

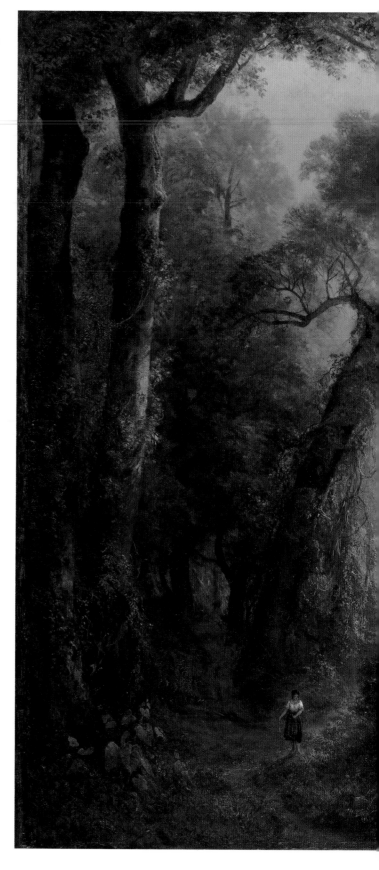

Church received a commission to paint a landscape for
Frederick Billings (1823–1890) and his wife, Julia Parmly
Billings (1835–1914), in 1880; it was among the last major
commissions the artist would undertake. Billings, one of the
century's great builders of railroads across the country, was
president of the Northern Pacific Rail Road Company. In
addition, as a leading conservationist, he helped establish
Yosemite National Park and initiated the reforestation of
Vermont.[77] The Billings family had a home in Woodstock,
Vermont, and in 1881 acquired a townhouse on Madison
Avenue in New York City, where the landscape was
intended to hang.

Correspondence between Church and the Billingses
indicates that the artist served as a broker for the sale of
paintings to the couple, including three works by Thomas
Cole.[78] The letters also provide detailed information of
Church's progress on his own painting for the Billingses,
beginning in February 1880, when Church discussed suitable
sizes for the work as well as his current prices, determined
by canvas size.[79] The Billingses selected the largest size;
Frederick Billings wrote to Church, "The order is for a *four
feet* picture—The more I can have of you the better!"[80]

Church began the painting in February 1880 but had
trouble finishing it. He wrote to Billings the following
November, asking permission to take the canvas from his
New York City studio to his Hudson estate, Olana: "I can
usually work to the better advantage in my quiet country
studio—besides—I have all my studies from Nature here and
may have occasion to refer to a number of them to enable me
to make the improvements I wish."[81] The many artist changes
evident on the canvas indicate that Church labored over this
work. In the end the Billingses received the landscape in Feb-
ruary 1882 and were very pleased with it, having paid Church
in the previous year the sum of three thousand dollars, plus

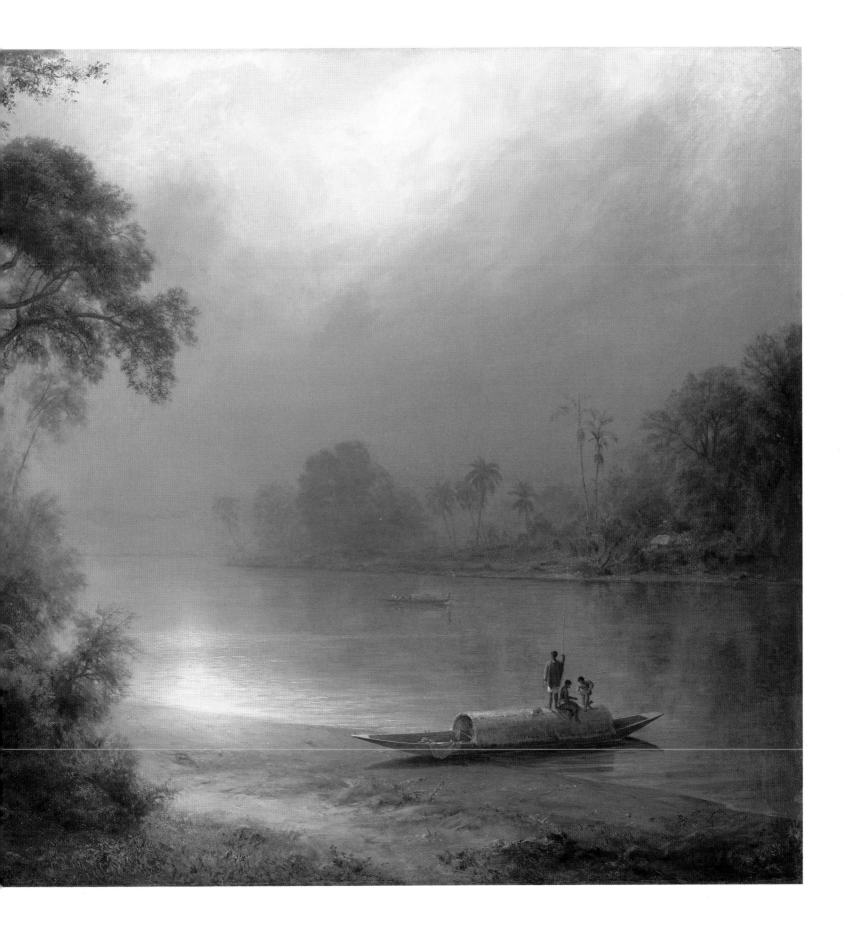

eighty-five dollars for the frame that Church had arranged to be made at Knoedler and Company.[82] Billings did, however, note in his diary of February 16, 1881: "Julia saw Church picture—& advised him [Church] I thought too much left for imagination."[83]

Painted late in the artist's career, *Evening in the Tropics* is a nostalgic work based on drawings and observations made during Church's travels to South America in the 1850s. The landscape is suffused with a warm yellow light and heavy atmosphere evocative of a steamy tropical environment. The painting does not convey the same force and energy found in Church's earlier tropical landscapes, for example, his *Vale of St. Thomas, Jamaica* (cat. 18) of 1867. Instead, the artist has provided a more poetic interpretation of nature, using more subdued tones of thickly applied browns and yellows, perhaps reflecting his attempt to move toward the currently popular European landscape styles, particularly the French Barbizon School. In addition, the foreground elements dominate the canvas and are broadly treated. Church may have been responding to his critics, who by the mid-1870s no longer considered desirable his ability to paint in a precise and detailed style.[84]

The subject matter of *Evening in the Tropics* is a direct reference to a specific event in the life of his patron and served as a reminder of the difficult voyage Billings and his sister Laura had made up the Chagres River in Panama in 1849.

The two had gone out West during the California gold rush. At that time, the trip was accomplished first by sailing to Panama and then by making the treacherous thirty-eight-mile journey by canoe up the Chagres River, known for its unhealthy environment. The causes of "Panama fever," or yellow fever, and malaria were unknown at this period, and the travelers ignored the swarming mosquitoes. Most drank the river water during the trip upriver to the town of Panama. From there, they traveled by mule and ship to California, but, tragically, Laura died of what was diagnosed as "Chagres Fever," either malaria or yellow fever, probably contracted on the Chagres River trip.[85] The figure of a young woman at left in Church's painting, shown holding a fishing line and encompassed by the ominous steamy yellow atmosphere, may symbolize Billings's sister Laura, thought to be the first woman to die in the gold rush. Church also included partially clad native boatmen, further documenting Frederick Billings's memory of the canoe trip that ended in tragedy.

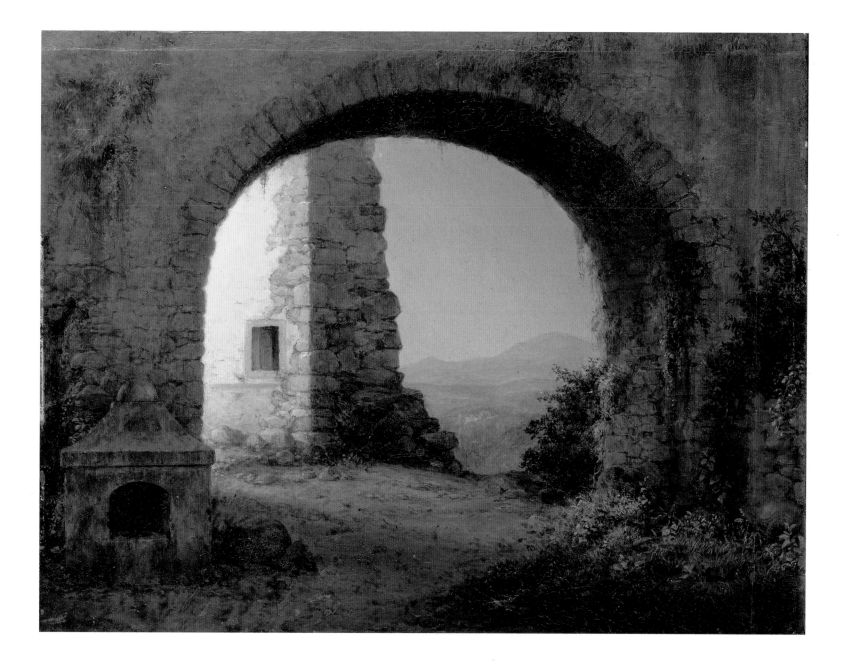

21 · *A View in Cuernavaca, Mexico,* c. 1898–1900

Oil on paper mounted on canvas, 9¼ × 12¼ in. (23.5 × 31.1 cm)
Ex coll.: the artist's children, Mrs. Jeremiah Black (Isabel Church) and
Louis Church; to Mrs. Charles Dudley Warner and family by 1915
Gift from the estate of Mrs. Charles Dudley Warner, 1936.448

Church had begun to experience recurrent pain stemming from degenerative rheumatism as early as 1869, a condition that worsened over time.[86] In Mexico, however, he found "a climate more suited to his health," and from 1880 to 1900 he spent most winters there.[87] The artist often made the trip to Mexico in the company of friends, as well as with his son Louis Palmer Church (1870–1943), who began managing his

parents' property at Olana beginning in 1891. In 1896, in addition to his son, Church also traveled with Charles Dudley Warner (1829–1900), author, editor, and close friend.

Church encouraged Warner to join him by writing, "If you wish to see the Spain of 300 years ago you must go to Mexico."[88] The artist was interested in documenting the ruins of Mexico because, as he explained, "American influence is . . .

asserting itself more and more," and with the extension of rail lines "the fatal wedge will soon reach this centre and the old and picturesque will be dismembered."[89]

A View in Cuernavaca, Mexico is based on a drawing from Church's *Mexican Sketchbook* (New York State Office of Parks, Recreation, and Historic Preservation, Olana State Historic Site, Hudson, New York) dated February 1898. The artist's interest in recording the ancient ruins of the country is evident in this light-filled scene, in which he depicted a close-up view of an arch through which are visible a crumbling wall and a distant view of mountains beyond. As a late work, this is a skillfully executed landscape with beautifully rendered vegetation and subtle tones.

Warner began a biography of Church shortly before the artist's death in April 1900. Unfortunately he completed only five chapters before his own death several months later.[90] Warner moved to Hartford in 1860, where he became coeditor of the *Hartford Courant* and later of *Harper's* magazine. In addition to writing biographies of John Smith and Washington Irving, he wrote four novels, including *The Gilded Age* (1873), which he wrote with his friend and neighbor Samuel Langhorne Clemens. He also wrote the catalogue for Church's memorial exhibition of paintings held at The Metropolitan Museum of Art in 1900.[91]

Church visited a number of archaeological sites while in Mexico, occasionally acquiring local artifacts. In one instance, in his role as a trustee of the Metropolitan Museum (from 1870 to 1887), Church made a donation to the museum of "two earthen ware tiles or slabs—Aztec works—which were found near Tampico, Mexico, in the vicinity of extensive ruins."[92] Church felt that "the pair will add something to the meager collection of the Ancient Art of the New World in our Museum and I will be alert to capture other examples of merit."[93]

Louis Church inherited Olana and its contents at the time of his father's death. He and his sister Isabel Charlotte Church (1871–1935) gave this sketch to the Warner family.

THOMAS COLE

Born 1801, Bolton-le-Moor, Lancashire, England;
died 1848, Catskill, New York

The preeminent member of the founding generation of Hudson River School painters, Thomas Cole was one of eight children of an English woolen manufacturer. As a young boy, Cole trained as an engraver of woodblocks used for printing calico. During the financial depression that followed the Napoleonic Wars, the Cole family immigrated to America. After working briefly as a wood engraver and illustrator in Philadelphia and making a trip to St. Eustatius in the West Indies in early 1819, Cole joined his family in Steubenville, Ohio, where he worked for his father's wallpaper manufactory. At this time he learned the essentials of oil painting from an itinerant portrait painter named John[?] Stein. After moving to Pittsburgh around 1823, Cole began to make landscape studies from nature.

Determined to become a painter, Cole soon moved to Philadelphia, where, for nearly the next two years, he studied the landscapes of Thomas Doughty (1793–1856) and Thomas Birch (1779–1851). He moved to New York City in 1825 and that summer made his first sketching trip, financed by the merchant George W. Bruen, up the Hudson River. The landscapes that resulted from this trip finally brought Cole success. When John Trumbull, William Dunlap (1766–1839), and Asher B. Durand each purchased a painting of Hudson River valley scenery, his career was launched. He quickly established relationships with important patrons in New York and elsewhere, including Daniel Wadsworth of Hartford.

Cole continued to make regular summer sketching trips to upstate New York and New England, eventually settling permanently in Catskill, New York, in 1834. There, in 1836, he met and married Maria Bartow. By the time he made his first trip to Europe in 1829, Cole was considered America's leading landscape painter. Traveling to London, Paris, Florence, and Rome, he visited artists, galleries, and museums. The high-minded themes and ideas of European art filled Cole's imagination and inspired him. When he returned to America in 1832, he sought to elevate landscape art to the realm of history painting by imbuing his works with historical and literary themes and a moral tone. In addition to his views of American scenery, Cole looked to European scenery as a subject. The landscape of Italy particularly interested him, and he drew on the artistic conventions of European masters such as Claude Lorrain for his many Old World landscapes and historical series.

Cole's series The Course of Empire (1836, The New-York Historical Society), a five-canvas cycle commissioned by the New York merchant and art collector Luman Reed, depicted the progress of society from the savage state to its ultimate extinction. This series represented the artist's magnum opus and foretold a harsh future for the United States. By the late 1830s, the artist's deepening religious faith resulted in The Voyage of Life (1840, Munson-Williams-Proctor Institute), a four-part series, and later, the unfinished four-part Cross and the World (c. 1846–47), based on John Bunyan's Pilgrim's Progress. His second trip to Europe, in 1841–42, resulted in the monumental Mount Etna from Taormina (cat. 31).

Cole left a formidable body of writing, including journals, poems, correspondence, and an essay on American scenery. At the end of his life, he imparted his knowledge to the young painter Frederic Church, his most illustrious student, who would carry on Cole's landscape painting tradition. Cole's untimely death—likely from pleurisy—shook the New York art world, and inspired many posthumous tributes and an extensive retrospective exhibition in New York City in 1848. He left behind an artistic legacy that would be honored by the school of American landscape painters that succeeded him.

22 · *Kaaterskill Falls,* 1826

Oil on canvas, 25¼ × 36⁵⁄₁₆ in. (64.1 × 92.2 cm)
Ex coll.: commissioned by Daniel Wadsworth, Hartford, in 1826
Bequest of Daniel Wadsworth, 1848.15

When Cole returned to New York City after his first sketching trip up the Hudson in 1825, he completed as many as five landscapes of the river and the surrounding Catskill Mountain scenery. That autumn, he placed the five landscapes in the shop of William Colman, a book-and-picture dealer, offering them for sale at twenty-five dollars each. John Trumbull, president of the American Academy of the Fine Arts, bought *Catterskill Upper Fall, Catskill Mountain* (unlocated) and brought the remaining two works to the attention of the artists William Dunlap (1766–1839) and Asher B. Durand, who each purchased one. Dunlap recorded the details of Cole's discovery in his *History of the Rise and Progress of the Arts of Design in the United States* (1834), noting that Trumbull had said of Cole: "This youth has done at once, and without instruction, what I cannot do after 50 years practice."[94]

In December 1825 Trumbull loaned *Catterskill Upper Fall, Catskill Mountain* to the American Academy of the Fine Arts, and did so again the following year. Daniel Wadsworth, Trumbull's nephew-in-law, learned of Trumbull's interest in Cole's work and may have seen Cole's recent paintings in New York at this time. A series of letters between Cole and Wadsworth indicates that Wadsworth ordered a copy of the picture that Trumbull had purchased less than a year earlier.[95]

Cole wrote to Wadsworth on July 6, 1826, from Catskill, proposing a different view of the falls from one of his many sketches.[96] Wadsworth was so taken with the original view, however, that he turned down Cole's offer. Cole executed the copy as ordered but was unhappy with the result.[97] Despite Cole's misgivings, Wadsworth was satisfied with the painting and ordered several other landscapes from him, thus initiating a long association as a major patron and friend of the artist.

The site Cole depicted for Trumbull and Wadsworth, Kaaterskill Falls, was by this time considered one of the great scenic wonders of the Northeast. Located in Greene County, New York, in the eastern range of the Catskill Mountains, the twin-tiered cascade falls two hundred and sixty feet into the Catskill Cove, joining the Catskill Creek about twelve miles west of the town of Catskill, and eventually flowing into the Hudson River. By the time Cole first depicted the site in 1825, a tourist hotel, the Catskill Mountain House, had been in existence for a year.

In his view of the upper fall seen from beneath the rock semidome, Cole provided a romantic vision of the American wilderness. The dark and dramatic scene includes a stormy sky and turbulent spray from the falls. Standing as though inside the cavern, the viewer is thrown into the scene without the benefit of a conventional foreground. Drawing on his knowledge of picturesque theory, Cole used a framing element—the outer cavern walls—to heighten the painting's effect.[98] He evoked the season with touches of autumnal color. An American Indian stands on a precipice in the center middle ground, surveying the wild beauty before him. The anachronistic inclusion of a Native American symbolizes the nation's distant past.

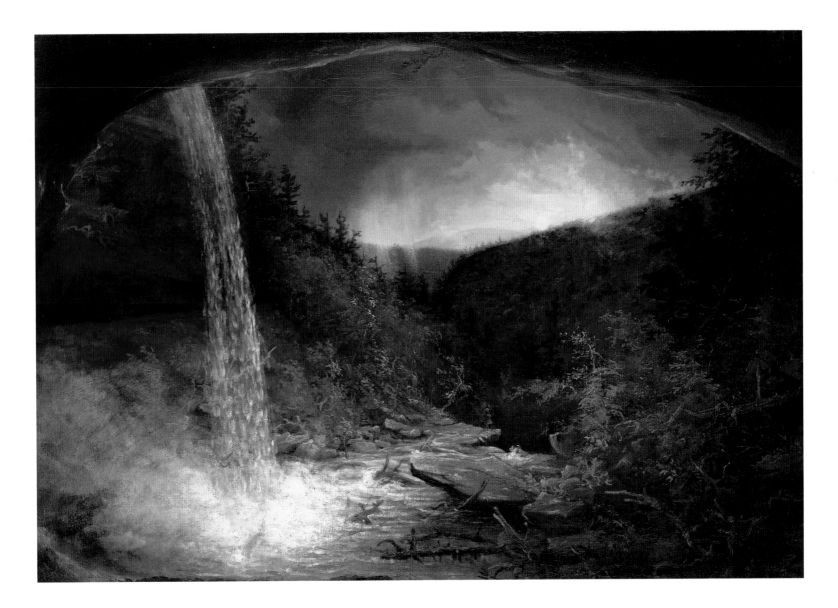

23 · *Landscape Composition, St. John in the Wilderness,* 1827

Oil on canvas, 36 × 28¹⁵⁄₁₆ in. (91.4 × 73.5 cm)
Signed and dated at lower left: T. Cole / 1827
Ex coll.: Daniel Wadsworth, Hartford, in 1827
Bequest of Daniel Wadsworth, 1848.16

Executed without a commission, Cole's *Landscape Composition, St. John in the Wilderness* was exhibited in 1827 at the National Academy of Design in New York City, along with five other landscapes by Cole. In this work, Cole freed himself from the confines of recorded observation, using his imagination to compose a scene that conveyed a message. Cole's use of the word *composition* in his title for this landscape implies that he envisaged a high moral theme—what he called a "higher style"—for this work, placing it in the realm of history painting. He explained his attitude toward his art at this time to his patron Robert Gilmor, Jr.:

> *I do not conceive that compositions are so liable to be failures as you suppose, . . . the finest pictures which have been produced, both Historical and Landscape, have been compositions. . . . If the imagination is shackled, and nothing is described but what we see, seldom will anything truly great be produced either in Painting or Poetry . . . a departure from Nature is not a necessary consequence in the painting of compositions: on the contrary, the most lovely and perfect parts of Nature may be brought together, and combined in a whole that shall surpass in beauty and effect any picture painted from a single view.*[99]

A religious man, Cole maintained that the divine presence could be experienced in the wilderness. The composition for *St. John* was inspired by a passage from the Gospel of Matthew, which begins: "In those days came John the Baptist, preaching in the wilderness of Judea, 'Repent, for the kingdom of heaven is at hand.' For this is he who was spoken of by the prophet Isaiah when he said, 'The voice of one crying in the wilderness: Prepare the way of the Lord, make his paths straight.'"[100]

The foreground is dominated by a large rock formation, with the figure of St. John, who stands atop it. The rocky pulpit suggests the profile of a human face, which hangs over the valley, seeming to defy gravity.[101] Below is an illuminated valley with a stand of palm trees and two tiny figures, a man leading a woman on horseback, evoking the Holy Family's flight to Egypt. A towering pinnacle of rock rises above the valley, and a waterfall cascades downward. Behind and to the left rears a high-peaked mountain. The drama of the scene is further enhanced by sharp contrasts of light and dark and the mists that swirl up to meet the burst of white clouds in the sky. The figure of John the Baptist, clad only in a loincloth and standing next to a wooden cross, appears diminutive against the dark, looming shapes of the natural landscape. Cole's emblematic personifications of nature, seen here in the anthropomorphic rock formation and the other dramatic forms, serve as symbols of God's presence in the unfolding historical drama of civilization.

Daniel Wadsworth probably saw this picture on a trip to New York in the late spring or early summer of 1827, for he bought it that same year for seventy-five dollars.[102]

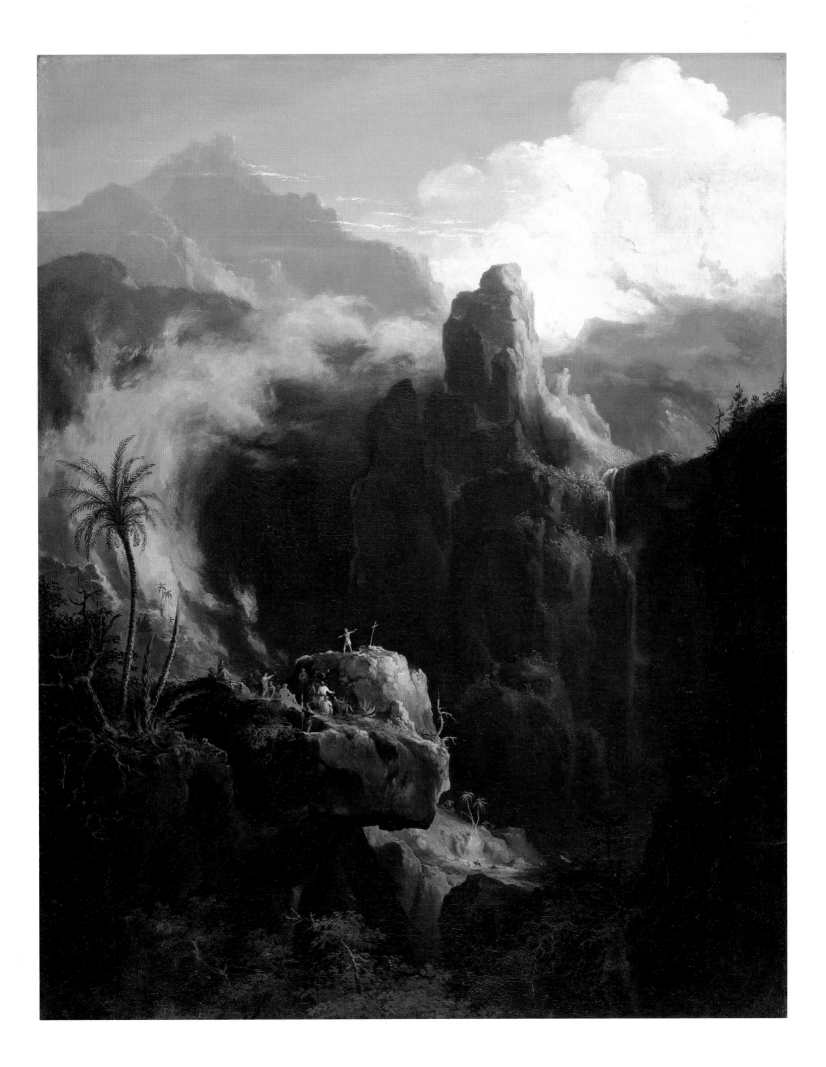

24 · *View in the White Mountains*, 1827

Oil on canvas, 25⅜ × 35³⁄₁₆ in. (64.5 × 89.4 cm)

Ex coll.: commissioned by Daniel Wadsworth, Hartford, in 1827

Bequest of Daniel Wadsworth, 1848.17

When Cole visited his friend and patron Daniel Wadsworth in Hartford in July 1827, Wadsworth encouraged him to visit the White Mountains of New Hampshire. As one of the first to appreciate the region's aesthetic qualities, Wadsworth himself had gone on a sketching trip there the preceding summer and was thus able to provide Cole with a written itinerary for the trip.[103] Cole followed his friend's advice, writing to Wadsworth on August 4, 1827, from Center Harbour, New Hampshire: "I am encompassed by beautiful scenery. . . . It is here in such sublime scenes that man sees his own nothingness, and the soul feels unutterable."[104] He made two trips to the White Mountains—in 1827 and 1828—accompanied by Henry Cheever Pratt (1803–1880), resulting in diaries and sketchbooks by both artists.[105]

Returning from his 1827 trip, Cole stopped in Hartford to show Wadsworth his sketches, and by August 16 he was back in New York City. Later that month Wadsworth wrote Cole, "Ever since you went from here, I have felt that it would be impossible for me to resist the temptation, of having a picture of the Coroway Peak with the little lake.—I think it is one of the most beautiful of your subjects.—I will therefore thank [you] to Paint one for me."[106]

Cole based *View in the White Mountains* on the many sketches he had executed there. In a notebook titled "Book of Sketches from Pictures I Have Painted Since My Return from White Mountains 1827," Cole inscribed one of the sketches for this painting as follows: "A morning in spring about 10 o'clock. Clouds. windy, cool. Snow on Mt. Washington. Many parts of landscaping shaded by clouds. Water lying on road as though there had been rain. Tree in foreground having appearance of being miserably blown down."[107] In addition there is an oil study titled *View of the White Mountains, New Hampshire (Storm near Mt. Washington)*, in which the artist included a stream in the foreground and two figures, one carrying a gun and the other a walking stick, accompanied by a dog (c. 1825–30, Yale University Art Gallery, New Haven).[108]

Although he honored most of the landscape elements in the oil sketch, Cole added a deep perspective to the final painting. Light striking a roadway and figures placed intermittently along it mark the receding space. A deep valley in the middle ground leads back toward the foothills at the base of the snowcapped Mount Washington. In the foreground, a man carrying a basket in his right hand, with an ax thrown over his left shoulder, walks toward a large vine-covered tree, a fallen branch from which lies across the road, blocking his

progress. Behind the settler, along the path are a number of tree stumps—symbols of the rapid settlement of the wilderness.[109] The blasted tree branch serves as a reminder of the power of untamed nature. Large rocks and vegetation add balance to the composition.

On receiving the painting in December 1827, Wadsworth wrote to Cole that he found it to be "a most beautiful scene"

and requested a description of the precise location, "as I shall wish when asked to say distinctly."[110] Cole replied on December 8, 1827, "The view of M. Washington is taken about nine miles from Crawfords, on the road to Franconia—The yellow lines on the Mountains are the traces of slides which are numerous, particularly on M. Pleasant—the river you see in the valley is the Amonasuc rather more

obvious than it is commonly in nature. I suppose the view to be taken in the morning about nine or ten, after a stormy night—you may see there has been rain by the pieces of water in the cart tracks."[111]

Wadsworth wrote again on December 21, 1827, describing his sister's reaction after looking at the picture: "I am sure I can walk upon that road . . .—And that Tree in its fore ground is as real as a tree in Nature, & indeed more real than any one out doors." The painting was exhibited at the National Academy of Design in 1828.[112]

25 · Scene from "The Last of the Mohicans," Cora Kneeling at the Feet of Tamenund, 1827

Oil on canvas, 25⅜ × 35¹⁄₁₆ in. (64.5 × 89.1 cm)
Signed and dated lower center on rock: T. Cole 1827.
Inscribed, signed, and dated on back in black paint: Scene from the Last of the Mohicans. 2 Vol., Chap. 12. T. Cole 1827
Ex coll.: Daniel Wadsworth, Hartford, in 1827; willed to Alfred Smith, Hartford, in 1848; to the Wadsworth Atheneum in 1868
Bequest of Alfred Smith, 1868.3

Cole's painting The Last of the Mohicans was inspired by a passage from James Fenimore Cooper's popular novel of the same title, which became an instant bestseller after its publication early in 1826. That summer, Cole took an extended trip to the Lake George region in northern New York State and visited Fort Ticonderoga, which Cooper had recently made famous in his novel.[113] Following this trip, one of Cole's major patrons, Robert Gilmor, Jr., of Baltimore, wrote to him on August 1, 1826, requesting a painting of "some known subject from Cooper's novels to enliven the landscape."[114] Cole did not immediately act on this request, but in the following year, for the National Academy of Design exhibition in New York City, he painted a picture titled Scene from the Last of the Mohicans (1827, Van Pelt Library, University of Pennsylvania, Philadelphia).

Also in 1827 Cole painted another scene from Cooper's novel, but, before he could ship it to Gilmor, Daniel Wadsworth purchased it. Titled Scene from "The Last of the Mohicans," Cora Kneeling at the Feet of Tamenund, it was exhibited at the National Academy of Design in 1828, at which time it was already owned by Wadsworth. Cole identified the subject with an inscription on the back of the painting, noted above. The painting provides little narrative detail, and Cole seemed to rely on the viewer's familiarity with Cooper's description of the scene:

Magua cast a look of triumph around the whole assembly before he proceeded to the execution of his purpose. . . . He raised Alice from the arms of the warrior against whom she leaned, and beckoning Heyward to follow, he motioned for the encircling crowd to open. But Cora, instead of obeying the impulse he had expected of her, rushed to the feet of the patriarch, and raising her voice, exclaimed aloud—"Just and venerable Delaware, on thy wisdom and power we lean for mercy! Be deaf to yonder artful and remorseless monster who poisons thy ears with falsehoods to feed his thirst for blood." The eyes of the old man opened heavily, and he once more looked upwards at the multitude. As the piercing tone of the supplicant swelled on his ears, they moved slowly in the direction of her person, and finally settled there in a steady gaze. Cora had cast herself to her knees; and, with hands clenched in each other and pressed upon her bosom, she remained like a beauteous and breathing model of her sex, looking up in his faded, but majestic countenance with a species of holy reverence.[115]

A series of letters between Cole and Wadsworth reveals that Wadsworth allowed the artist to delay delivery of the painting in order to paint a similar scene for Robert Gilmor, Jr. Wadsworth wrote to Cole on November 5, 1827, "Will you order such a frame for the 'Last of the Mohicans' as you would like best to see it in,—and send it with the Picture by

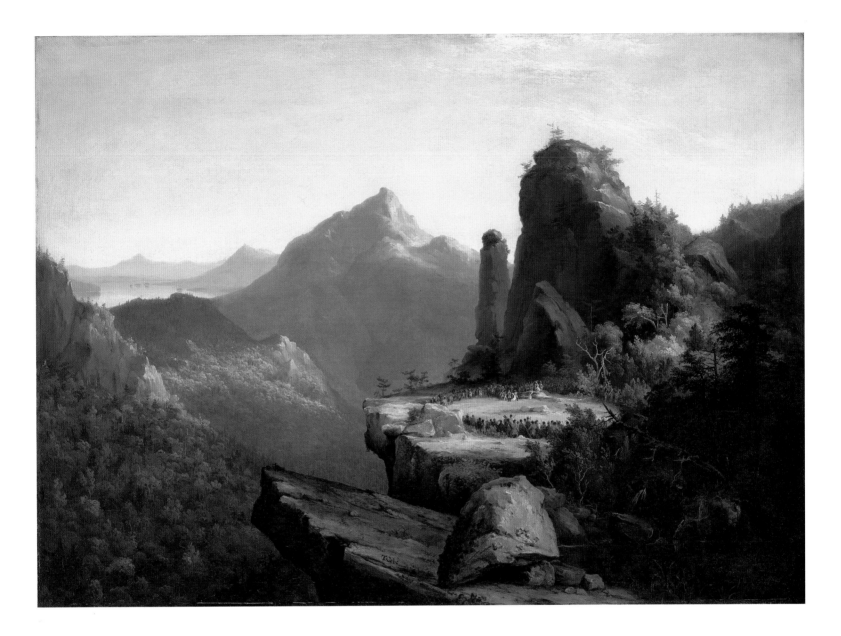

the Steam Boat, as soon as you have done the Copy entirely to your mind."[116] The Wadsworth painting retains its original frame. Drawings for both paintings exist in the Cole sketchbooks at the Detroit Institute of Arts.

Despite the fact that Cole had visited the Lake George area (the site Cooper selected for this passage) in the early summer of 1826, the artist used White Mountain scenery in these two versions of *The Last of the Mohicans*. Wadsworth had introduced Cole to the New Hampshire region in the summer of 1827, including Mount Chocorua and Lake Winnipesaukee.[117] White Mountain scenery assumed primacy in Cole's mind at this time, replacing the Catskill Mountains;

Mount Chocorua, for instance, dominated Cole's single-view paintings in the years 1827 and 1828.[118] In addition, by using a scene that he had described in a letter to Wadsworth as "far beyond my expectation and . . . the finest one I have ever beheld," Cole created a "composition" that carried the message he wished to convey rather than merely transcribing nature.[119]

Cole combined the real and the ideal in this work—a faithful rendering of White Mountain scenery in the background with idealized geological features that enhance the minute narrative scene in the foreground. The circular stage, set on a rocky ledge, the vast rock outcroppings, and the

dramatic chiaroscuro enhance the theatrical effect of the scene and delighted his patron. On receiving the painting, Wadsworth wrote to Cole on December 4, 1827:

> I can hardly express my admiration, the Grand & Magnificent Scenery,—the Distinctness with which every part of it, is made to stand forward, & speak for itself.—The deep Gulfs, into which you look from real precipices,—The heavenly serenity of the firmament, contrasted with the savage grandeur, & wild Dark Masses of the Lower World,—whose higher pinnacles only, catch a portion, of the soft lights where all seems peace. . . . And all these objects so exquisitely finished, that it appears as if each one had been the object of particular care . . . it seems to me that nothing can improve [this painting]."[120]

Wadsworth paid Cole one hundred dollars for this painting and fifteen dollars for the frame.[121]

Cole's interest in science is well documented.[122] He was acquainted with Benjamin Silliman (1778–1864), a leading professor of natural history and chemistry at Yale College and the brother-in-law of Daniel Wadsworth, himself an avid amateur geologist. Cole chose to surround the narrative scene with landscape features that reflect his interest in science: the round boulder or "rocking stone," in particular, was an object of great curiosity in New England. Discussed at length in Silliman's writings, the stone was considered evidence of the divine in nature.[123] In Wadsworth's painting, the rocking stone is resting precariously atop a high pinnacle, marking the sacred spot for the tribal gathering of the Delawares.[124] This rock formation, especially the phallic pinnacle and, to its right, a large cave behind the group of figures, evokes the sexual tension in Cooper's novel.[125]

(detail)

26 · *View of Monte Video, the Seat of Daniel Wadsworth, Esq.,* 1828

Oil on wood, 19¾ × 26⅟₁₆ in. (50.2 × 66.2 cm)
Signed and dated at lower right: Cole / 1828.
Signed on back: Cole / 1828
Ex coll.: commissioned by Daniel Wadsworth, Hartford, 1828
Bequest of Daniel Wadsworth, 1848.14

Between 1805 and 1809, Daniel Wadsworth, in conjunction with his uncle-in-law John Trumbull, designed and built his country estate, Monte Video, at the top of Talcott Mountain in Avon (then Farmington), Connecticut.[126] Wadsworth continued to acquire land on the site, and at the time of his death the estate comprised two hundred and fifty acres. The Gothic features on the house and outbuildings made Monte Video among the earliest and certainly most elaborate Gothic Revival country estates in America.[127]

One of Wadsworth's many sketches of his estate was engraved and published by his brother-in-law, Benjamin Silliman (1779–1864), in *Remarks Made, on a Short Tour, Between Hartford and Quebec in the Autumn of 1819* (1820) (sketch, *Monte Video,* Wadsworth Atheneum). The sketch supplemented Silliman's written description of the scenery: "The diameter of the view in two directions, is more than ninety miles, extending into the neighboring states of Massachusetts and New York, and comprising the spires of more

(detail)

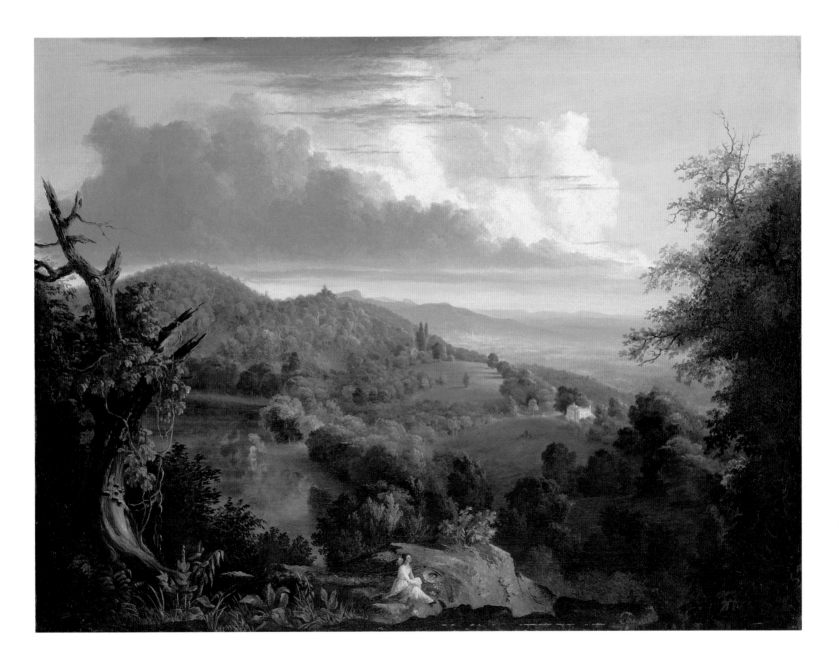

than thirty of the nearest towns and villages. The little spot of cultivation surrounding the house and the lake at your feet, with its picturesque appendages of boat, winding paths, and Gothic buildings, compose the foreground of this grand Panorama."[128]

In July 1827 Thomas Cole visited his friend and patron Daniel Wadsworth at Monte Video. Correspondence between them indicates that in the latter half of 1827, Wadsworth commissioned Cole to paint a view of his country estate. Cole completed the painting and, before sending it to Hartford, exhibited it at the National Academy of Design exhibition of 1828. He wrote to Wadsworth on December 1 of that year that the painting would be sent by steamboat that afternoon; of the work itself, Cole commented: "I think it has as much truth in it as any picture I have ever painted."[129]

The vantage point for the painting was the base of the fifty-five-foot hexagonal wooden tower Wadsworth built in 1810. This tower, from which visitors could view the extensive landscape below, became a focal point of the estate at Monte Video. The tower allowed those spectators to experience the thrill of the sublime and a sense of power or mastery over all below.[130] The artist placed Monte Video within the grand panorama of Wadsworth's landholdings, with the pond and bathhouse visible on the left and the main house on the right. In the distance, Cole included what appears to be the tenant's house, with smoke emerging from its chimney. Cole honors the two visions of the American landscape visible from the house, wilderness and cultivated landscape. He prominently placed a seated female figure in the foreground—a poetic muse, perhaps suggesting Wadsworth's creativity and symbolizing the quickly disappearing wilderness landscape. On the right, the view opens up to a settled scene, looking south down the valley toward Farmington Village and marked by the town's church steeple.

This painting and *View on Lake Winnipiseogee* (cat. 27), which was based on a drawing by Wadsworth, were conceived as a pair and hung together in the library at Monte Video during Wadsworth's lifetime.[131] Later, Cole remembered his visits to Wadsworth's country seat with fondness, and he wrote to Wadsworth during a trip to Italy with his "recollection" of their friendship and of "the many happy hours I spent at Hartford & Monte Video—also those rambles—those sunsets I enjoyed with you [which] have never faded in my mind & I look at those pleasures as 'flowers that never will in other garden grow'. . . . I anticipate the pleasure of seeing with you another sunset from the *Tower*—One of the views of Monte Video I had engraved in England & I intended to send you a number of the proofs."[132]

27 · *View on Lake Winnipiseogee,* 1828

Oil on wood, 19¾ × 26⅛ in. (50.2 × 66.4 cm)
Signed and dated at lower center: T. Cole 1828
Signed and dated on the back: T Cole / N.Y. 1828
Ex coll.: commissioned by Daniel Wadsworth, Hartford, 1828
Bequest of Daniel Wadsworth, 1848.13

Cole painted *View on Lake Winnipiseogee* in 1828 in New York City, and correspondence between the artist and his patron Daniel Wadsworth indicates that Cole used a sketch by Wadsworth for inspiration (1826, Wadsworth Atheneum). He wrote to Wadsworth on December 1, 1828: "The Pictures will be sent by Steam Boat that starts this afternoon—One is the view of Monte Video . . . the other is from your sketch of Winnipiseogee with a little variation. I have imagined it in its wild state—it is a morning view in Indian Summer. Those who have seen the pictures seem highly pleased with them."[133]

As Wadsworth does in his drawing, Cole presents a view of Lake Winnipesaukee looking south from Meredith, New Hampshire, but encloses the view and includes a foreground. The artist painted a light-filled scene of the lake with the sun, shown as a tight ball of heat in the center of the painting, attempting to break through the atmosphere. Haze and low-hanging clouds hovering above the lake soften the view of the distant mountains. Cole captures the heat of an Indian summer day with these atmospheric effects, as well as the heightened autumnal colors of the foliage surrounding

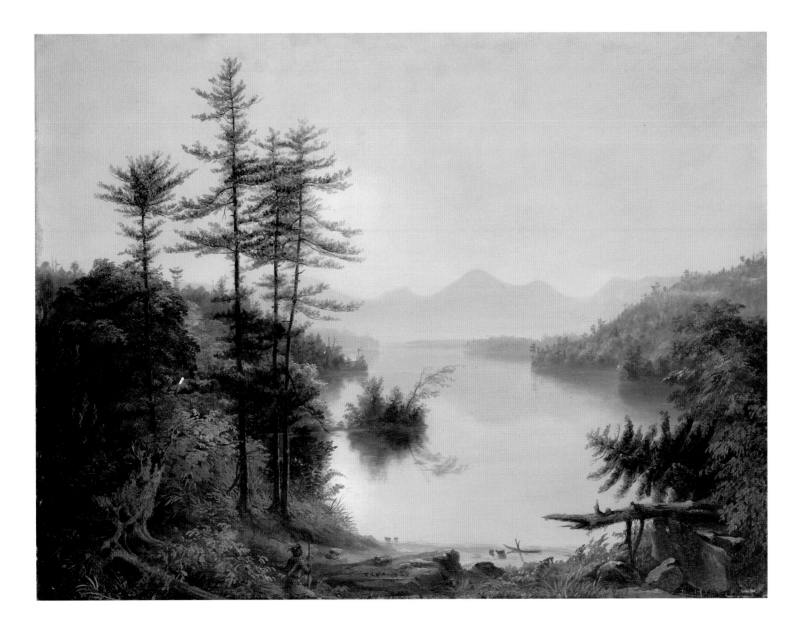

the lake. The addition of a single Native American in the foreground, surveying the pure wilderness scene before him, completes the picture—an evocation of the nation's past.

Additional correspondence between Cole and Wadsworth suggests that Cole intended *Monte Video* (cat. 26) and *View on Lake Winnipiseogee* as companion pieces.[134] Cole wrote Wadsworth on November 10, 1828: "With respect to your pictures I shall be able to send two before the river closes (in two weeks at farthest) one is the view of Meredith—which I think will please you—the other is the view of Monte Video—the price is fifty dollars each if agreeable to you to pay so much."[135]

As a pair of landscapes, *Lake Winnipiseogee* and *Monte Video* complement each other and provide a testament to the friendship that existed between artist and patron. At the time of Wadsworth's death the two works hung together in the library of Monte Video. *Lake Winnipiseogee* depicts American wilderness untouched by civilization and exemplified by the White Mountain scenery that both men revered, while *Monte Video* provides a pastoral view of Wadsworth's estate situated between the wilderness at the left and the ongoing cultivation of the landscape at the right. In both paintings, figures preside over the landscape before them. The Indian in *Lake Winnipiseogee* kneels in the foreground at ground level and surveys the lake and mountain scene before him. The muse in *Monte Video* is similarly positioned but perched on high ground, with her back turned to the landscape, instead gazing upward to the sky, perhaps symbolic of the inevitable progress of culture.[136]

28 · *Landscape with a Round Temple,* c. 1832–38

Oil on paper board attached to canvas, 8½ × 12½ in. (21.6 × 31.8 cm)
Ex coll.: to Elizabeth Hart Jarvis Colt, Hartford, about 1867
Bequest of Elizabeth Hart Jarvis Colt, 1905.12

Cole probably painted this imaginary pastoral landscape following his first tour of Italy, from 1831 to 1832. Although a secure date has not been established for this work, its Italianate subject matter—the temple, bucolic figures, and Claudean landscape features—relate to Cole's great series *The Course of Empire* (The New-York Historical Society, 1833–36).[137]

This is the only work by Cole that was a part of the private picture gallery of American and European paintings formed by Elizabeth Hart Jarvis Colt in the latter half of the nineteenth century. Most of the works were acquired directly from the artists. In this instance, as the artist was no longer living, she possibly could have acquired the work with the assistance of her friend and adviser, Frederic Church, who implemented the sale of a number of Cole's paintings, which he obtained directly from the Cole family. Colt placed the painting in her gallery next to Frederic Church's *Vale of St. Thomas, Jamaica* (cat. 18).

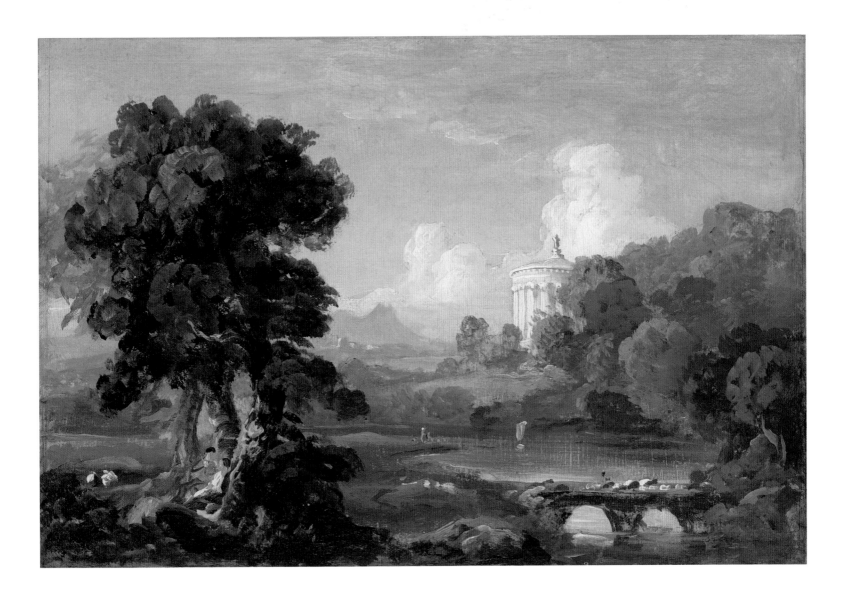

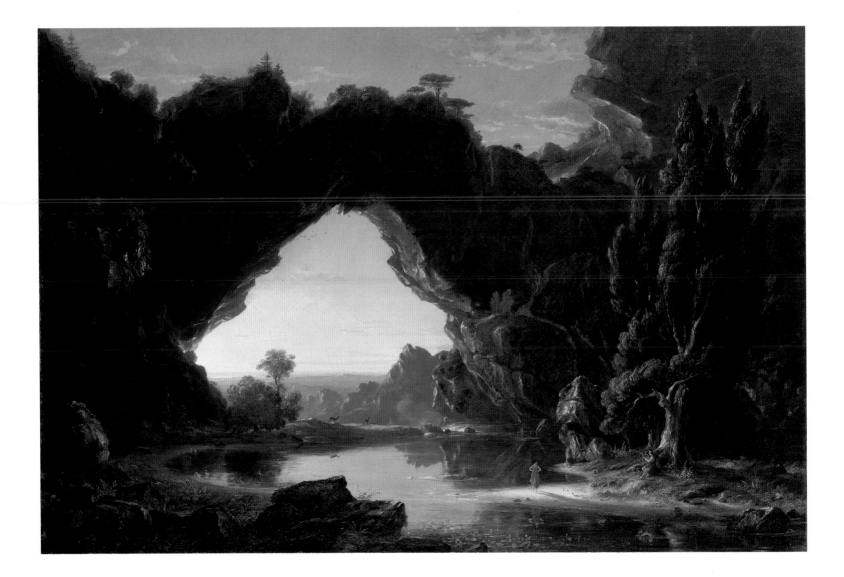

29 · *Evening in Arcady*, 1843

Oil on canvas, 32⅝ × 48⁵⁄₁₆ in. (82.9 × 122.7 cm)
Signed on rock at lower center: T Cole
Ex coll.: acquired from the artist by Miss [Sarah ?] Hicks, by 1844; acquired
from a private owner in California by Dalzell-Hatfield Galleries, Los Angeles,
by 1935; to Clara Hinton Gould, Santa Barbara, California, before 1948
Bequest of Clara Hinton Gould, 1948.190

30 · *Roman Campagna*, 1843

Oil on canvas, 32½ × 48 in. (82.6 × 121.9 cm)
Signed lower left: T. Cole
Ex coll.: acquired from the artist by Miss [Sarah ?] Hicks, by 1844; acquired
from a private owner in California by the Dalzell-Hatfield Galleries, Los
Angeles, by 1935; to Clara Hinton Gould, Santa Barbara, California, before
1948
Bequest of Clara Hinton Gould, 1948.189

In August 1841 Thomas Cole embarked on his second European trip, during which he stayed briefly in London, Paris, and Switzerland, and then traveled south to Rome and later to Sicily. He returned to New York City in 1842 and in the following year painted a series of Italian landscapes, including *Roman Campagna* and a companion piece, *Evening in Arcady*. The pair was painted for Miss Hicks as Cole indicated in a letter to Charles Parker on January 8, 1844: "I have just finished two pictures for Miss Hicks. The one is a view of Aqueducts in the Campagna di Roma, the other a fancy picture. Her Brother seems to be much pleased with them & I trust they will meet with her approbation when she sees them."[138]

Roman Campagna, featuring the Roman aqueduct and the Apennine Mountains in the distance, was one of several views that Cole painted of this site, which was among the Italian landmarks most recognizable to Americans. His earlier *Aqueduct Near Rome* of 1832 (Washington University Gallery

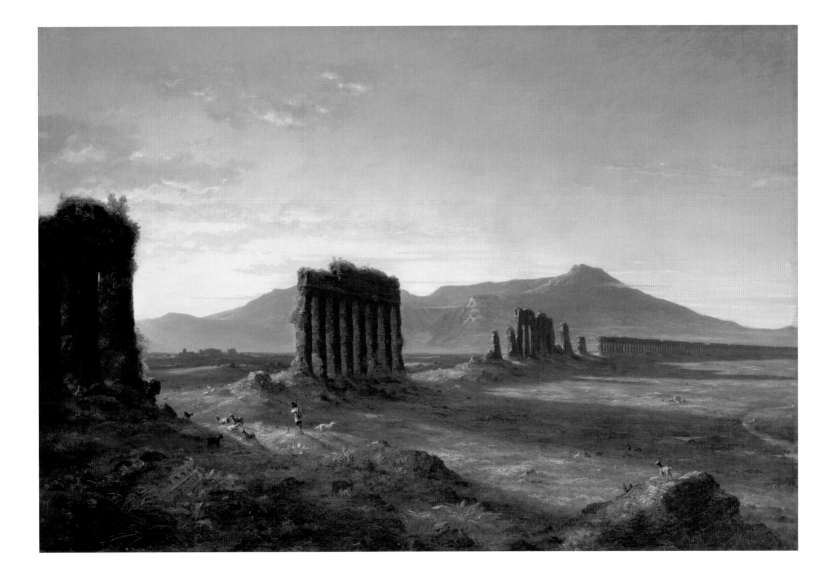

of Art, St. Louis) was engraved by James Smillie as the frontispiece for Henry T. Tuckerman's popular *Italian Sketch Book* (1835). The site, with its meandering progression from foreground to middle distance and to mountainous far distance, provided an ideal Claudean setting. The countryside also held strong historical associations with the fallen Roman Empire and so spoke to Cole's deep interest in Roman antiquities. This particular ruin was the most popular subject for American artists who stopped in Rome in the nineteenth century.[139] Henry Tuckerman later wrote of *Roman Campagna*, "[Cole's] Roman aqueduct breathes the very loneliness and sublime desolation of the Campagna. It is not a few barren fields of arches and decaying brick that we behold, but the silent arena of a vanished world."[140]

In his funeral oration for Cole in 1848 William Cullen Bryant praised this work as one of the pictures "which we most value and most affectionately admire . . . with its broad masses of shadow dividing the sunshine that bathes the solitary plain strewn with ruins, its glorious mountains in the distance and its silence made visible to the eye."[141] Several drawings of the Roman countryside exist in Cole's sketchbooks (Detroit Institute of Arts).

The companion painting, *Evening in Arcady*, which Cole termed a "fancy picture," complements *Roman Campagna* as to the time of day (one depicts dawn; the other, evening) as well as historic time (one is current; the other is set in an idealized past). The arcadian scene includes a winding river in a mountainous countryside dominated by an immense natural bridge. In the foreground a young woman dances to the music of a lyre played by a seated man. These figures evoke the legend of Orpheus and Eurydice, an impression reinforced by a serpent gliding toward the dancer.[142] Cole included this theme in his 1827 list of possible subjects for pictures as "no. 99 Evening in Arcadia & Morning—."[143]

31 · *Mount Etna from Taormina, 1843*

Oil on canvas, 78⅝ × 120⅝ in. (199.7 × 306.4 cm)
Signed and dated at lower left: T. Cole 1843
Ex coll.: purchased from the artist by Alfred Smith, Daniel Wadsworth,
and the original subscribers to the Wadsworth Atheneum
Museum purchase, 1844.6

During his second trip to Italy, in 1842, Cole visited many
of the famous Greek and Roman sites in Sicily. He was espe-
cially struck by the juxtaposition of the ruins of civilization
with the eternal features of the natural landscape. At Taor-
mina, Cole saw the remains of the ancient theater set against
the awesome backdrop of the volcanic Mount Etna. Accom-
panied by the English artist Samuel J. Ainsley, Cole ascended
the great Sicilian volcano. In two articles based on his Sicilian
travels, published in the *Knickerbocker* in 1844, he described
his impressions as he reached the volcano's summit: "It was a
glorious sight which spread before our eyes! We took a hasty
glance into the gloomy crater of the volcano, and throwing
ourselves on the warm ashes, gazed in wonder and astonish-
ment . . . Sicily lay at our feet. As the sun rose, the great
pyramidal shadow of Aetna was cast across the island, and
all beneath it rested in twilight gloom."[144]

Cole returned to the United States in July 1842, and over
the course of the next six years he painted at least six known
versions of the volcano.[145] The Atheneum's version, the third
and largest of the group, was made for an exhibition of Cole's
works in New York in 1843. Cole worked on it in the newer
rooms of the National Academy of Design on the fifth floor
of the New York Society, or Atheneum, Building, where the
exhibit was held.[146] He had hoped to obtain *The Course of
Empire* series for this show, but the owner, Mrs. Luman Reed,
would not lend the paintings. In a burst of energy and inspi-
ration, Cole painted *Mount Etna from Taormina* to take the
place of the series. With enthusiasm, he announced to his
wife on December 9, 1843: "I have finished two-thirds of
it, and have only painted on it two days. I never painted so
rapidly in my life."[147] The show opened to the public on
December 18, 1843. Cole issued special invitations to his im-
portant patrons, and visitors received a four-page pamphlet
listing the twelve works on view.[148]

Cole completed the painting in only five days, working
from detailed drawings that he had made on the spot. In one
drawing (*Mt. Etna from Taormina* or *Ruins at Taormina*, 1842,

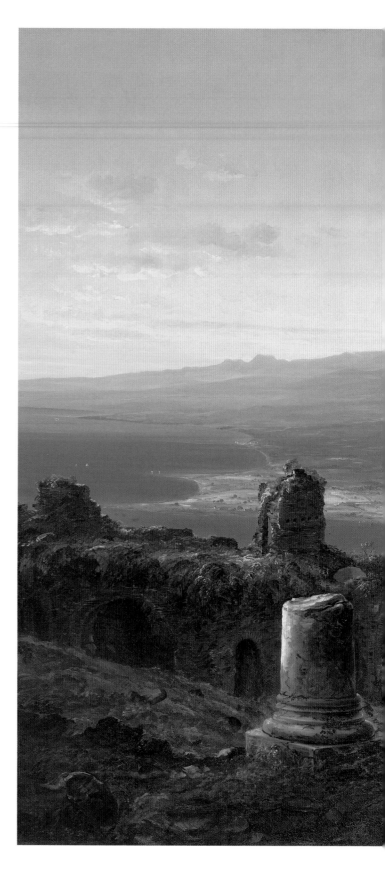

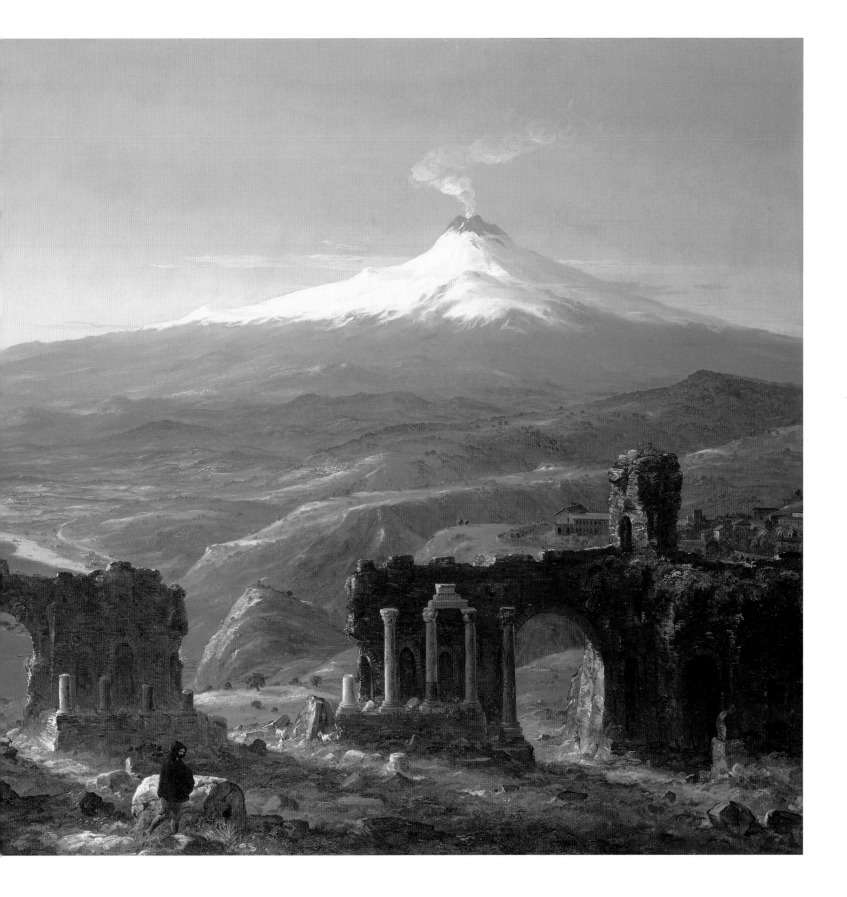

Detroit Institute of Arts), light from the west is cast on the column seen at the far left, indicating that it was drawn at sunset. Cole noted at the top of this drawing: "What a magnificent site! Aetna with its eternal snows towering in the heavens—the ranges of nearer mountains—the deep romantic valley—the bay of Naxos . . . I have never seen anything like it. The views from Taormina certainly excel anything I have ever seen."[149] The finished painting is a tour de force. The work is painted with great assurance (only minor artist changes are evident). The viewer's eye enters the scene at the lower left and is led past the ruins and the hooded figure of a monk in the foreground toward the volcano's summit, which, though snowcapped, emits smoke into the sky above. Cole conveyed his fascination with the hidden might of the volcano in a poem titled *Mt. Etna*, which he wrote on his return to America in 1842 and later published in *The Knickerbocker* in 1844.[150] For Cole, the volcano was a manifestation of God.

On January 5, 1844, Cole wrote to his wife that the original subscribers to the Wadsworth Atheneum were interested in acquiring *Mount Etna*.[151] Letters between Cole and Alfred Smith, who was Daniel Wadsworth's lawyer and the business manager for the newly opened Wadsworth Atheneum and who was also one of its original subscribers, document the negotiations for the purchase of *Mount Etna from Taormina* for the gallery.[152] Smith made clear the financial constrictions of the museum due to rising building costs, which left little money for purchasing paintings. Wadsworth was not asked to contribute toward this purchase, as Smith explained, because: "our most munificent donor [Wadsworth] has already contributed so much, that we should be reluctant to ask or even to receive more from him."[153] In the end, Wadsworth voluntarily contributed fifty dollars toward its acquisition and wrote to Cole: "I rejoice in the hope of seeing your *Etna* & trust the arrangement will result in the mutual advantage of yourself, & the Atheneum."[154] Cole assured Smith that in purchasing *Mount Etna* "you will have one of the finest pictures I have ever painted and one of the grandest scenes in the world."[155]

SAMUEL COLMAN

Born 1832, Portland, Maine;
died 1920, New York City

THE METROPOLITAN MUSEUM OF ART

Samuel Colman grew up in New York City, where his father, who had been a successful bookseller and publisher in Portland, had moved his family and started a publishing house when Colman was quite young. Nathaniel Parker Willis and Henry Wadsworth Longfellow were just two of the authors whose works Samuel, Sr., published in illustrated editions.

It is not known where or with whom Colman received his training in art, but Henry Tuckerman credits the elder Samuel's Broadway bookshop for the young boy's aesthetic appreciation. As early as 1851 Colman exhibited at the National Academy of Design in New York City. In 1854 he was elected an associate there, and eight years later he was made an academician. In the 1850s Colman sketched and painted the scenery of the Hudson River, Lake George, and the White Mountains. By 1856 he had a summer studio in North Conway, New Hampshire, which he shared with the artists Aaron Draper Shattuck (1832–1928), Daniel Huntington (1816–1906), William Sidney Mount (1807–1868), Sanford Gifford, and Richard Hubbard.

Colman took the first of many trips abroad in 1860, traveling to France and Switzerland. He also visited Spain and was one of the first American artists to sketch there. He was gone for one year, gathering visual material that would serve as the basis for the many paintings of Spanish sites he made and exhibited in the 1860s. In 1866 Colman helped found the American Society of Painters in Water Colors and was elected its first president, an office he held until 1871. The same year he was one of a number of artists—

including Asher B. Durand, Frederic E. Church, and Albert Bierstadt—to contribute to an album of sketches in honor of the poet William Cullen Bryant. Colman tried his hand at etching in 1867 and was to become adept at it, gaining critical praise for his work in the medium. Throughout the period from 1864 to the 1870s, Samuel P. Avery was Colman's New York dealer.

In 1870, the year following the completion of the Union Pacific Railroad, Colman probably traveled West, to Wyoming and, possibly, California. He took at least three additional trips to the West in 1886, 1888, and 1898–1905, visiting Canada and Mexico on his last sojourn. He also made a four-year tour of Europe and Africa, visiting such places as Italy, France, Holland, Algeria, Morocco, and Egypt. Two years after his return to America, he joined with George Inness, Thomas Moran (1837–1926), and others to form the Society of American Artists. In 1878 he became a member of the New York Etching Club and an associate of Tiffany and Company, for which he was an interior decorator until 1890. He built his own home in 1883 in Newport, Rhode Island, and also decorated others there during this period. Around this time he began collecting Asian art, and he gradually came to possess a wide array of objects, particularly Japanese articles, including brocades, swords, porcelains, and prints.

During his later years Colman devoted himself to writing theoretical treatises. In 1912 he wrote Nature's Harmonic Unity, and in 1920 he co-wrote (with C. A. Coan, editor of Colman's first book) Proportional Form.

32 · *Gibraltar from the Neutral Ground,* c. 1863–66

Oil on canvas, 26⅛ × 36⁵⁄₁₆ in. (66.4 × 92.2 cm)
Signed at lower left: S. Colman
Ex coll.: purchased from the *Judge* newspaper by George H. Story for the
Wadsworth Atheneum in 1901
Gallery Fund, 1901.35

Colman was one of the first American painters to venture off the traditional European route to visit Spain, where he sketched monuments such as Granada and Gibraltar.[156] Early on, the artist expressed an interest in port activity, and, as George Sheldon wrote in 1881, "at an early age [Colman] was often seen sketching the ships and the shipping, the waters and the sky, the wharves and the wharfmen."[157] It is not surprising, then, that he should be drawn to Gibraltar, an impressive site as well as an important port of call in southern Spain. What is surprising, however, is that the Atheneum's picture, unlike a number of his other depictions of the monument, is supposed to be a view from the north side, where the peninsula joins the Spanish mainland, and is probably an imaginary or composite view.[158] The setting of *Bay of Gibraltar* (c. 1863, Knoedler Galleries, New York City), one of Colman's most critically acclaimed paintings set in Gibraltar, is southeast of the view in the Atheneum's picture. A second treatment of this view, *Gibraltar*, is dated 1866 and is in

the collection of the George Walter Vincent Smith Museum, Springfield, Massachusetts.

When Colman was visiting the area, Gibraltar was controlled by Great Britain. The Neutral Ground was the sandy strip of land at the boundary between Spain and the British territory. One biased travel writer highlighted Spanish tobacco smuggling as the most distinctive feature of the Neutral Ground.[159]

In the Atheneum's painting, the scene appears to be of the ruins of a Moorish castle at the base of the north side of the rock. Colman's interest in the Moorish architecture of this part of southern Spain is evident in the care he took to define the blocky solidity of the buildings, which were probably made of the limestone indigenous to the area and of which the Rock of Gibraltar itself is composed. Colman treats the buildings, the rock, and the foreground with equal attention; the middle ground and background are engulfed in the haze of a summer's day.[160]

33 · *The Saw Mill Valley, near Ashford, Westchester County,* c. 1865

Oil on wood, 7 × 16⅗₁₆ in. (17.8 × 41.4 cm)

Signed at lower left: Sam. Colman.

Label on back: The Saw Mill Valley Near Ashford, Westchester Co. Late Summer / Sam'l Colman / Pinx / A Study from Nature

Inscribed on back: No. 30 Saw Mill Valley Near Ashford

Ex coll.: possibly at auction at Somerville Art Gallery, New York City, April 1872; Mrs. Benjamin Knower, Hartford, by 1922

Gift of Mrs. Benjamin Knower, 1922.150

This summer scene of the pastoral valley near the Saw Mill River, like the Atheneum's other small landscape from the period, *Landscape: Looking Across Country at Irvington-on-Hudson* (cat. 34), is rendered with the loose brushwork that replaced Colman's earlier, finely detailed depictions. It may also reflect the artist's trip to Europe in 1860–61 as well as his work in watercolor.[161]

Colman painted at least two other paintings of the area depicted in the Atheneum's painting.[162] One of these, a painting titled simply *Saw-Mill River,* was exhibited in New York City in 1875 and measured 30 × 15½ in. (76.2 × 39.4 cm), suggesting that the *Saw Mill Valley, near Ashford* could be a study for a larger work.[163] A label on the back of the painting reading, in part, "Late Summer / Sam'l Colman / Pinx / A Study from Nature" indicates that the landscape was painted en plein air.

34 · *Landscape: Looking Across Country at Irvington-on-Hudson*, 1866

Oil on canvas glued to matboard, 9¼ × 16¹⁵⁄₁₆ in. (23.5 × 43 cm)
Signed and dated at lower right: Sam Colman. 1866.
Inscribed on back: autumn looking across country at irvington
Inscribed on back: (24) / no. 37
Ex coll.: at auction at Somerville Art Gallery, New York City, April 1872;
to Mrs. Benjamin Knower, Hartford, by 1922
Gift of Mrs. Benjamin Knower, 1922.151

In 1875 a critic wrote, "Mr. Colman from his early life has been remarkable for his pure and rich coloring, which shows in his delicate and beautiful skies, in the soft meadows of our own country, and in our variegated autumn forests."[164] The writer could well have been referring to this painting or to the other small domestic landscape by Colman in the Atheneum's collection, *The Saw Mill Valley, near Ashford* (cat. 33). Colman painted this autumn view of the Hudson River at Irvington the same year he was elected the first president of the American Society of Painters in Water Colors. The fluidity and looseness of brushwork in *Looking Across Country*, probably executed en plein air, contrasts with his earlier, detailed

compositions in the tradition of the Hudson River School. The brushwork in this painting reflects his experience as a watercolorist, as well as his 1860–61 trip to Europe, and indicates the direction in which his work would move.[165] The small size of the canvas is typical of second-generation Hudson River School painters, among whom Colman is counted, and the signature on the work suggests that Colman may have considered the landscape a finished painting.[166]

At some point, Colman lived in Irvington-on-Hudson, during which time he probably painted the Atheneum's painting, as well as several other landscapes, both in watercolor and oil, which were exhibited between the years 1866 and 1875.[167]

JOHN DENISON CROCKER

Born 1823, Salem, Connecticut;
died 1907, Norwich, Connecticut

John Denison Crocker was one of seven children born to George Crocker and Nancy Lamphere. When he was young the family moved to Norwich, where the artist spent most of his life.

Early on, Crocker displayed the mechanical ingenuity that would later lead to such inventions as the canvas stretcher he patented in 1870. His first employment was at the age of nine with a wagon maker; at twelve he learned the trade of the silversmith. By the time he was seventeen he was working at a chair manufactory, and it was there, when a customer sent in a portrait to be varnished, that he was first exposed to art. According to H. W. French, chronicler of Connecticut artists, Crocker was so taken with the canvas that he was determined to become a portraitist. Crocker received some advice on painting from Charles Lanman (1819–1895), who was working in Norwich when Crocker began painting, but otherwise he was self-taught.

His first work was a self-portrait, and he continued to take portraits throughout his life. It was not long, however, before he began painting the landscapes with which his name is now associated. Many of his landscapes are set in the Connecticut area, but he also traveled to the Catskill Mountains and visited the Mountain House there, where Thomas Cole, among other Hudson River School artists, sketched. Crocker also traveled to the Adirondack Mountains.

In addition to landscapes and portraits, Crocker explored other subjects for his paintings as well, experimenting with still-life, genre, and history painting. The Slater Memorial Museum owns a history painting by Crocker, The Capture of Miantonomo (before 1880), which depicts the defeat of a Narragansett chief by Uncas, chief of the Mohegans, an event that took place in Norwich.

35 · *Home in the Wilderness*, 1853

Oil on canvas, 30 × 42⅜ in. (76.2 × 108.3 cm)

Signed and dated at lower left: Crocker, 1853

Ex coll.: purchased from the artist by Mary and Dennis Moran, Hartford; descended in the Moran family to Mary G. Colton (great-granddaughter of Mary and Dennis Moran) and her husband, William H. Colton, Vermont; purchased from Mary G. and William Colton by Lapham and Dibble Gallery, New York City and Vermont

American Paintings Purchase Fund, Krieble Family Fund, and Dorothy and Thomas L. Archibald Fund, 2002.22.1

After the death of Thomas Cole in 1848, a number of artists painted symbolic and overt tributes to the leader of the Hudson River School. These paintings, inspired by Cole's style, subject matter, or both, carried on the artist's mission to create an edifying art that would improve the minds and manners of its viewers.[168] Crocker's *Home in the Wilderness* is an homage to two late paintings by Cole: *The Hunter's Return* (1845,

Amon Carter Museum) and *Home in the Woods* (1847, Reynolda House Museum of American Art).

All three paintings, the two by Cole and the one by Crocker, deal with the white settlement of the frontier.[169] In each composition, a log cabin is set near water. The father of the family returns from hunting, fishing, or some other activity to greet his wife and child or children. In both *Home in the Woods* and *Home in the Wilderness*, lettuce is lined up in neat rows, growing in a garden near the family cabin, indicating that the land is being cultivated. In Crocker's work, a man with an ax over his shoulder symbolizes the continuing work of clearing and settling the land.

Home in the Wilderness is probably set on the Thames River, which runs through Norwich, Connecticut, where Crocker lived.

Crocker

97

JASPER FRANCIS CROPSEY

Born 1823, Rossville, Staten Island, New York;
died 1900, Hastings-on-Hudson, New York

As a boy, Jasper Francis Cropsey developed an interest in architecture. In 1837, the thirteen-year-old won a diploma at the Mechanics Institute of the City of New York for his model of a country house. Cropsey pursued his interest in architecture as an apprentice at the firm of Joseph Trench in New York City, where, by the fourth year of his five-year term, he was painting backgrounds for the finished architectural renderings. At this time, he studied watercolor painting with an Englishman named Edward Maury and began to attend classes in life drawing at the National Academy of Design. In 1841 he started to make oil paintings after his watercolors. In 1843 Cropsey's first painting was exhibited at the National Academy, and in 1844 he exhibited a view of Greenwood Lake, New Jersey, thereby gaining election as an associate of the Academy (in 1851, he would be elected academician). The following year, Cropsey addressed the American Art-Union, praising and encouraging the study of nature in an essay called "Natural Art," the themes of which would recur in his 1855 essay for The Crayon, "Up Among the Clouds."

Cropsey made two trips to Europe. On the first (a honeymoon trip with his wife, Maria Cooley, from 1847 to 1849) he followed closely in the steps of Thomas Cole, traveling

to England, France, and Italy. On his return to the United States, he made sketching trips to the White Mountains, New Hampshire; Newport, Rhode Island; Greenwood Lake, New Jersey; the Ramapo valley; and, in 1855, Michigan and Canada. The following year, he set off on his second trip to Europe, establishing a studio in London in 1856 and not returning to New York City until 1863. While in London, Cropsey studied paintings by Constable, Turner, and the Pre-Raphaelites, became involved in book illustration, and painted American landscapes, which were engraved and then published by Gambert and Company. Back home, he helped found the American Watercolor Society. Having obtained financial security from the sale of The Valley of Wyoming (1865, The Metropolitan Museum of Art) and Starrucca Viaduct (1865, Toledo Museum of Art), he bought land in Warwick, New York, in 1866, where he designed and built Aladdin, a Gothic Revival mansion and studio.

Cropsey taught art and continued to accept architectural commissions, but by 1884 he was in financial straits and was forced to sell Aladdin (it burned to the ground in 1909). In 1885 he moved to Hastings-on-Hudson to a house he named Ever Rest, where he duplicated the studio he had built at Aladdin. He remained there until his death.

36 · *Winter Scene—Ramapo Valley,* 1853

Oil on canvas, 22 × 36⅛ in. (55.9 × 91.8 cm)
Signed and dated at lower right: J. F. Cropsey / 1853
Ex coll.: George H. Clark from 1853 to 1901
Gift of George H. Clark (through Charles Hopkins Clark, before 1901),
1901.37

Cropsey, most often recognized as a painter of autumn scenes, was one of the few artists connected with the Hudson River School to try his hand at pictures of winter.[170] The Atheneum's painting, originally thought to depict the Hudson River valley, is a scene in the Ramapo valley. Henry T. Tuckerman, having seen *Ramapo Valley* in Cropsey's studio, wrote that there is "much truth to nature" in the painting and that it recalled an important moment in early American history: "In this vicinity Washington made his head-quarters

during the fearful episode of our revolutionary struggle identified with Valley Forge: and from the summit of his abrupt and lofty mountain, he often gazed toward New York, thirty miles distant, visible on a clear day. With how many months of weary and intensely anxious vigil is that bleak and isolated observatory associated; and how vividly the terrible ordeal through which the scanty and famished army passed, reappears to the mind while contemplating the scene in all its wintry desolation!"[171]

The frontier scene also points up the virtues of industry in a difficult climate, a scene that the nineteenth-century mind associated with the founding of the American colonies. This didactic aspect of the painting is in keeping with Cropsey's moralist tendencies and the early Hudson River School connection between landscape and morality.[172] The cross between landscape and genre painting in *Ramapo Valley*—a

Cropsey

99

combination that was not common in Cropsey's oeuvre—may be due to the influence of a French painter, Régis Gignoux (1816–1882), who frequently painted winter scenes and was active in the New York area from 1841 to 1870.[173]

Although he attended life-drawing classes in New York City in the late 1840s, Cropsey, like other artists primarily concerned with landscape, never became an accomplished figure painter. This is apparent in *Ramapo Valley*, where the figures stiffly pursue their chores about the farm, all pointed in different directions with no interaction.[174]

Vigorous brushwork, a hallmark of Cropsey's painting style, is evident only in the snow on the roofs and barn walls. Long shadows would seem to indicate early morning or late afternoon, and Cropsey's attention to light and to the hues of the shadows is typical of this colorist's work. With some humor, Cropsey signed his name in the snow as if it were carved into the frozen landscape with a stick.

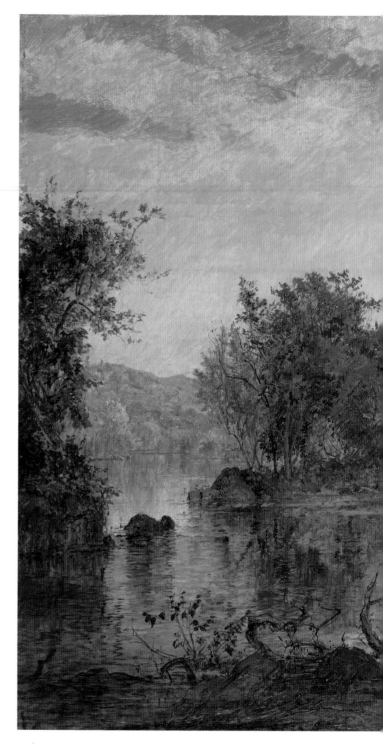

37 . *Autumn on the Susquehanna,* 1878

Oil on canvas, 23⅛ × 40⅛ in. (58.7 × 101.9 cm)
Signed at lower right: J. F. Cropsey / 1878
Ex coll.: the artist; Dr. Emerson C. Angell, Tarrytown, New York (friend of the artist); Anne Alice Angell, Tarrytown (daughter of Dr. Angell); Greta Wallian Agutter, Falmouth, Massachusetts (granddaughter of Dr. Angell and daughter of Anne Alice Angell and Edward P. Wallian); with unidentified dealer, Falmouth; with Vose Galleries, Boston, by 1966; acquired by the Wadsworth Atheneum by exchange and purchase in 1967
The Ella Gallup Sumner and Mary Catlin Sumner Collection Fund, 1967.68

By the mid-1850s, Cropsey was already considered a master of the autumn landscape, and by 1884 a critic wrote that Cropsey had "no superior as a painter of autumnal scenes."[175] He had exhibited his earliest-known painting of autumn, *Forest on Fire*, in New York City in 1845. In 1856 and 1859 he painted two versions of *Autumn on the Susquehanna* that differ from the Atheneum's later version only in their inclusion of a man rowing a boat (see *Autumn Landscape with Cattle*, 1879, Virginia Museum of Fine Arts, Richmond).[176] The absence of figures combined with an essentially empty middle ground in the Atheneum's painting are typical of post–Civil War views of the area. In these, the viewer is estranged from the landscape, looking on it from a separate, slightly elevated vantage point.[177]

In keeping with an earlier, mid-century trend toward naturalism, the distant mountains are outlined against the sky as if to bring them into high relief. Cropsey used an energetic brush for foliage and sky and a fine-tuned hand to delineate details of birds in the foreground. An article written almost

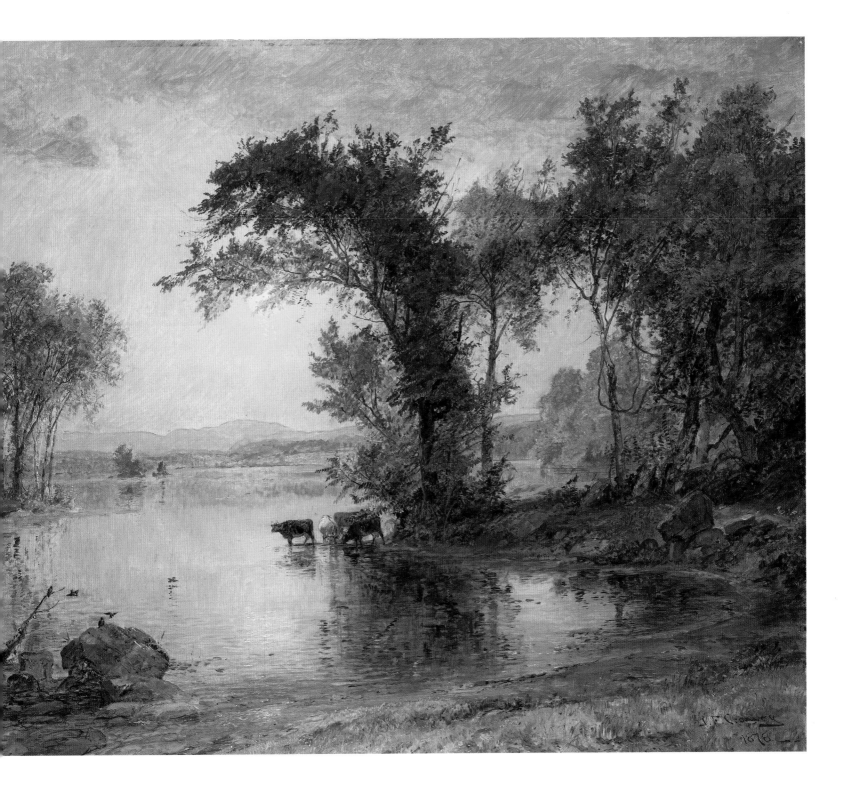

one hundred years later noted that Thomas Cole's "dramatic brushwork" was his legacy to Cropsey.[178]

Cropsey's skill as a colorist is evident in this painting: bold oranges, greens, and golds predominate, and a round, yellow sun that is visible through the branches burns through the hazy atmosphere. The palette is typical of Cropsey's later work, and the painting features unusual juxtapositions of intense colors that may have come directly from the paint tube.

ROBERT S. DUNCANSON

Born 1821, Seneca County, New York;
died 1872, Detroit, Michigan

NOTMAN ARCHIVES, MCCORD MUSEUM

obert Scott Duncanson was born in New York State to a racially mixed couple. His childhood was most likely spent in eastern Canada, where his parents would have found an environment less racist than the United States. By 1842, however, Duncanson was living near Cincinnati, Ohio, where he would spend much of his working life. It was there that he met his most important early patron, Nicholas Longworth, who would commission from Duncanson a series of murals for his Cincinnati home Belmont (now the Taft Museum). Duncanson painted a total of twelve panels for the Longworth home, the largest measuring 6½ feet by 9 feet (2 × 2.7 m). The subject matter of the murals reveals Duncanson's versatility: there are four vignettes of still-life compositions as well as one of an eagle, along with larger landscape compositions. Duncanson completed the murals in approximately 1849 or 1850.

In the forties and fifties Duncanson was a daguerreotypist, and in the latter decade he worked with James P. Ball, an African-American who owned a large gallery devoted to this early form of photography. The artist also executed oil paintings after daguerreotypes for display in Ball's gallery. During the same period Duncanson painted a number of portraits in Detroit and Cincinnati, many of abolitionists, and in 1853 he was commissioned by Rev. James Francis Conover, editor of the Detroit Tribune, to paint a scene from Harriet Beecher Stowe's novel Uncle Tom's Cabin, which had been published the previous year. The painting, Uncle Tom and Little Eva (1853, Detroit Institute of Arts), is possibly the only painting by Duncanson in which an African-American figure is central to the composition.

Duncanson visited Europe for the first time in 1853, traveling with fellow artists William L. Sonntag (1822–1910) and John Robinson Tait to England, France, and Italy, where he saw the paintings of J.M.W. Turner and Claude Lorrain, among others. When he returned to the United States in 1854, he began painting landscapes, many of which compare stylistically to the work of Thomas Cole and Frederic Church. As early as 1847, Duncanson would have been able to see Cole's landscapes at the Western Art Union in Cincinnati and, in 1852, at the Fireman's Hall in Detroit.

The years 1863–65 Duncanson spent in Montreal (probably to avoid the Civil War), where, in 1863, commercial photographer William Notman (1826–1891) held Duncanson's first recorded Montreal exhibition. Duncanson's Montreal period is characterized on the one hand by fantastic landscapes inspired by literary works, and on the other by realistic scenes of the Canadian landscape.

Duncanson returned to Europe in 1865, staying primarily in England and Scotland, and again in 1870–71, when he revisited Scotland. His later paintings reflect these trips; many are Scottish landscapes. He also continued to paint scenes from the poetry and prose of such British authors as Tennyson, Thomas More, and Sir Walter Scott.

Duncanson died at around age fifty at the Michigan State Retreat, after three months' treatment for mental illness. The cause of his death is unknown.

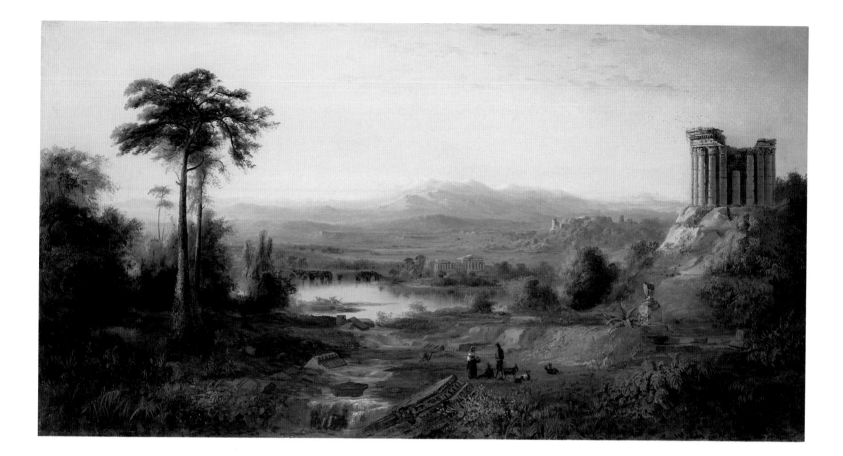

38 · *Recollections of Italy,* 1864

Oil on canvas, 20½ × 39 in. (52.1 × 99.1 cm)
Signed and dated at lower left: RS. Duncanson. / Montreal. 1864
Signed and dated bottom center: R. S. Duncanson / 1864.
Ex coll.: E. Thomas Williams, Jr., New York City, by 1991
The Dorothy C. Archibald and Thomas L. Archibald Fund and a fractional
gift of E. Thomas Williams, Jr., and Auldlyn Higgins Williams, 1991.81

Duncanson, though an artist of great versatility, was perhaps best known as a landscape painter. In 1864, when *Recollections of Italy* was painted, the artist was in Montreal, where he painted mostly so-called literary landscapes and Canadian scenery.[179] The Atheneum's painting represents another type of landscape that Duncanson painted throughout his career: the imaginary landscape. The fundamental composition of *Recollections of Italy* reflects the influence of Claude Lorrain: a coulisse (here, a body of water) flanked by two banks, a group of trees at the left, and a picturesque ruin at the right.

A stream snaking toward the viewer acts as a *repoussoir,* leading the eye into the painting to the lake and, finally, to the distant mountain. This composition method was commonly used by Thomas Cole and Frederic Church, as well as by other artists of the Hudson River School.

Considerably influenced by the work of the Hudson River painters, especially Cole's arcadian scenes, Duncanson shared their fascination with the ruins of classical Italy. At the right in the Atheneum's painting are the ruins of the Temple of Vesta (or the Temple of the Sibyl) at Tivoli.[180] This temple recurs in

Duncanson

at least two other paintings, one of which, *Landscape with Classical Ruins (Temple of Sibilla)* (1859, private collection), compares readily with the Atheneum's *Recollections of Italy*. A contemporary noted that the artist had been "executing beautiful Italian compositions" from sketches he made in Europe and in which Duncanson "gives extra-ordinary promise."[181]

The Atheneum's Duncanson is similar to paintings by William Sonntag from the period after his return from Italy, in particular such works as *Classic Italian Landscape with Temple of Venus* (n.d., Corcoran Gallery of Art, Washington, D.C.) and *Italian Lake with Classical Ruins* (1858, Dartmouth College Museum and Galleries). In the early 1850s William Sonntag was generally considered Cincinnati's most important landscape painter. Art historian Joseph Ketner has suggested that Duncanson assimilated Cole's influence indirectly through Sonntag.[182]

ASHER B. DURAND

Born 1796, Jefferson Village (now Maplewood), New Jersey;
died 1886, Jefferson Village, New Jersey

Best known as an influential member of the Hudson River School, Asher B. Durand was trained as an engraver, not as a painter. He began this first career as apprentice to Peter Maverick in 1812, remaining in that position until 1817, when Maverick made him a partner. The partnership lasted only three years, however: in 1820, without first consulting Maverick, Durand accepted a commission to engrave John Trumbull's Declaration of

Independence. *The commission, completed in 1823, cost Durand his job, but it also established him as one of the country's premier engravers. At Daniel Wadsworth's death, a copy of the engraving hung in the dining room of his home at Monte Video.*

Durand helped organize the New-York Drawing Association (later the National Academy of Design) in 1825 and the Sketch Club (later the Century Club) in 1829. Soon after, in the early 1830s, he began painting portraits, genre scenes, and a few landscapes. In 1835, with the encouragement of Luman Reed—an important patron of Durand and other American artists—Durand gave up engraving and turned all his attention to oil painting. By 1838, after a

trip to the Adirondacks in 1837 with Thomas Cole and Cole's wife, Maria Bartow, Durand was specializing in landscapes, and by 1845, the year he was elected president of the National Academy of Design, he was sending landscapes almost exclusively to the exhibitions.

In 1840 another patron, Jonathan Sturges, made it possible for Durand to visit Europe, where he traveled with John W. Casilear, John F. Kensett, and Thomas P. Rossiter (1818–1871). While abroad, Durand studied landscapes by Claude Lorrain and John Constable, as well as the work of Dutch painters such as Aelbert Cuyp. He returned to the United States in 1841 to paint a number of large landscapes that reflected the influence of the European painters he had studied, combined with that of Cole.

Durand published nine "Letters on Landscape Painting" in 1855 in The Crayon, *which was co-edited by his son John. These essays advise painting directly from nature and recording it realistically.*

In 1869, at age seventy-six or seventy-seven, Durand left New York City and retired to his hometown of Maplewood, New Jersey.

39 · *View Toward the Hudson Valley*, 1851

Oil on canvas, 33⅛ × 48⅛ in. (84.1 × 122.2 cm)
Signed and dated at lower left, on rock: A. B. Durand 1851
Ex coll.: Franklin Murphy, governor of New Jersey, to 1936; American Art
Association, Anderson Galleries, New York City, Public Sale, January 23,
1936, no. 95; private collection, New York City, by 1947; sold as no. 65 in
"Old Masters & Nineteenth Century Paintings," Parke-Bernet Gallery,
New York City, May 8, 1947; with M. Knoedler and Co., New York City,
to 1948
The Ella Gallup Sumner and Mary Catlin Sumner Collection Fund, 1948.119

In one of his "Letters on Landscape Painting," Durand wrote:

> *If your subject be a tree, observe particularly wherein it*
> *differs from those of other species: in the first place, the*
> *termination of its foliage, best seen when relieved on the*
> *sky, whether pointed or rounded, drooping or springing*
> *upward, and so forth; next mark the character of its trunk*
> *and branches, the manner in which the latter shoot off*
> *from the parent stem, their direction, curves, and angles.*
> *Every kind of tree has its traits of individuality—some*
> *kinds assimilate, others differ widely—with careful*
> *attention, these peculiarities are easily learned, and so, in*
> *a greater or less degree, with all other objects.*[183]

The trees Durand has singled out at the left foreground of
View Toward the Hudson Valley, with the branches "relieved
on the sky," are based on a drawing inscribed "Catskill," now
in the collection of The New-York Historical Society.[184] The
landscape was probably invented in the studio: Durand's
practice up through the early 1850s was to combine tree stud-
ies taken directly from nature with landscape compositions of
his own conception.[185]

Foreground passages in the painting include rock studies
and plant studies. Durand made several rock studies in the
1850s, usually geologically specific. In the second of his

"Letters on Landscape Painting," Durand echoes John
Ruskin's advice in *Modern Painters* (also published in *The
Crayon*): "Form is the first subject to engage your attention.
Take pencil and paper, not the palette and brushes, and draw
with scrupulous fidelity the outline or contour of such objects
as you shall select, and, so far as your judgment goes, choose
the most beautiful or characteristic of its kind."[186]

Several paintings in Durand's oeuvre share the compo-
sitional scheme of a chasm separating a foreground and a
middle ground, with figures in the foreground, one of whom
points off into the distance.[187] The figures in the Atheneum's
painting (perhaps the artist and his patron) look out over and
toward a cultivated and pastoral stretch of land.[188] Their
symbolic position with regard to the valley can be seen as one
of domination, implicitly celebrating the Manifest Destiny of
the American empire to expand into, control, and civilize the
wild in the name of progress.[189] The large size and panoramic
vista of *View Toward the Hudson Valley*, in conjunction with
the date of the painting—1851, the year after the Compromise
of 1850—suggest that Durand intended the painting as opti-
mistic.[190] In this case, the two figures in the painting might be
standing at the edge of past chaos and surveying the calm and
peaceful future that lies before them.[191]

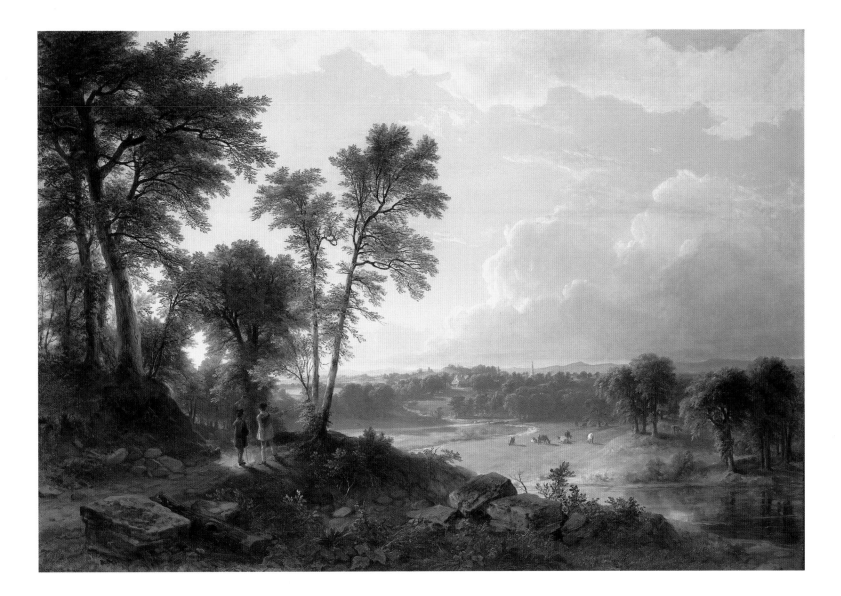

GEORGE HENRY DURRIE

Born 1820, New Haven, Connecticut;
died 1863, New Haven, Connecticut

George Henry Durrie was born into a family with English ancestry. In 1781 his paternal grandfather settled in Hartford, where he met and married Mary Steele, a descendant of John Steele, one of the founders of Hartford. Durrie's father and mother, Clarissa Clark of West Hartford, moved to New Haven, where his father established the firm Durrie and Peck, publishers, booksellers, and stationers.

Durrie was nineteen when he began traveling around Connecticut in search of portrait commissions. Durrie and his elder brother, John, Jr., studied with Nathaniel Jocelyn (1796–1881), a well-known New Haven portrait and miniature painter, and Durrie's first excursions were to Hartford, Meriden, Naugatuck, and Bethany. Later he traveled to Monmouth County, New Jersey; New York; and Petersburg, Virginia. At twenty-one, he married Sarah A. Perkins of Bethany, Connecticut, the daughter of a friend and client. Soon afterward, under the patronage of Judge James S. Lawrence, the artist and his wife returned to New Jersey. There, Durrie painted portraits and did other work, including varnishing paintings and decorating window shades.

Before October 1842 the Durries returned to New Haven. Records indicate that Durrie's first public exhibition of his work was in 1842: one portrait was shown at the National Academy of Design in New York City, and two others were exhibited at the New Haven Horticultural Society. Two years later, two winter landscapes were shown, and after 1845 Durrie began to shift his focus from portrait to landscape painting. During this period, however, Durrie's portraits still sold quickly from twenty to thirty dollars apiece, although he had trouble selling his snow pieces. Still, he persevered, and in 1854 he held a sale of winter pictures in his studio.

In 1857, Durrie moved to New York City and opened a studio at 442 Broadway. He exhibited two winter scenes at the National Academy and continued to exhibit there until his death, but he returned to New Haven to live after only one year. Some time in the late 1850s, Currier and Ives began to publish lithographs after Durrie's paintings, bringing his work to the attention of a broad audience. Durrie is also known to have painted genre scenes, pictures with Falstaff as their subject, still lifes with fruit, and a number of self-portraits. He died after a long illness at the age of forty-three, leaving a number of unfinished canvases that were completed by his brother John, Jr., and his son, George Boice; this later caused attribution problems for scholars.

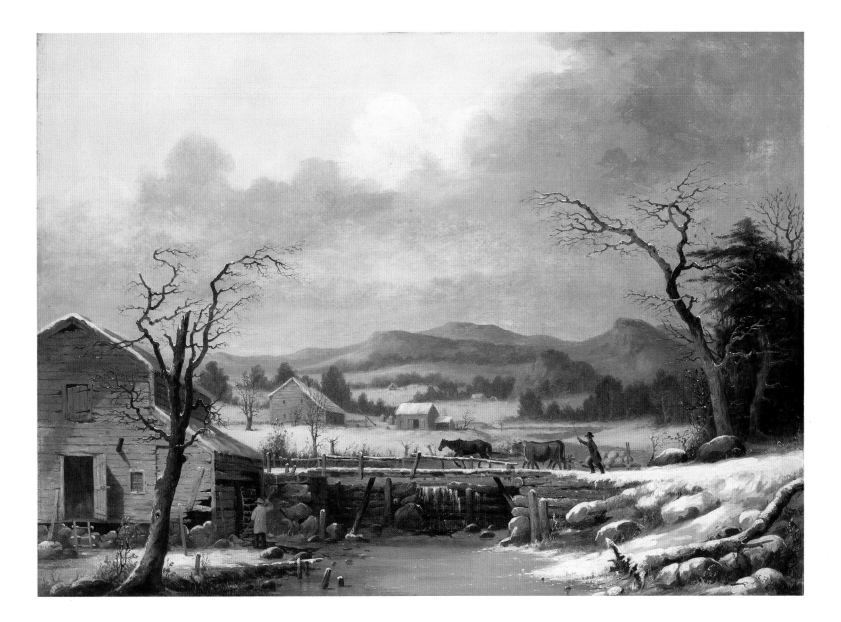

40 · *Old Grist Mill*, 1853

Oil on canvas, 25 3/16 × 36 in. (64 × 91.4 cm)

Signed at lower right: G. H. Durrie

Signed and dated at lower right on back of canvas (photograph mounted on backing after relining): G. H. Durrie / N. Haven. 1853.

Inscribed with stencil on back of canvas (photograph mounted on backing after relining): GOUPIL & Co / Artists Colourmen / 89 / Broadway / NEW-YORK

Ex coll.: with Kennedy Galleries, Inc., New York City, 1961

The Ella Gallup Sumner and Mary Catlin Sumner Collection Fund, 1961.154

Durrie painted all the seasons, but he is most famous for his winter landscapes or snow scenes, in which he paid special attention to the visual effects of snow and ice. Winter scenes were the least popular of seasonal subjects for landscape painters in the native tradition for a number of reasons. Nineteenth-century ideology viewed seasons in terms of

growth and decay, and winter clearly represented the less vital aspects of that cycle. Furthermore, landscape was thought to be a conveyer of morality, and winter was thought to be incapable of fulfilling that didactic role. Other reasons were practical: winter was cold, and the weather was harsh, and so most artists would take sketching trips in the warmer months, returning home in the winter to compose paintings from their sketches.[192] Durrie, as was typical of the time, idealized American landscape, but he idealized the winter season in particular. Consequently, the lithography firm Currier and Ives chose his snow scenes for reproduction and distribution.

In his diary Durrie wrote the following, which may well describe the scene of *Old Grist Mill:* "Took a walk up to the Mill on the River—was much pleased with the scenery which is very wild and exceedingly picturesque. . . . The scenery along the river where the water rushes over the dam is very bold. . . . The ground, trees, etc. were completely covered with ice, which glittering in the sun looked beautiful."[193]

Although Durrie tempered the wildness of this scene in *Old Grist Mill,* he did capture the ice-covered water with mastery. The touches of white snow on the sea-green ice, as well as the icicles that formed as water comes over the dam, convincingly convey the raw feeling of a New England winter. It is tempting to compare Durrie's handling of snow and ice to the work of earlier Dutch painters, and Durrie probably was aware of Dutch examples of landscape and genre: several were shown at the Crystal Palace in New York in 1853.[194]

In 1854 Durrie ran an advertisement in the New Haven *Daily Register* for a sale of his winter scenes.[195] Durrie held his sale on Thursday, May 11, 1854. It seems possible, although not certain, that *Old Grist Mill* was among the pictures for sale.

Currier and Ives began publishing lithographs after Durrie's paintings in 1861. The Atheneum's files show that its *Old Grist Mill* was published by Currier and Ives under the title *Winter in the Country: "Frozen Up."*[196]

ALVAN FISHER

Born 1792, Needham, Massachusetts;
died 1863, Dedham, Massachusetts

With Thomas Doughty (1793–1856) and Joshua Shaw (c. 1777–1860) of Philadelphia, Alvan Fisher was one of the first American artists to specialize in landscape painting. Inspired by the British landscape painters of the picturesque, Fisher and his American colleagues sought the ideal, poetic aspect of natural scenery in their early depictions of the American landscape. Fisher's work served as a modest prelude to the heroic compositions of the Hudson River School, led by Thomas Cole.

MUSEUM OF FINE ARTS, BOSTON

Fisher grew up in Dedham, Massachusetts, and decided to become an artist at the age of eighteen, when he was placed under the instruction of the ornamental painter John Ritto Penniman (1782?–1841). Fisher related the following details of his early career to William Dunlap: "In 1814 I commenced being an artist, by painting portraits at a cheap rate. This I pursued until 1815. I then began painting a species of pictures which had not been practiced much, if any, in this country, viz.: barn-yard scenes and scenes belonging to rural life, winter pieces, portraits of animals, etc. This species of painting being novel in this part of the country, I found it a more lucrative, pleasant and distinguished branch of the art than portrait painting."197

In the 1820s Fisher traveled through Connecticut, Vermont, western Massachusetts, and upstate New York, recording his observations of the American wilderness in his notebook (Museum of Fine Arts, Boston). He produced canvases of such popular sites as Niagara Falls, the Connecticut River valley, and Monte Video, Daniel Wadsworth's country estate outside Hartford (see cat. 26 by Cole), presenting a pastoral vision of the young country.

In 1825 Fisher went to Europe, traveling in England, France, Switzerland, and Italy. In Paris he studied and copied the Old Masters at the Louvre. Claude Lorrain, in particular, impressed Fisher. He reported that, in Paris, he "studied drawing at a private life academy."198 He returned to the United States in 1826, settling in Boston, and continued until mid-century to paint the American landscape, including White Mountain scenery and views of Mount Desert, Maine, as well as genre paintings and portraits. Fisher moved to Dedham in 1840 and at the time of his death had a substantial estate, a tribute to his entrepreneurial ability as an artist.

41 · *Niagara Falls*, 1823

Oil on canvas, 23⅛ × 29⅞ inches (58.7 × 75.9 cm)
Signed and dated at lower center, on rock: A Fisher / pixt / 1823
Ex. coll.: E. F. Coffin, Worcester, Massachusetts; purchased by Robert
C. Vose Galleries, Boston, in 1934; sold to Macbeth Gallery, New York City,
in 1938; with Dalzell-Hatfield Galleries, California; purchased by Clara
Hinton Gould, Santa Barbara, California, before 1948
Bequest of Clara Hinton Gould, 1948.199

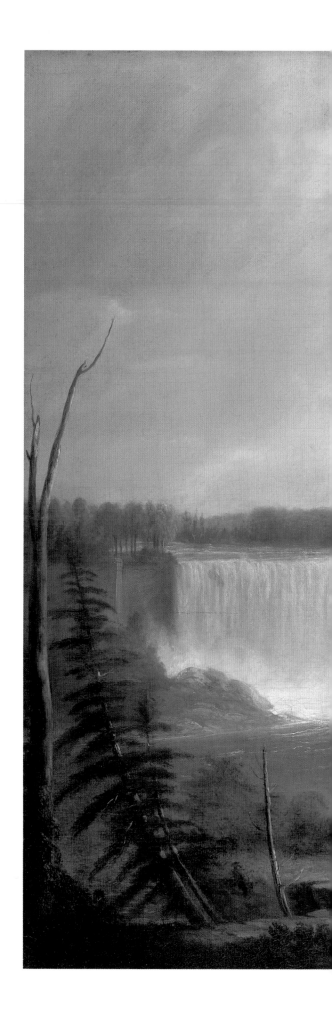

Alvan Fisher traveled to Niagara Falls during the summer
of 1820, having received a commission from Judge Daniel
Appleton White of Salem, Massachusetts, to paint views of
the falls.[199] During this trip he produced many sketches, on
which he based at least ten oil paintings of the falls. Relying
on the example of John Vanderlyn, who had created several
of the earliest views of Niagara in the 1810s, Fisher com-
posed fairly conventional scenes, from the Canadian side.[200]
Most were versions of the two original paintings, *A General
View of the Falls of Niagara* (1820, Smithsonian American
Art Museum) and *The Great Horseshoe Fall, Niagara* (1820,
Smithsonian American Art Museum), painted for Judge
White.[201]

 The Atheneum's *Niagara Falls* is the smallest of Fisher's
known canvases on the subject and is based on the earlier
General View of the Falls of Niagara. In both works, Fisher
combines an accurate representation of the distant falls, taken
from the Canadian side, with a picturesque foreground of a
detailed genre scene framed by trees. In the Atheneum's ver-
sion, a couple stands calmly by as one man is pulled up from
the ledge overlooking the falls by a second man wearing a
black top hat, while a third crouches over the edge to assist.
To the right, a single figure of a man looks over the edge with
arms outspread in awe of the scene before him. A small boat
filled with figures is seen in the waters below.

 In this work and several others, Fisher conveys the fact
that the site had become a popular attraction for tourists. By
1820 a number of comfortable hotels on both the American
and Canadian shores accommodated the hundreds of tourists
that visited the falls on any given day.[202]

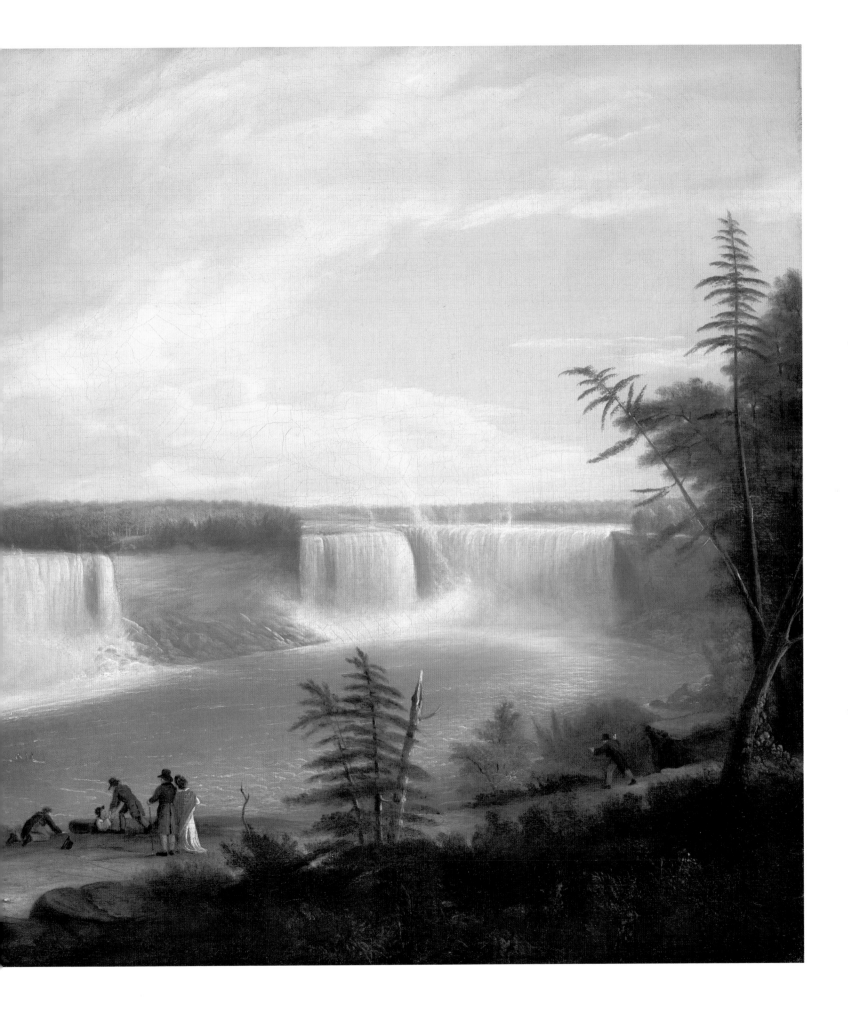

SANFORD ROBINSON GIFFORD

Born 1823, Greenfield, New York;
died 1880, New York City

A leading figure of the second generation of the Hudson River School, Sanford Robinson Gifford grew up in Hudson, New York, overlooking the Hudson River and the Catskill Mountains and near the studio of Thomas Cole. His father was co-owner of an iron foundry. After two years of study at Brown University, from 1842 to 1844, Gifford left for New York City in 1845 to study with drawing master John Rubens Smith (1775–1849). In 1846 his love of nature and admiration of the works of Cole led him to dedicate himself to landscape painting. Success came quickly, and in 1847 the American Art-Union and National Academy of Design accepted his landscapes for distribution and show.

Elected as an academician at the National Academy of Design in 1854, Gifford went to Europe the following year. He visited several countries, among them England and France, where he became familiar with the works of J.M.W. Turner and John Constable, and he met John Ruskin and Jean-François Millet. While in Italy, he traveled with fellow American Albert Bierstadt, among others. In 1857 he returned to New York City and set up a studio in the Tenth Street Studio Building, where he painted for the remainder of his career. Nearly every summer, Gifford took sketching trips with other landscape painters to the Catskill and Adirondack Mountains, his favorite sketching sites. He also visited the Green Mountains in Vermont, the White Mountains in New Hampshire, and Maine and Nova Scotia. In 1861 he enlisted in the Seventh Regiment of the New York State National Guard, and his Civil War experience resulted in a number of paintings, including Bivouac of the Seventh Regiment at Arlington Heights, Va. (1861, Seventh Regiment Armory, New York City).

Gifford made a second trip to Europe from 1868 to 1869, extending his travels to Jerusalem, Syria, Lebanon, and Egypt. On his return he traveled to the American West, first in 1870 and again in 1874. On the first trip, he joined John F. Kensett and Worthington Whittredge on a trip to the Rocky Mountains of Colorado and then joined a government survey expedition to Wyoming. His second trip included the West Coast from Alaska to California.

Three months after his death in 1880 from malarial fever, the Century Association honored Gifford at a memorial meeting, at which time John Ferguson Weir (1841–1926) admiringly assessed the artist's work: "He was a close student of nature, of her forms and facts, as well as of her moods. He recognized in the landscape, that its expression, for him, rested mainly in its atmosphere. He rendered this atmosphere, palpably, with every subtle sympathy, with great delicacy; but the forms he flooded with it he drew firmly, for he well knew that the finest delicacies of nature are those that are associated with vigorous truths."[203]

In the following year, The Metropolitan Museum of Art held a memorial exhibition of Gifford's paintings and published a catalogue that included a chronological list of 739 of the artist's known works.

42 · *A Passing Storm in the Adirondacks,* 1866

Oil on canvas, 37¼ × 54¼ in. (94.6 × 137.8 cm)
Signed and dated at lower right: S R Gifford. 1866.
Ex. coll.: commissioned by Elizabeth Hart Jarvis Colt, Hartford, in 1866
Bequest of Elizabeth Hart Jarvis Colt, 1905.23

Elizabeth Colt of Hartford, the wife of arms manufacturing magnate Samuel Colt, commissioned Gifford to paint *A Passing Storm in the Adirondacks* in 1866, in preparation for the completion of her second-floor picture gallery in her mansion Armsmear. Many artists with studios in the Tenth Street Studio Building in New York City worked on major landscapes for Colt's gallery during this year, including Gifford's friends and colleagues Frederic Church and Albert Bierstadt.

Gifford created one of his largest and most dramatic works for Colt's gallery. Having recently traveled through Keene valley in the late summer of 1866, he chose a scene in the Adirondack Mountains.[204] For this important commission, he followed his usual working method, described by his contemporary George Sheldon: "[Gifford] makes a little sketch of it [a landscape] in pencil on a card. . . . The next step is to make a larger sketch, this time in oil." He then waited for a favorable day: "[W]hen the day comes, he begins work just after sunrise, and continues until just before sunset. . . . His studio-door is locked."[205] Gifford had reached this point when he wrote to Colt in June from his studio, describing his ideas for the composition:

> I will try to give you an idea of my intention that you may know what to look for. The scene, though not intended to be exact as a portrait, is founded on a view in the Adirondack Mountains. The time is about 3 o'clock in the afternoon of a summer day. Over the large mountain which fills the middle of the picture there is passing a thin, illuminated, veil of rain, which gradually thickens to the extreme right into a dense shower. From a wide opening in the sky over the mountain the sunlight bursts from behind a cloud, and passes over the whole central portion of the picture, illuminating the rain-veil, the rugged flanks of the mountain, the foot-hills, and the valley below. A still stream winds through the meadows at the bottom of the picture. On a low point under a mass of trees on the farther side of the stream are some cattle, which, with the trees and mountains, are reflected in the quiet water. The subject interests me very much, and I hope to produce a picture

> worthy of it, and such [a] one as will be satisfactory to you. I think the picture will be finished in December next.[206]

The composition Gifford described in his letter relates to, and was probably inspired by, two pencil sketches and a contour study next to them of the central mountain peak, drawn perpendicularly along the right edge of a page. They were found in the artist's sketchbook (Albany Institute of History and Art) from a trip he took to the Adirondack Mountains in 1863.[207] The two tonal studies, which measure about two inches wide, represent examples of his "postage-stamp"-size miniatures—a timesaving method admired by his fellow artist Worthington Whittredge, who noted: "When sketching [Gifford] preferred to look about for the fleeting effects of nature. He would frequently stop in his tracks to make slight sketches in pencil in a small book which he always carried in his pocket, and then pass on, always suspicious that if he stopped too long to look in one direction the most beautiful thing of all might pass him by at his back."[208] The sketch at the top of the page reveals the idea for the foreground details, including the prominent clump of trees reflected in the lake, while the second drawing shows the contours of the mountains against the sky.

Unlike the "coming" or "approaching" or "passing" storm scenes that Gifford executed during the height of the Civil War era, his later work for Colt dealt with a passing storm in the aftermath of the war years. The ten "coming," "approaching," or "passing" storm scenes painted between 1859 and about 1868 constitute an important thematic group that relates directly to the effects of the Civil War on Gifford's art.[209] Several oil studies may have served as inspiration for the largest storm scene Gifford painted for Colt, in which he refined the effects of light and stormy atmosphere that he described in his letter and incorporated into the final painting.

The dramatic effect of the veil of atmosphere in this work recalls a similar rain veil in Frederic Church's *Vale of St. Thomas, Jamaica* (cat. 18), which hung directly across from Gifford's painting in Colt's gallery. Gifford included this painting on a list of his "chief pictures."[210]

Gifford

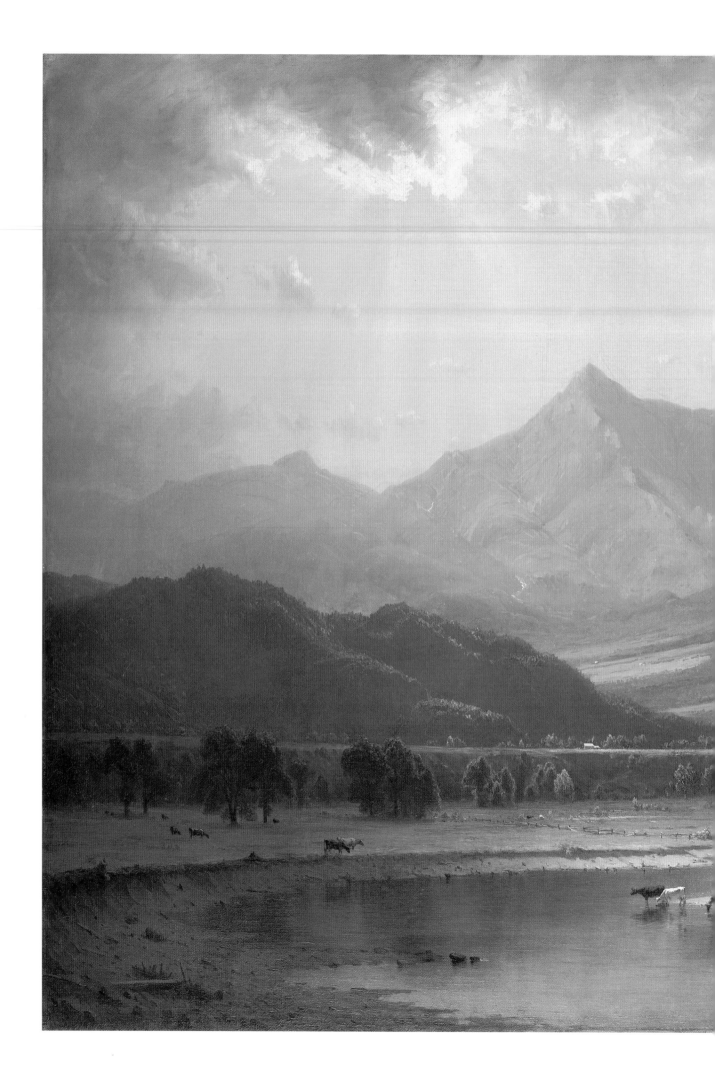

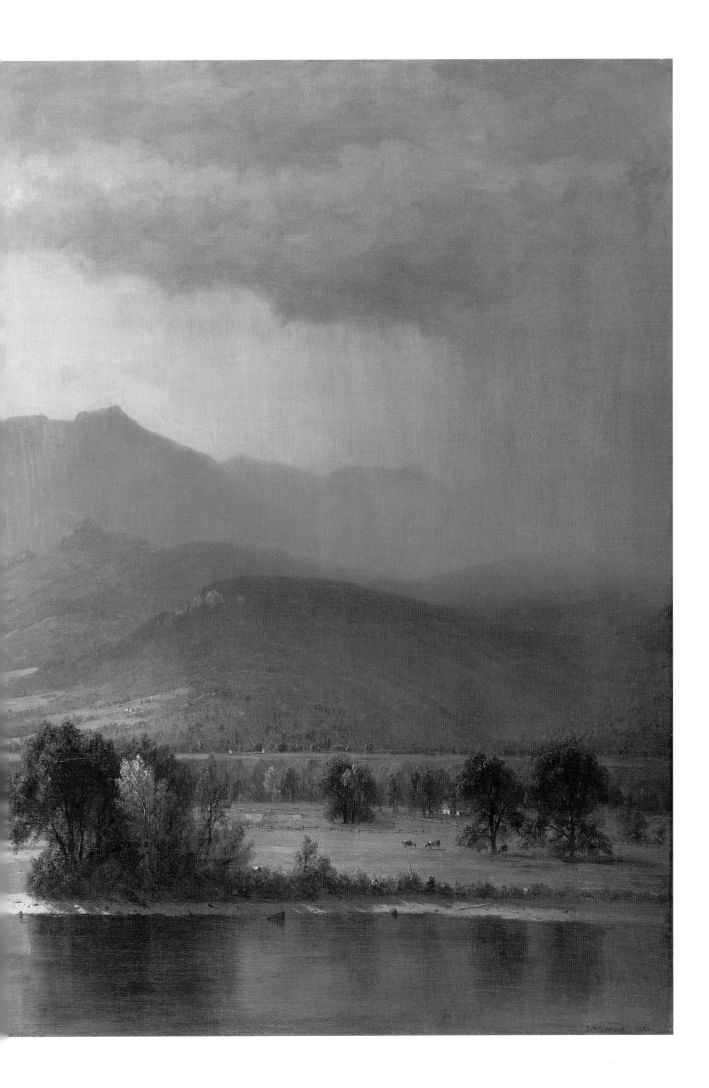

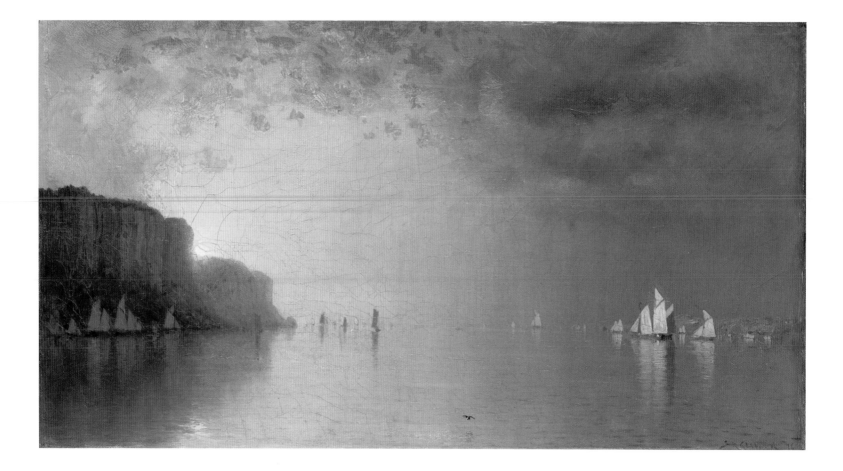

43 · *Sunset on the Hudson*, 1876

Oil on canvas, 9 × 15¹⁵⁄₁₆ in. (22.9 × 40.5 cm)

Signed and dated at lower right: S R Gifford 76

Signed on the reverse of the canvas (as noted in museum files previous to
the addition of a new canvas lining): Sunset on the Hudson / S. R. Gifford /
1876

Ex coll.: the artist in 1877; to Richard Goodman, Lenox, Massachusetts, by
1881; to Frank Cheney; to Mrs. Roger Platt, New York City, by 1958

The Ella Gallup Sumner and Mary Catlin Sumner Collection Fund, 1958.151

Gifford grew up on the Hudson River and maintained a love
for the region; he treated the subject of the Hudson River in
his work throughout his life. After returning from his second
and final trip to Europe, he demonstrated a renewed interest
in his home scenery. *Sunset on the Hudson* is one of a late
series of seven known luminous treatments of the Hudson
River Palisades at sunset that Gifford painted between 1876
and 1879, all of which were exhibited in the 1881 memorial
exhibition at The Metropolitan Museum of Art.[211] In these
related works, Gifford was mainly interested in the effects of
light and atmosphere—the opalescence of the setting sun
against sky, water, natural forms, and sailboats. A year after
painting *Sunset on the Hudson* he was quoted as saying, "The

really important matter is not the natural object itself, but the
veil or medium through which we see it."[212]

Of the series, *Sunset on the Hudson* relates most closely
to *Sunset on the Hudson, A Study* (c. 1877, unlocated) which
measures 8 by 15 in. (20.3 × 38.1 cm). However, the artist var-
ied the placement of the ships and the bird in the foreground
of each work, as well as the coloring. Both show light and
dark contrasts in the sky, but the Atheneum's painting is bril-
liant gold and pink in tone, with the sun dissolving behind the
Palisades at left and dark clouds opposing the sunset light,
whereas the painting of c. 1877 is less brilliant and has a green
tonality.[213] Most likely, both of these paintings were studies
for a larger work, *Sunset over the Palisades on the Hudson*,
painted in 1879. This last was given to the Hudson Academy,
New York City, by Gifford, and inscribed by him on the
reverse: "Presented to the Hudson Academy by S. R. Gifford
June 1879 / A sunset on the Hudson / by S. R. Gifford."[214]

Gifford

(detail)

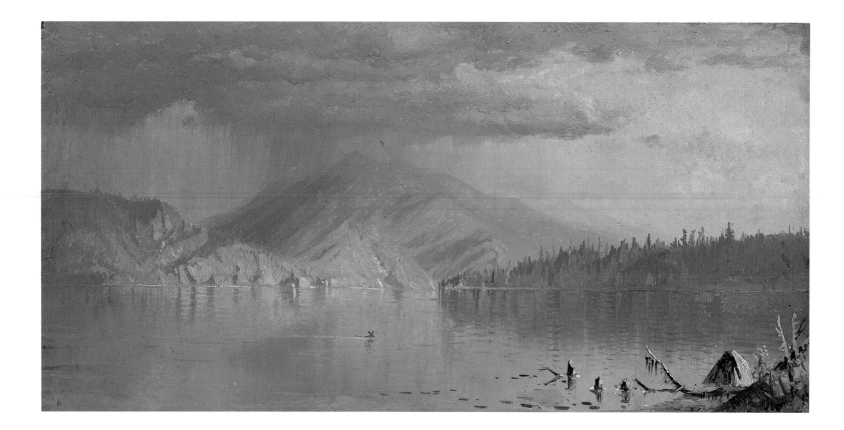

44 · *Lake Scene* (possibly *A Rainy Day on Lake Kenogamy*), c. 1878

Oil on paper attached to composition board, 8 × 16⅛ inches (20.3 × 41 cm)
Ex coll.: to Clara Hinton Gould, Santa Barbara, California, by 1948
Bequest of Clara Hinton Gould, 1948.204

Little is known about the provenance or exhibition history of this painting, a situation complicated by the fact that, when it entered the Atheneum collection as part of the bequest of the collector Clara Hinton Gould, it bore the signature of Homer Dodge Martin (1836–1897). Subsequently, it was found that the signature had been added at a later date; the signature was removed in 1969 to reveal the remains of an indecipherable original signature, apparently deliberately removed.[215] Following Martin's death in 1897, his paintings began to draw much higher prices than they had during his lifetime. A surge of fakery followed, particularly of his later, more freely painted works. In addition, William Macbeth is known to have added Martin signatures to unsigned works that were thought to be by that artist.[216]

Stylistically, this landscape bears a marked resemblance to the work of Sanford Gifford. The finely applied brush strokes, subtle tonality, and atmospheric effects, particularly the storm clouds and veil of rain passing over the lake and mountains, relate this work to Gifford's series of approaching and passing rainstorm scenes that he painted during the 1860s and 1870s (cat. 42).

A landscape that relates in size and subject as well as date to this painting is one that was exhibited at the memorial exhibition of Gifford's paintings, under the title *A Rainy Day on Lake Kenogamy* (unlocated), dated 1878. Lake Kenogamy is in Quebec, where Gifford traveled frequently in the 1870s to go salmon fishing. In the summer of 1877, he was on a fishing trip in the region, and he executed *A Rainy Day on Lake Kenogamy* the following year.[217] The subject matter of the Atheneum's painting, particularly the small antlered head of a moose swimming across the center of the lake, further suggests that this painting is the 1878 work.[218]

JAMES HAMILTON

Born 1819, Entrien, Ireland;
died 1878, San Francisco, California

James Hamilton was born near Belfast, Ireland, of Scottish parents who immigrated to Philadelphia in 1834. Encouraged by the engraver, painter, and publisher John Sartain (1807–1897), who admired his early efforts in watercolor, Hamilton pursued an artistic career in Philadelphia. He supported himself by giving drawing lessons; Thomas Moran (1837–1926) and Edward Moran (1829–1901) were among his better-known pupils. Working mainly as a marine painter, he exhibited his romantic twilight scenes, naval battles, and shipwreck paintings at the Artists Fund Society of Philadelphia in 1840 and then almost yearly from 1843 to 1869 at the Pennsylvania Academy of the Fine Arts, where he was elected a member in 1861. He also exhibited marine paintings at the National Academy of Design and the American Art-Union in New York City. During a trip to England in 1854–55, Hamilton viewed the paintings of British artists such as John Constable and J.M.W. Turner, whose influence can be seen in the artist's mature works.

In the 1840s Hamilton became well known for his work as an illustrator. He collaborated with the arctic explorer Elisha Kent Kane to produce illustrations for Kane's U.S. Expedition in Search of Sir John Franklin (1853) and the two-volume Arctic Explorations: The Second Grinnell Expedition in Search of Sir John Franklin (1856), as well as for other publications.

In 1875 Hamilton sold the contents of his studio with the intention of making a trip around the world with his family. He first traveled to California, settling in San Francisco, where he worked for two years. He died there suddenly on March 10, 1878, and was buried by the Art Association of San Francisco. Hamilton was considered the best marine painter of his time.

45 · *Evening on the Seashore,* 1867

Oil on canvas, 23⅜ × 42⅛ in. (59.4 × 107 cm)
Signed at lower left: J. Hamilton
Signed and dated on the reverse: Evening on the Seashore / Ja Hamilton /
Philada 1867 [inscription was recorded and photographed before a new
canvas lining was attached in 1976]
Ex coll.: with James S. Earle and Sons, Philadelphia, probably in 1875;
purchased by Elizabeth Hart Jarvis Colt, Hartford, probably in 1875
Bequest of Elizabeth Hart Jarvis Colt, 1905.50

Evening on the Seashore was painted in Philadelphia and
demonstrates the importance of the British Romantic painters
to Hamilton. The artist's early mentor, John Sartain, noted,
"Hamilton's style is broad and effective . . . not apt to be
overdone with non-essential detail and minute forms."[219]
Focusing on the brilliant effects of the light in the sky and
on the water, Hamilton concentrated on the fiery red sunset,
adding the romantic details of a shipwreck washed up on-
shore and a castle that looms high on the cliffs above, with
flocks of illuminated seabirds. Several ships dot the horizon.
Many of the stylistic elements in this work show the impact
of Hamilton's earlier study of the works of Turner. He may
also have been influenced by the popular success of Frederic
Church's *Twilight in the Wilderness* (1860, Cleveland
Museum of Art), an influential painting in its time, which
portrayed a spectacular sunset of vivid color.

Elizabeth Hart Jarvis Colt acquired this work for the pic-
ture gallery at her Hartford mansion, Armsmear. Colt may
have first known Hamilton's work through his illustrations:
her husband's extensive library included Elisha Kent Kane's
two-volume *Arctic Explorations* (1856), illustrated by Hamil-
ton.[220] In a nineteenth-century photograph of her gallery
(completed by 1868), *Evening on the Seashore* hangs next to
Bradford's *Coast of Labrador* (cat. 8). The purchase date is
unknown, but Colt possibly bought this work at the 1875
auction of Hamilton's paintings in Philadelphia at James
S. Earle and Sons, the catalogue for which lists "no. 49
Evening on the Seashore, with Wreck."[221] The label on
the reverse of the painting indicates that it was framed for
Mr. J. S. Earle, suggesting that this hypothesis is correct.

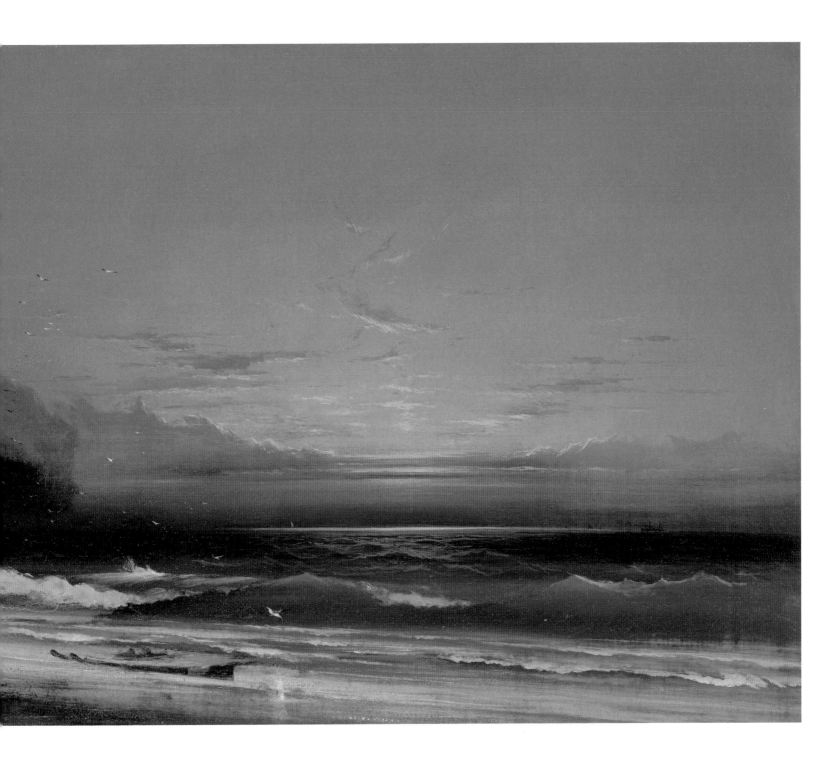

Hamilton

123

MARTIN JOHNSON HEADE

Born 1819, Lumberville, Pennsylvania;
died 1904, St. Augustine, Florida

artin Johnson Heade, like many American artists in the nineteenth century, began as a portrait painter. His early training—in the late 1830s—was with primitive painter Edward Hicks (1780–1849) in Newtown, Pennsylvania. Heade may also have studied with Hicks's cousin Thomas Hicks (1823–1890), who was also working in Newtown at that time. Thomas Hicks took a portrait of Heade at age fourteen that is now in the Bucks County Historical Society, Pennsylvania.

Heade first traveled to Europe around 1840, visiting England and France and spending two years in Italy. The trip had little impact on his art, however, which remained linear and somewhat stiff. Nevertheless, in 1841, Heade exhibited a portrait in the Pennsylvania Academy, and, two years later, another at the National Academy of Design in New York City. Heade also painted a number of genre subjects, which he exhibited in the 1840s.

After his return to the United States, Heade worked in New York City, Brooklyn, Philadelphia, Trenton (New Jersey), and Boston, and toured the Midwest, painting portraits and a few landscapes. In 1857–58 he was in Providence, Rhode Island. In 1859 Heade took a studio at the Tenth Street Studio Building in New York City, where he

painted until 1861, returning from 1866 to 1879. There, he met Frederic Church and Albert Bierstadt.

During the 1850s Heade turned from portraiture and genre to landscape and seascape. Heade's earliest marsh scenes—the subject for which he became famous—date from 1862. He created his most compelling landscapes with marshes during the 1860s, and their composition and light made him a key figure in the study of luminism.

In late 1863 Heade traveled to Brazil and began a series of pictures of hummingbirds, which he planned to publish as a book in London, a project he never completed. He returned to South America in 1866, traveling this time to Nicaragua, and again in 1870, when he visited Colombia, Panama, and, later in the year, Jamaica. In 1872 Heade went to British Columbia and in 1875 to California. Heade's paintings of orchids and hummingbirds dating from this period are thought to be his greatest.

During the 1880s Heade began painting series of still lifes. By 1883 he and Elizabeth Smith, his new wife, had moved to St. Augustine, Florida, and his paintings began to feature Floridian flowers such as magnolias and Cherokee roses in sensuous portrayals.

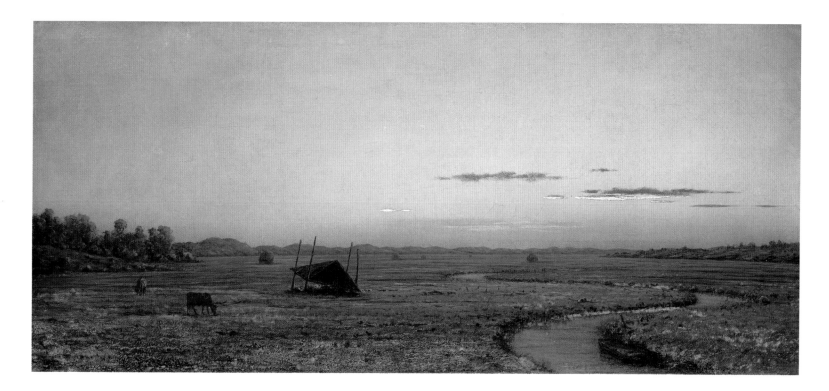

46 · *Winding River, Sunset*, c. 1863

Oil on canvas, 10³⁄₁₆ × 22³⁄₁₆ in. (25.9 × 56.4 cm)
Signed at lower left: M. J. Heade
Ex coll.: Robert G. Ingersoll, Dobbs Ferry, New York; with Victor Spark,
New York City, by 1952; purchased by the Wadsworth Atheneum in 1952
in exchange for *View of Rio de Janeiro*, formerly attributed to Heade (now in
the collection of the Saint Louis Art Museum)
The Ella Gallup Sumner and Mary Catlin Sumner Collection Fund, 1952.410

Winding River, Sunset is one of a group of small landscapes featuring meadows and marshes with haystacks painted by Heade around 1863. Others include *Sunset over the Marshes* (c. 1863, Museum of Fine Arts, Boston), *Sunset, Newburyport Meadows* (1863, Saint Louis Art Museum), *Sunrise on the Marshes* (1863, Flint Institute of Arts, Flint, Michigan), and *Salt Marshes, Newport, Rhode Island* (c. 1863, Museum of Fine Arts, Boston). Theodore E. Stebbins, Jr., has pointed out that only a few of Heade's sketches compare with extant paintings, and they date from the 1860s. Stebbins writes that "Heade worked like an abstractionist," using a limited number of sketches over and over in different compositions in different combinations, arranging and rearranging the same pieces—a haystack, a marsh landscape, a cow.²²² Heade's drawing of a *Covered Haystack* (c. 1860s, Museum of Fine Arts, Boston) is an example of a sketch that recurs in variations in several of the artist's oils, the Atheneum's *Winding River, Sunset* among them.²²³

James Jackson Jarves wrote that "[Heade's] specialty is meadows and coast-views, in wearisome horizontal lines and perspective, with a profuse supply of hay-ricks to vary the monotony of the flatness, but flooded with rich sun-glow and sense of summer warmth."²²⁴ Jarves may have been unduly harsh in his remarks, but he pointed out the interest in light and atmosphere in these paintings, an element that would become central to much of the later twentieth-century writing on Heade and this group of paintings.²²⁵

Stebbins identified the marshes in *Winding River, Sunset* as those of Newburyport, Massachusetts.²²⁶ In 1862 Heade first visited the salt marshes in Massachusetts, where the Atheneum's painting is set. This area, which stretches for miles along the coast, was a source of thatch and fodder from the early colonial period on. By the time Heade was painting the marshes, they had been divided among individual owners. Winding ditches, like the "river" in this painting, marked property lines, in addition to providing drainage for the marshes.²²⁷

47 · *Gremlin in the Studio II,* c. 1865–75

Oil on canvas, 9¼ × 13 in. (23.5 × 33 cm)
Signed at lower right: M. J. Heade
Ex coll.: George Washington Heed (brother of the artist); Samuel Heed,
his son (1871–1963); Mrs. Elsie Housley, Lumberville, Pennsylvania, his
daughter; with Christie's, New York City, December 9, 1983, sale 5472,
lot 42; with Andrew Crispo Gallery, New York City (Crispo Collection);
with Sotheby's, New York City, December 3, 1997, sale 7064, lot 90
The Dorothy Clark Archibald and Thomas L. Archibald Fund, 1997.29.1

Working in the latter half of the nineteenth century as a
member of the second generation of Hudson River School
painters, Heade distinguished himself from his predecessors
and contemporaries by being one of the first American
painters to break with the artistic theories of the picturesque.
With one hundred and twenty known marsh paintings consti-
tuting nearly one-fifth of the artist's oeuvre, Heade became
identified with the flat, anonymous marshes of New England,
just as other Hudson River School painters sought out and
are linked with the grandeur of the Catskills and spectacular
mountain vistas of the American West.[228] While Heade's
contemporaries, such as Albert Bierstadt, produced paintings
such as *In the Mountains* (cat. 5) and *In the Yosemite Valley*
(cat. 4), Heade focused his attention on marshlands primarily
in Massachusetts, Rhode Island, and Connecticut. The aes-
thetics of these marshes deny any association with the water-
falls, distant peaks, towering trees, or familiar landmarks of
other Hudson River School paintings.

Heade's departure from the standards of the Hudson
River School become increasingly complex in *Gremlin in
the Studio II,* a slightly smaller version of a similar painting,
Gremlin in the Studio I (private collection). In this painting,
Heade's marshland canvas sits on two sawhorses, with a mis-
chievous gremlin smirking beneath the painting, apparently
having pulled down on the canvas to release a stream of
water from the painted marsh. This trompe l'oeil (trick of
the eye) is a rare example of humor in American landscape
art and is a witty comment on the nature of reality and
artifice in art.

Although Heade's humorous approach may have been
unusual, the discussion was not, as many other Hudson River
School painters also dealt with concepts of artifice and reality
in their work. Thomas Cole's *Kaaterskill Falls* (cat. 22) offers
the viewer a picturesque vision of an unspoiled nature,
inhabited only by the solitary American Indian. In reality, at
the time of this painting, Native Americans had long since
been removed from the Northeast, and the Catskills in partic-
ular were overcome with white settlement and tourism, evi-
dence of which Cole entirely removes from his painting.[229]
Similarly, many of Bierstadt's paintings of the West do not
accurately depict a specific landscape or view of the Rocky
Mountains; rather, the artist composed these magnificent
panoramas from several separate observations, precisely to
heighten the effect of their grandeur.[230]

However, while the paintings of Cole and Bierstadt indi-
rectly speak to these issues of artifice and reality, Heade's
Gremlin in the Studio II is a forthright and candid comment
that directly addresses the nature of pretense and accuracy in
artistic representations. By virtue of their subject, Heade's
marsh paintings already depart from any picturesque ideal,
and the impish gremlin in *Gremlin in the Studio II* further
heightens the viewer's awareness of the painting as a repre-
sentative object, an image of nature that should not be con-
fused with nature itself.

GEORGE INNESS

Born 1825 near Newburgh, New York;
died 1894, Bridge-of-Allan, Scotland

George Inness grew up in Newark, New Jersey, where his family moved after the death of his mother, and later moved to New York City. At about age sixteen, Inness began work as a map engraver at the Manhattan firm of Sherman and Smith. As an artist, he was primarily self-taught: at fourteen he studied drawing briefly with John Jesse Barker (active 1815–1856), and when he was about eighteen he worked with Régis François Gignoux (1816–1882) for one month. By 1844 he was exhibiting regularly at the National Academy of Design and, soon after, he was selling through the American Art-Union. In 1853 he was elected an associate at the National Academy, and in 1868 he was elected an academician. In 1877 he helped found the Society of American Artists, a group that revolted against the conservative practices of the National Academy.

Inness made several trips to Europe, the first in 1847 when he traveled to London and Rome with the financial assistance of a dry-goods auctioneer, Ogden Haggerty. In Rome, Inness studied works by Salvator, Claude, and Poussin. The artist made another trip to Europe in 1851–52 with his second wife, Elizabeth Hart of New York City. The couple stayed in Paris, where Inness studied paintings by the Barbizon School. The Innesses returned to Europe again in 1870 and stayed until early 1875, spending most of their time in Rome and Paris.

In the 1870s the art collector and dealer Thomas B. Clarke became Inness's agent and patron. Clarke's support gained Inness clients as well as financial security for the remainder of his life. In 1875 Inness returned from Europe and spent a year in Boston and two in New York City, moving to Montclair, New Jersey, in 1878. Summers were spent in Nantucket, Niagara Falls, and Durham, Connecticut, among other places, and winters in Georgia and Florida. In 1891, he traveled to California. He died in Scotland in 1894.

48 · *Along the Hudson,* late 1860s

Oil on canvas, 6⅝ × 12⅛ in. (16.8 × 30.8 cm)
Signed at lower right: G Inness
Inscribed on back of stretcher: Along the Hudson . Geo. Inness. s. 4870
Ex coll.: at Plaza Auction Rooms, New York City [?], in 1942; sold to
Babcock Galleries, New York City, in 1942; purchased by Henry
Schnakenberg, New York City, in 1943
Gift of Henry Schnakenberg, 1966.308

In this small painting Inness depicted an area along the Hudson River just north of Yonkers that once had been rural farmland but was increasingly becoming the province of the new leisure class produced by the manufacturing economy. The painting shows a view to the south of Hastings-on-Hudson; through the hazy sunshine and across the Hudson, the Palisades can be seen.[231] It dates from the period in which Inness was still working in a Hudson River School style and was most likely a study painted on the spot.[232]

Unlike many other artists who painted this area during this period, Inness did not include well-dressed figures in the foreground to indicate the changes that society was experiencing.[233] He did, however, include the trappings of this class. At the left center of the composition is Greystone Mansion, designed by John Davis Hatch and built for nearly half a million dollars by John T. Waring, a Yonkers hat manufacturer, sometime around 1864. At the extreme left is the Cochran mansion, called Duncraggan, which was owned by the Yonkers carpet manufacturer William F. Cochran.[234]

DAVID JOHNSON

Born 1827, New York City;
died 1908, Walden, New York

THE METROPOLITAN MUSEUM OF ART

One of the second generation of Hudson River School artists, David Johnson traversed much of the same ground as did the first generation, sketching and painting in places such as the Hudson River valley, the Catskills, the Adirondacks, and Lake George, as well as the Genesee region of New York. He also worked in the White Mountains, where the Atheneum's painting is set (cat. 49), as well as in Connecticut and northern New Jersey.

Johnson may have studied at the Antique School at the National Academy of Design in New York City from 1845 to 1846, and briefly with Jasper F. Cropsey in 1850. He was probably somewhat influenced by his older brother, the portrait painter Joseph Hoffman Johnson (1821–1890). David Johnson painted a number of skillful portraits himself, but most of those now known are after photographs or paintings by others. John I. H. Baur has suggested that Johnson's career began in 1849, the date of Haines Fall, Kauterskill Clove (private collection). That same year, Johnson exhibited for the first time at the National Academy and the American Art-Union.

Most of the paintings from the early part of Johnson's career are panoramic landscapes or detailed studies of rocks in forest interiors, and they compare with work by Asher B. Durand and artists associated with the American Pre-Raphaelite movement. Johnson's middle period consists of paintings closer to the luminist works of John F. Kensett, while his later art is inspired by the Barbizon School. There is no concrete evidence that Johnson ever traveled to Europe, but he was familiar with the work of the French Barbizon artists and particularly admired the art of Corot.

Johnson was one of the founders of the Artist's Fund Society in 1859, and in 1861 he was elected an academician of the National Academy. He lived for most of his life in New York City and for many years had a studio at the YMCA building there.

49 · *Study, Franconia Mountains from West Campton, New Hampshire*, c. 1861–63

Oil on canvas, 14⅝ × 26⅛ in. (37.1 × 66.4 cm)
Signed (monogram) at lower right: DJ
Inscribed on back: Study, Franconia Mountains / From West Campton,
N. H. / *D. Johnson*
Ex coll.: the artist to 1890; sold at a sale of the artist's works, Ortgies
and Co., New York City, 1890; purchased by Clara Hinton Gould,
Santa Barbara, California, by 1948
Bequest of Clara Hinton Gould, 1948.187

Johnson made his first visit to the White Mountains in 1851, traveling to North Conway, New Hampshire, with a number of artists, including John William Casilear and Benjamin Champney (1817–1907).[235] On one of many return trips to the region, Johnson painted this highly detailed view of the Franconia Mountains looking north from West Campton, along the Pemigewasset River to Mount Lafayette, the tallest mountain in the Franconia range, seen in the far distance.[236] The view is panoramic, seen from a privileged height over the landscape below.

This topographical study features a distinctly outlined cleft in the mountaintop just to the right of center in the

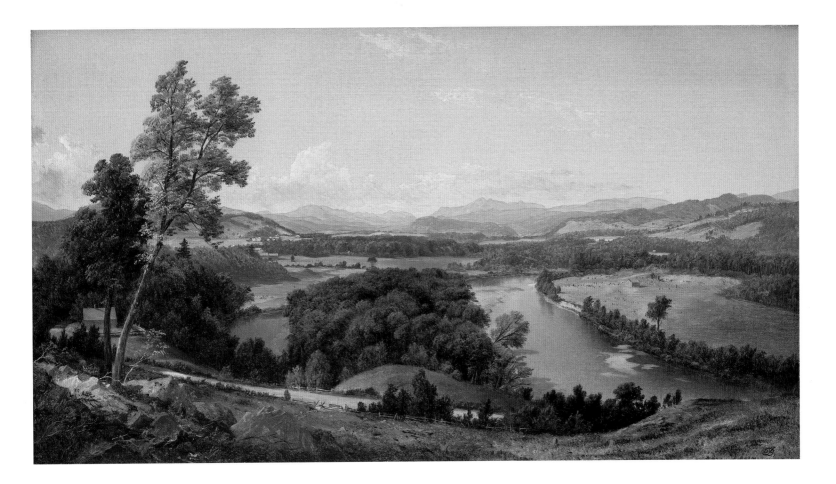

distance; a cleared field with tree stumps is visible in the right middle ground.[237] A forested hill in the center of the composition balances the view and links the fore- and backgrounds, while the tall tree at the left—probably taken from his sketchbook inventory—and the river draw the viewer into the painting from either side of the canvas.[238] The rock studies at the left foreground of the composition are typical of the artist, who, like Asher B. Durand, painted rocks with particular attention throughout his career and often devoted entire canvases to their treatment.[239]

The artist employed feathery brushwork in a small scale to give a delicate quality to his landscape.[240] Divergent from some of his own, earlier work, Johnson avoids the hyperrealistic delineation of form and the high-keyed color that would become characteristic of many other artists sometimes linked with the American Pre-Raphaelite School.[241] The vivid blue of the river at the middle right, however, is in keeping with not only the Pre-Raphaelite palette, but also that of the White Mountain School.

Johnson

JOHN F. KENSETT

Born 1816, Cheshire, Connecticut;
died 1872, New York City

A member of the second generation of the Hudson River School, John Frederick Kensett was one of the most popular American landscape painters of the Civil War era. He began his career as an engraver, training under his father, Thomas, and his uncle, Alfred Daggett, and later working in print shops in New York City, New Haven (Connecticut), and Albany. Anxious to develop a career in the fine arts, Kensett turned his attention to landscape painting. In 1838 he joined John Casilear, Asher B. Durand, and Thomas P. Rossiter (1818–1871) on an extended tour of Europe that lasted until 1847. He lived and worked in England and Paris and toured the Rhine region, Switzerland, and Italy.

Kensett enjoyed a long and prolific career, showing paintings in the major exhibitions of his day and holding numerous positions of leadership in art organizations. On his return to New York in 1847, he exhibited several landscapes at the National Academy of Design and the American Art-Union. He was elected an associate of the National Academy of Design in 1848 and in the following year was made an academician and was also elected to the Century Association. In addition, he was a member of the United States Capital Art Commission in 1859, a principal organizer of the Metropolitan Sanitary Fair held in New York in 1864, and, in 1870, a founder and president of the Artist's Fund Society as well as one of the founders of the Metropolitan Museum.

Kensett spent his summers sketching in the White Mountains of New Hampshire, in the Adirondack Mountains, and on the New England coast, particularly in Newport, Rhode Island, and Beverly, Massachusetts. In winter he returned to his Washington Square studio, Waverly House, which he shared with fellow artist Louis Lang (1814–1893). Kensett made additional trips to Europe in 1856 and 1867, traveled to the Mississippi River in 1854 and 1868, and visited the American West, including Missouri and Montana in 1857 and the Rocky Mountains in 1870. His best works, however, were depictions of the picturesque yet unspectacular scenery closest to home, in New York and along the New England coast.

In the final year of the artist's life, he painted thirty-eight or thirty-nine paintings that he presented as a gift to The Metropolitan Museum of Art in 1874. Called "Last Summer's Work," the paintings were executed in the summer of 1872, when he lived on Contentment Island, off Darien, Connecticut (with brief periods in Newport, Rhode Island, and Lake George in New York). The style for which the artist is most admired is evident in many of his later works; it consists of an asymmetrical, reductive composition, a subdued tonal palette, and an emphasis on the effects of light and atmosphere.

Kensett died of heart failure in New York City at the age of fifty-six.

50 · *Niagara Falls*, 1855

Oil on canvas, 45 × 32 in. (114.3 × 81.3 cm)
Initialed and dated at lower right: J F [in monogram] K / 55
Ex coll.: Antoinette Eno Wood, Simsbury, Connecticut, and Washington, D.C.; bequeathed by Wood to the Abigail Phelps Chapter, Daughters of the American Revolution, and the Town of Simsbury, Connecticut, by 1931
The Dorothy Clark Archibald and Thomas L. Archibald Fund, 2002.4.1

Kensett traveled three times to Niagara Falls in the mid-nineteenth century, first in August 1851, again in 1852, and finally in the autumn of 1857. Repeatedly drawn to the details of nature in water, rocks, trees, light, and sky, Kensett found

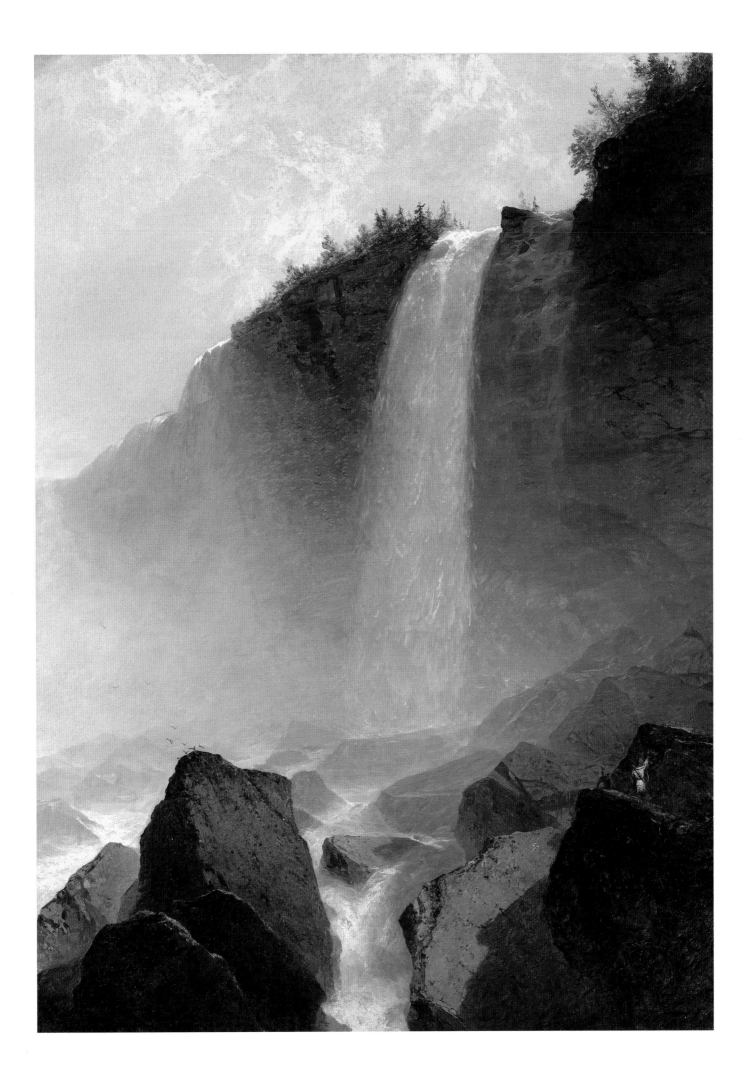

Niagara to be an ideal subject, and he examined the juxtaposition of these natural elements in several paintings of the falls completed in the early 1850s, including *Niagara Falls* (1851, Mead Art Museum, Amherst College).[242] In that painting Kensett strays from the standard depiction of the falls, as he positions them in the distant background, focusing the viewer's attention on the jagged rocks and choppy water in the foreground rather than on the majesty of the falls themselves.

Similarly, Kensett's approach to Niagara Falls in the Wadsworth's 1855 painting differs in composition and format from other renderings by Hudson River School artists, who often adopted a sweeping horizontal view of the falls, as in Frederic Church's 1856 *Niagara Falls* (cat. 16) and Alvan Fisher's 1823 *Niagara Falls* (cat. 41). In Kensett's 1855 *Niagara Falls*, he focuses on Luna Fall, a narrow sheet of water created by Luna Island on the American side of the falls.[243] In addition to singling out this specific site, which provides a less dramatic view than what was characteristic of other Niagara paintings of this period, Kensett also abandons the conventional horizontal canvas in favor of a vertical format.

Despite this departure from the standard viewpoint, Kensett still approaches the falls with the same romantic and idealized vision common among the Hudson River School artists. The presence of Native Americans in the lower right corner reinforces the theme of the falls as primeval, unspoiled wilderness, an idea and representation that hearkens back to Thomas Cole's 1826 *Kaaterskill Falls* (cat. 22) or Jacob Ward's c. 1833 *Wolf in the Glen* (cat. 55). As in his 1851 painting of the falls, Kensett delights in drawing attention to the rocks, including "The Rock of Ages" (seen in the lower left below the seagulls). These rocks could be reached only by descending the Biddle Staircase constructed down the side of the cliff below Goat Island, thereby further heightening the drama of the scene.[244]

The painting's early history remains unclear, although it is known that Antoinette Eno Wood came from a family with close personal ties to James Pinchot, a noted collector of Hudson River School paintings.[245]

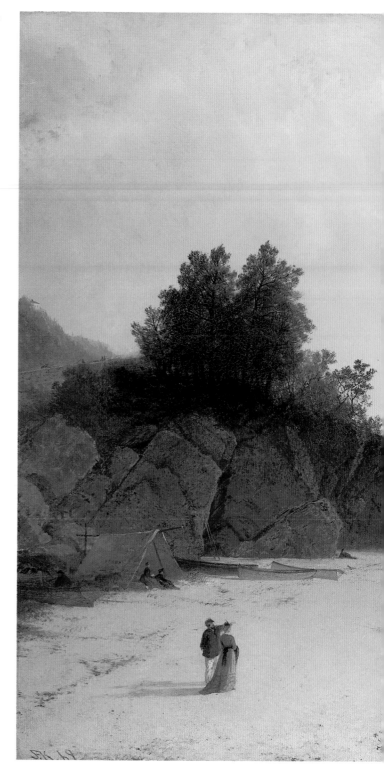

51 · *Coast Scene with Figures (Beverly Shore)*, 1869

Oil on canvas, 36 × 60⅜ in. (91.4 × 153.4 cm)
Signed (monogram) and dated at lower right: JF. K. '69
Ex coll.: purchased from the artist by Daniel Willis James, New York City, in 1869; to his son, Arthur Curtiss James, New York City, in 1907, to 1941; with A. F. Mondschein, New York City, by 1942
The Ella Gallup Sumner and Mary Catlin Sumner Collection Fund, 1942.375

Kensett was one of the most popular American landscape painters of the Civil War era. He distinguished himself by depicting the northeastern seashore, with an emphasis on the shoreline's rocks and sand. The artist focused his attention on the major tourist areas in New England, painting a series of coastal views of Newport, Rhode Island, as well as numerous sites along the northern shore of Massachusetts, particularly the Beverly coast. Kensett concentrated on views of Beverly, of which over thirty-five paintings, executed between 1859 and 1872, are known.[246] *Coast Scene with Figures (Beverly Shore)* is the largest and among the finest of the series.

Located about twenty-five miles north of Boston, Beverly attracted a number of leading figures in the arts and society in the mid-nineteenth century. During his many sketching trips

to Beverly, Kensett was attracted to the "broad, curving beaches, calm inlets, jagged promontories, and the views from forested hillsides and rocky eminences to the ocean"; he relied on his careful observations of the water, shore, and sky to create his paintings.[247]

In *Coast Scene with Figures (Beverly Shore)*, the specific site has been identified as a rocky projection on Mingo Beach, the site most frequently painted by Kensett in Beverly.[248] In some of his paintings of this subject he depicts the rocky promontory faithfully.[249] In other such works, however, such as the Atheneum's painting and a closely related work, *On the Coast, Beverly Shore, Massachusetts* (18¼ × 30 in. [46.4 × 76.2 cm]) (1865–70, Amon Carter Museum, Fort Worth, Texas), the artist removed the large boulder located at the end of the rocky projection and opened up the composition at the right with vast areas of sea and sky.

The Atheneum's painting is remarkable for its size, the reduction of compositional elements, and its heroic theme: the confrontation between human and nature. The sheer size of the canvas and the exaggerated scale of the shore, sky, and giant breakers about to crash on the beach add to the drama of the scene witnessed by the man and woman who stand on the shore facing the vastness before them. In the 1860s Kensett perfected a compositional technique in which he achieved the harmonious balance of two large masses—land and the body of water—with a large portion of the canvas devoted to the sky. The low horizon dotted with sailboats and a ship trailing a long line of smoke provides a dramatic sense of distance. On the beach, in addition to the two standing figures, are a tent that shields two seated women, a man in a dory near the tent, and a reclining figure near one of the boulders that make up the rocky projection. To the left of the boulders, covered with foliage, is a ledge, with several houses dotting the hillside above. Despite the giant breakers, the scene is permeated with a benign quietude.

To accentuate the peacefulness of the scene, the artist used soft tones with thinly painted, nearly imperceptible brush strokes for water and sky. The brilliant light, which casts long shadows, contrasts with the darkly and thickly painted boulders and foliage. Kensett's technical finesse is seen in such passages as the changing surface of the beach, where he varied his brush strokes from smooth, thinly painted areas of sand, to a stippled effect to convey the rough areas of sand disturbed by the breakers. The artist's compositional simplicity and sensitive treatment of atmospheric effects became the hallmark of his mature work.

Works such as this have been associated with what some art historians have defined as a distinct movement called "luminism," a term that first came into use in the middle of the twentieth century.[250] Certain landscapes by Kensett and by other key luminists, among them Fitz Hugh Lane (1804–1865), Martin Johnson Heade, and Sanford Gifford, are characterized by clarity and tranquility, and by a preoccupation with effects of light and atmosphere.

JOHN TRUMBULL

Born 1756, Lebanon, Connecticut;
died 1843, New York City

John Trumbull's career was distinguished by his lifelong political and artistic patriotism that led to his celebrated and iconic depictions of the Revolutionary War. Trumbull was a member of a well-to-do and politically prominent Connecticut family—his father was governor of Connecticut. At the age of five, he lost the sight in his left eye after a fall. He received his early education at Nathan Tisdale's school in Lebanon and, at his father's insistence, was sent to Harvard College. In spite of his father's disapproval, after graduating in 1773 Trumbull decided to pursue an artistic career and moved to Boston, where he painted portraits of family members and scenes from ancient history. The American War of Independence interrupted his plans, however, and Trumbull "caught the growing enthusiasm" of the Revolution in Boston, serving as second aide-de-camp to General Washington and later as colonel under General Horatio Gates.[251]

In 1777 Trumbull resigned his commission and resumed his artistic career. Determined to further his artistic training in England, he traveled to London in 1780, with the additional purpose of carrying out a family financial project. For a time he studied with Benjamin West (1738–1820) in his studio, but, failing to conceal his anti-British sentiments, he was arrested as a spy in November of that year, imprisoned for eight months, and eventually returned home. He returned to London in 1784, however, to continue his study with West and to pursue his ambition of creating a heroic record of the key events in the American War of Independence, paintings that could then be engraved for profit.

An able painter of portrait miniatures, Trumbull traveled in England and France (returning to the United States in 1789), taking likenesses in miniature of the principal partici-

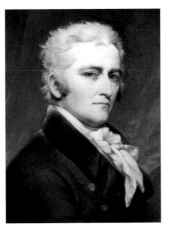

pants in the war. These oil portraits were then incorporated into his historic scenes. In the United States, Trumbull spent time in Connecticut painting landscapes and portraits. He fell in love with Harriet Wadsworth, but she died suddenly in 1793, and he lapsed into a deep depression. This tragedy, combined with the growing discord caused by the war between Great Britain and France, caused Trumbull to temporarily abandon his work on the American history series.

In 1794 Trumbull accepted an offer from Chief Justice John Jay to serve as his secretary on the Jay Treaty Commission in London. Though he had embarked on a diplomatic career, by 1800 he had resumed painting; that same year, he married an Englishwoman, Sarah Hope Harvey. The couple returned to the United States in 1804, where Trumbull regained his position as a leading artistic figure, opening a studio in New York City and being elected a director of the New York Academy of the Fine Arts (later renamed American Academy of the Fine Arts) in 1805. Four years later, he returned to London, where he was forced to remain until 1815 because of the economic depression caused by the War of 1812.

Trumbull finally achieved his principal goal in 1817 when Congress commissioned him to decorate the rotunda of the United States Capitol with four of his Revolutionary War scenes. In the same year he was elected the director of the American Academy of the Fine Arts and remained director for the next nineteen years.

In 1831 Trumbull sold most of his remaining works to Yale College for an art gallery affiliated with the college, the first of its kind in the country. In 1841 he published his autobiography, the first by an American artist. He died two years later and, as he had requested, was buried next to his wife in the Trumbull Gallery in New Haven.

Trumbull

52 · *Niagara Falls from an Upper Bank on the British Side,* 1807

Oil on canvas, 24⅜ × 36⅝ in. (61.9 × 93 cm)
Ex coll.: the artist to 1825; consigned by the artist to Joseph Trumbull,
Hartford, in 1825; purchased from the artist by Daniel Wadsworth,
Hartford, in 1828
Bequest of Daniel Wadsworth, 1848.4

53 · *Niagara Falls from Below the Great Cascade on the British Side,* 1808

Oil on canvas, 24⁷⁄₁₆ × 36⅜ in. (62.1 × 92.4 cm)
Ex coll.: the artist to 1825; consigned by the artist to Joseph Trumbull,
Hartford, in 1825; purchased from the artist by Daniel Wadsworth,
Hartford, in 1828
Bequest of Daniel Wadsworth, 1848.5

In August 1807 John Trumbull traveled with his wife to Niagara Falls, where he spent a week on the Canadian side. He returned to the falls in mid-September 1808. Drawings from both trips are preserved in one of the artist's sketchbooks.[252] Following the earlier example of John Vanderlyn, Trumbull intended to sell his finished views of the falls on the British art market. On November 11, 1808, he wrote to his English friend and banker Samuel Williams of his plan to visit London: "I shall also bring with me two panorama Views of the falls of Niagara, Surrounding Objects—The Scene is magnificent & novel.—I have copied it with all the fidelity

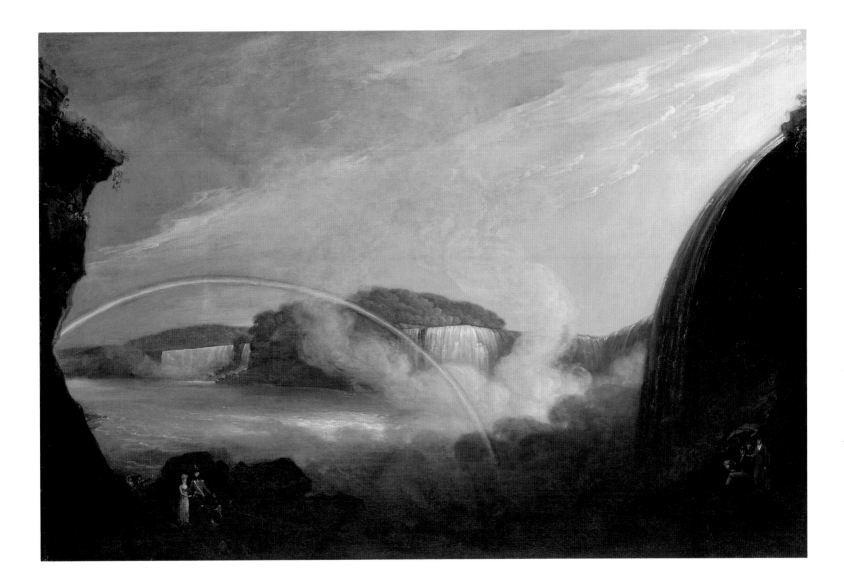

in my power, and am not without hope that it will at once excite and in some measure gratify the public curiosity.—I will thank you to mention to . . . some of your opulent friends who have a taste for the fine arts, that I have prepared such views and that they will soon be in London."[253]

In his "Account of the articles & packages to be taken with us to London," Trumbull listed "Niagara Falls," as well as "Two panorama Sketches of Niagara Falls by self."[254] The two panoramic views are thought to be the Wadsworth pair; however, the reference may also be to a second pair of sweeping panoramas, *Niagara Falls from Two Miles Below*

Chippawa and *Niagara Falls from Under Table Rock* (The New-York Historical Society), executed by Trumbull in 1808.[255]

Trumbull intended the Wadsworth Niagara paintings to function as a pair. *Niagara Falls from an Upper Bank on the British Side* is based on a pencil sketch executed during the artist's first trip in 1807.[256] The elevated view overlooks Horseshoe Falls, the panoramic vista condensed into a conventional composition. Following the precepts of the picturesque as advocated by William Gilpin and others, Trumbull framed the scene with trees and arranged it into three receding planes.[257] In the left foreground, a British soldier escorts two

Trumbull

female companions, while to the right an artist sketches under some trees. Beyond this civilized scene are the falls, with distant hills and sky in the background.

The companion painting, *Niagara Falls from Below the Great Cascade on the British Side,* is based on a pencil drawing dated September 13, 1808, at 3 P.M. (Beinecke Rare Book and Manuscript Library, Yale University, New Haven).[258] While the view from above was intended to be picturesquely beautiful, this scene is meant to convey the picturesque sublime, evoking a more immediate sensation of the scale and power of the falls. The cascade of water with its spray of mist at right, a rainbow, and a dramatic sky at sunset combine to represent the forces of nature. As if to mitigate the power of the

scene, Trumbull also included a self-portrait at right, underneath Table Rock, where he is seen sketching, accompanied by his wife and a manservant who holds an umbrella over the figures to shield them from the spray. The figures appear to be unmoved by the grandeur of the falls above them. To the left, British soldiers, one accompanied by a woman, stroll along the rocky foreground.

Trumbull failed to sell his Niagara paintings in England. He later exhibited the Wadsworth pair at the American Academy of the Fine Arts in 1824, and they were eventually purchased in 1828 for four hundred dollars by his nephew-in-law, the Hartford art patron Daniel Wadsworth, who added them to his growing art collection.[259]

JOHN VANDERLYN

Born 1775, Kingston, New York;
died 1852, Kingston, New York

An adherent of history painting's lofty ideals, John Vanderlyn belonged to the generation of American painters who reached artistic maturity in Europe. He distinguished himself by becoming the first artist to undertake formal training in the atelier of an academic teacher in Paris, where he mastered the French neoclassical style.

The grandson of the patroon painter Pieter Vanderlyn (1687–1778), John Vanderlyn demonstrated an early interest in art. By 1792 he found employment with Thomas Barrow, a print seller in New York City, enabling him to attend the drawing school of Archibald Robertson (1765–1835). In 1794 Gilbert Stuart (1755–1828) gave Vanderlyn permission to copy his recent portraits, and when Vanderlyn faithfully copied Stuart's portrait of Aaron Burr, he gained the subject's admiration. Burr became Vanderlyn's friend and patron. After subsidizing about ten months of study with Stuart, in 1796 Burr sent Vanderlyn to study in Paris, where the young artist received instruction under François-André Vincent and absorbed the neoclassical style of Jacques-Louis David.

Vanderlyn returned to America in 1801, remaining there until 1803, when the newly formed New York Academy of the Fine Arts commissioned him to purchase casts of famous ancient sculptures and copies of Old Master paintings. He returned to Europe to procure these objects as well as to find an engraver for two paintings he had made of Niagara Falls. Although he traveled to England, Switzerland, and Italy, where he stayed from 1805 to 1807, Vanderlyn spent most of this trip in Paris. He achieved unprecedented recognition and encouragement from the French, exhibiting several works at the Paris Salon, including The Murder of Jane McCrea (cat. 54) in 1804 and Caius Marius amid the Ruins of Carthage (1807, M. H. de Young Memorial Museum, San Francisco), the latter earning him a gold medal in 1808.

Before returning to the United States in 1815, he took sketches of Versailles in preparation for a panorama of this subject and also painted Ariadne Asleep on the Island of Naxos (1812–14, Pennsylvania Academy of the Fine Arts, Philadelphia), both entrepreneurial ventures intended for presentation in America. His effort to promote his reputation through an exhibition of these works—for which he charged admission—proved a financial failure, however. Disappointed by his American audience's lack of appreciation for his attempts to introduce them to high art, he resorted to painting portraits and exhibiting his huge panoramas of Versailles and Niagara Falls. In 1837 he secured a commission from the United States Congress to paint The Landing of Columbus for the Capitol rotunda in Washington, D.C., but despite this prestigious honor, Vanderlyn died embittered and poor.

54 · *The Murder of Jane McCrea*, 1804

Oil on canvas, 32½ × 26½ in. (82.6 × 67.3 cm)

Signed and dated on back of original canvas (as seen through a canvas lining with the aid of an infrared viewer): J. Vanderlyn . Faciebat / 1804 Paris

Ex coll.: the artist, Paris; purchased by Robert Fulton for the American Academy of the Fine Arts, New York City, possibly in 1805; in the collection of the American Academy of the Fine Arts, New York City, to 1842; purchased by Alfred Smith on behalf of Daniel Wadsworth and the original subscribers of the Wadsworth Atheneum, Hartford, in 1842; leased by the subscribers to the Atheneum from 1842 to 1855

Purchased by the Wadsworth Atheneum, 1855.4

During his first residency in Paris beginning in 1796, John Vanderlyn distinguished himself as the first American painter successfully to have submitted paintings to the Paris Salon of 1800. He returned to Paris in May 1803, and in 1804 he again successfully submitted a painting to the Salon, this one titled *A Young Woman Slaughtered by Two Savages in the Service of the English During the American War,* now called *The Murder of Jane McCrea.* This was the artist's first history painting.[260]

Vanderlyn began this painting in response to a commission from the artist-inventor Robert Fulton (1765–1815) for the poet Joel Barlow (1754–1812) to illustrate an episode from Barlow's epic poem *The Columbiad* (1807), which celebrated America's rejection of British authority and rule during the Revolution.[261] In 1802 Barlow had engaged his friend Fulton to select and illustrate the poem with eleven sketches. Pleased with Fulton's illustrated "The Murder of Lucinda" (now unlocated), he was surprised when he heard that Fulton had asked Vanderlyn to render the final composition.[262]

In recounting the Battle of Saratoga in his poem, Barlow described the death of Lucinda at the hands of North American Indians, basing the episode on a narrative of the actual murder of Jane McCrea of New Jersey. This well-known event occurred on July 27, 1777, and the details remain unclear. The young woman was traveling across the New York frontier under the protection of an Indian escort to rendezvous with her fiancé, an officer in General John Burgoyne's army. The group was attacked, and Jane McCrea was brutally murdered by two American Indians (Barlow's poem identifies them as Mohawks, but they may have been Ottawas from Canada), who claimed bounty for her scalp from the British. Despite the victim's Tory leanings, her murder set off a wave of sympathy that upset the alliances of the British and the Native Americans. The story immediately gained popularity

in America and France for its anti-British overtones. As early as 1784 it was published in France as a novelette titled *Miss McCrea, Roman Historique,* written by Michel René Hilliard d'Auberteuil. Certain facts were altered by tellers of the tale to promote the idea that such degradations were evidence of a systematic use of atrocities by the British against Continental sympathizers.[263]

Vanderlyn used gender and ethnicity—a fair-haired white woman (representing good) assaulted by savage American Indians (representing evil)—to convey his message of propaganda.[264] The victim kneels between the two assailants, her torn dress exposing her right breast. One attacker holds his gleaming tomahawk ready to strike, while the other, his mouth stretched in what Barlow called a "demon grin," pulls her head back by the hair. Vanderlyn reinforced the anti-British theme by portraying McCrea's fiancé—seen in the distance running to save the young woman—dressed not in the red uniform of the British but rather in the blue coat of the Continental army. Otherwise, however, he strove for historical accuracy, especially in his depiction of the American Indians' clothing and physiognomy, of which he was knowledgeable.

The subject of the murder of a virtuous maiden by savages, the struggle between light and dark, good and evil, was a theme with a distinguished history in art. Vanderlyn's composition of three friezelike figures sharply delineated against a dark background has been associated with a variety of sources ranging from ancient sculpture to French neoclassical painting.[265] Vanderlyn consulted the wall paintings at Herculaneum, which he had studied and traced, as well as a variety of classical sources for his stagelike setting. He was also influenced by contemporary French painters. For example, the figure of Jane McCrea, white hand outstretched in a futile

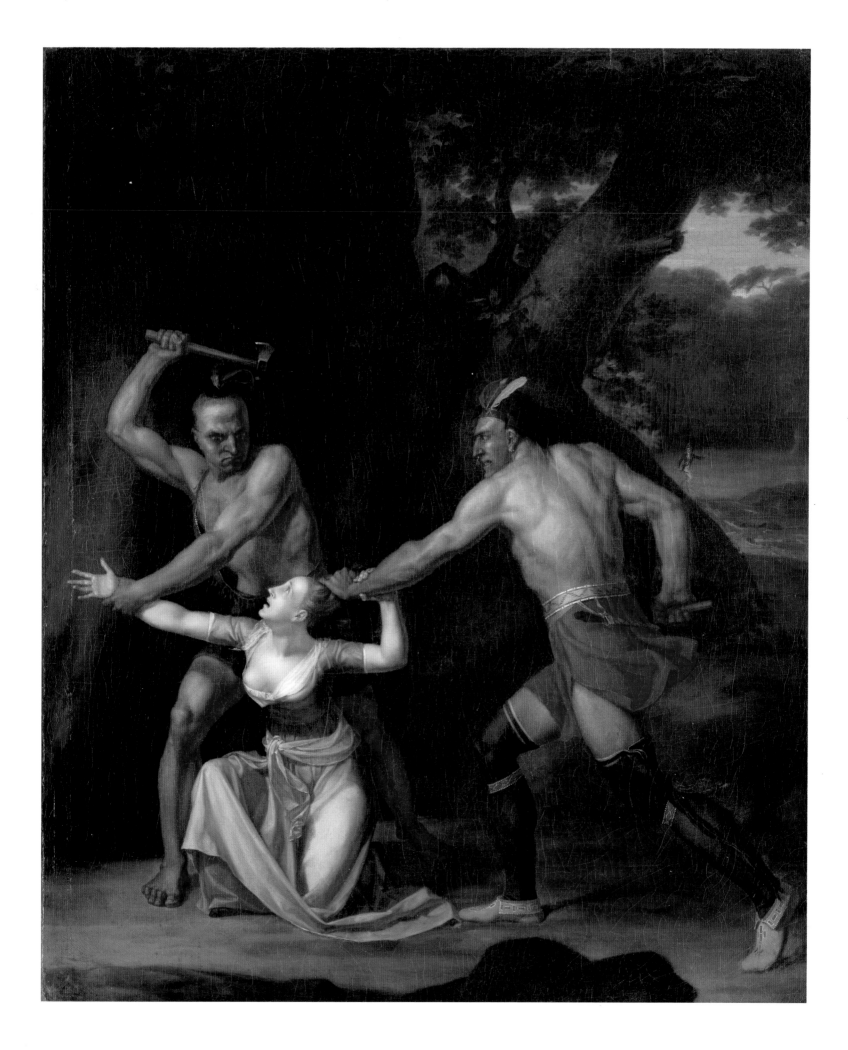

gesture, can be compared to that of the anguished mother in *The Lictors Bring Back to Brutus the Bodies of His Sons* by David (1789, Wadsworth Atheneum), and *The Sabines* (1781, Musée du Louvre, Paris), painted by his teacher, Vincent, served as inspiration for his American Indians.

Although Barlow's original commission required only a finished drawing, Vanderlyn's enthusiasm for the subject and his aspirations as a history painter prompted him to produce an exhibition piece that took a great deal more time than Barlow had planned. After the picture's exhibition in Paris, Bar-

low asked that it be sent to New York. Vanderlyn demanded more money, requesting that he be paid 1,072 livres—a price that included the cost of a gilt frame—688 more than originally established. When Barlow resisted paying the higher price, Robert Fulton intervened and bought the painting, probably in 1805, presenting it to the American Academy of the Fine Arts in New York.[266] The work was listed in the Academy's 1815 inventory and was frequently exhibited until the collection was sold to the subscribers of the Wadsworth Atheneum in 1842.[267]

JACOB C. WARD

Born 1809, Bloomfield, New Jersey;
died 1891, Bloomfield, New Jersey

A landscapist, illustrator, and pioneer daguerreotypist, Jacob C. Ward was the son of Caleb Ward, a businessman and purportedly an artist, and the brother of Charles Caleb Ward (1831–1896), who was also an artist. Although little is known of Jacob's early artistic training, he began exhibiting landscapes at the National Academy of Design in 1829, a practice he continued until 1852. He also had landscapes in exhibitions from 1833 to 1841 at the American Academy of the Fine Arts, where he served on the board of directors, and at the American Art-Union in 1849; his works received several favorable reviews (see, for example, the July 1833 and July 1835 issues of American Monthly Magazine*). Ward's* Natural Bridge *(c. 1834, Nelson-Atkins Museum of Art, Kansas City), shown in 1835 at the American Academy of the Fine Arts, is thought to be the earliest original oil depiction of this site by an American artist, and it served as the basis for a lithograph by William James Bennett (1787–1844).*[268]

During the 1830s Ward drew illustrations for the medical texts of Dr. David Hosack, a professor at Columbia College. In about 1836 he traveled west with a friend who had inherited property in Iowa. The party made it as far as the headwaters of the Mississippi, and Ward made portrait sketches of American Indians during the trip. The excursion eventually yielded several paintings; among the most successful was Soaking Mountain on the Upper Mississippi, *which was reproduced in the February 16, 1839, edition of the* New-York Mirror. *Not long afterward, John Trumbull recommended Ward for the position of draftsman on an expedition, headed by Charles Wilkes, that was to sail around the world from 1838 to 1842. Ward was forced to decline the offer for personal reasons, but in 1845 he did travel by steamer to South America to join his brother Charles, who was already in Chile. For the next few years the Wards conducted a daguerreotype business throughout South America, and Jacob sketched scenery in Chile, Peru, and Bolivia. After his return in 1848, he painted a number of works based on his travels, and he exhibited them at the National Academy of Design in 1849.*

Ward's address was listed as London in the 1852 exhibition catalogue for the National Academy of Design. He spent his later years in Bloomfield, New Jersey.

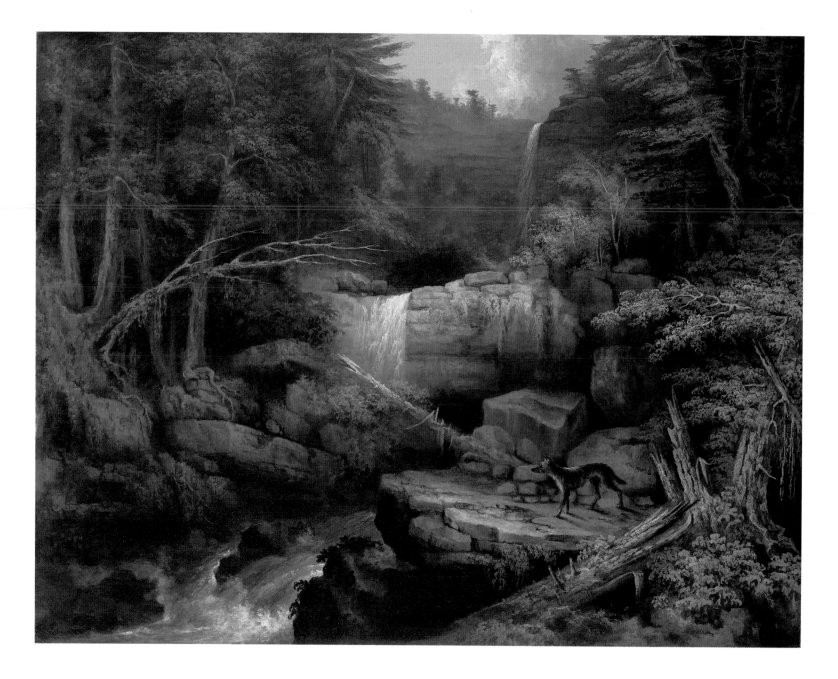

55 · *Wolf in the Glen (Cattskill Falls)*, c. 1833

Oil on canvas, 28½ × 36⅜ in. (71.4 × 92.4 cm)
Ex coll.: Benjamin Silliman, Jr., New Haven, possibly in 1844; to his
daughter Mabel McClellan Silliman (Mrs. Robert Kelly), Hastings, New
York, and Superior, Wisconsin, about 1885; to her daughter Mabel Kelly
(Mrs. Phillip Stratton), New York City, in 1923
Gift of Mrs. Phillip G. Stratton, 1956.152

Working as a contemporary of Thomas Cole, Ward pro-
duced *Wolf in the Glen (Cattskill Falls)* in the wake of a
series of paintings completed by Cole of the same site
between 1825 and 1826. Ward's depiction of the popular
Hudson River attraction closely resembles Cole's *Falls of
the Kaaterskills* (1827, private collection), both of which
adopt a horizontal composition and a vantage point of the

falls as seen from below. Cole's early success encouraged
other artists to paint the falls. However, although Ward took
a similar perspective and subject, subtle stylistic elements
differentiate this painting from Cole's. Unlike Cole, Ward
included a bright patch of blue sky that illuminates the falls,
which are also rendered with more detail than Cole used.
Further, the broadly painted foliage and lack of dramatic

lighting in *Wolf in the Glen (Cattskill Falls)* differ from Cole's early technique, and in place of Cole's single Native American figure Ward includes an awkwardly depicted wolf on the rocky ledge in the lower right. Both the American Indian and the wolf serve a similar purpose, however, common in many Hudson River School paintings; they are sole witnesses to the purity of the wilderness scene.

Despite these subtle differences, the Atheneum's *Wolf in the Glen (Cattskill Falls)* was itself originally thought to be a work by Cole.[269] It is documented as a Ward, however, in a review (first discovered by Howard Merritt) that appeared on the occasion of its exhibition at the American Academy of the Fine Arts in New York in 1833: "A lovely picture— If there be any fault, it is the brilliant light in the sky, which interferes with the principal gleam upon the pitch of the falls. Mr. Ward should pay a little more attention to his animals— no details, however small, are beneath the notice of an artist;

and the wolf at the edge of the basin is by no means so good as it might be."[270]

One of Daniel Wadsworth's closest friends, Benjamin Silliman, Jr., was the original owner of *Wolf in the Glen (Cattskill Falls)* and may have acquired it in 1844. That year Silliman wrote to Alfred Smith (Daniel Wadsworth's lawyer), agreeing to send some prints by the Italian artist Giovanni Volpato (1733–1803) as part of an exchange: "I omitted to say that I shall very gladly relinquish to you two of the Volpato's which I have, as it suits me remarkably well to do so, as so much toward payment for the Catskill fall picture which I purchased."[271] The "Catskill fall picture" mentioned in this letter was traditionally thought to have referred to Thomas Cole's *Caaterskill Upper Fall, Catskill Mountains,* which belonged to the estate of John Trumbull, for which Silliman was an executor in 1844. However, the letter more likely referred to Ward's *Wolf in the Glen.*

(detail)

Ward

WORTHINGTON WHITTREDGE

Born 1820 near Springfield, Ohio;
died 1910, Summit, New Jersey

ARCHIVES OF AMERICAN ART

The youngest son of a Massachusetts sea-captain-turned-Ohio-farmer, Worthington Whittredge (born Thomas Worthington Whitridge) acquired an early love of nature on his family's grazing farm. At the age of seventeen, Whittredge moved to Cincinnati to live with his older sister, Abigail, and her husband, Almon Baldwin. Baldwin was a house and sign painter in Cincinnati, and Whittredge apprenticed himself to his brother-in-law in 1837.

The artist soon turned to landscape painting rather than sign painting, and he had his first exhibition of three landscapes at the Cincinnati Academy of Fine Arts in 1839. The following year Whittredge began training as a daguerreotypist and moved to Indianapolis, where business failed and led to illness and impoverishment. The Reverend Henry Ward Beecher took Whittredge into his home, where the artist spent one year recovering and painting portraits of the family, none of which have been discovered.

Whittredge returned to Cincinnati to recuperate, and over the course of the next decade he developed locally as a prominent landscape painter, exhibiting View on the Kanawha River, Morning *(now lost) at the National Academy of Design in New York in 1846, for which he received a complimentary letter from Asher B. Durand, the Academy's president at the time. In these early landscapes, prior to the development of a regional style in Cincinnati, Whittredge drew from the styles of leading painters of the Hudson River School, primarily Thomas Cole, although there is no evidence that Cole's work ever made it to Cincinnati before 1847. The link between Whittredge and Cole was likely an intermediary, Benjamin McConkey, who studied with Whittredge in Cincinnati until leaving for the Catskills to study with Cole and Frederic E. Church.*

In the spring of 1849 Whittredge left Cincinnati and traveled to London via New York, financing his travels through the support of commissions. He spent the summer sketching in Belgium and Germany, and then traveled on to Paris, where Church was studying at the time. In Paris Whittredge met up with McConkey, but, unsatisfied and growing restless after a month, Whittredge decided to leave the French capital. He traveled to Düsseldorf, where he modeled for Emanuel Leutze's Washington Crossing the Delaware *(1851, The Metropolitan Museum of Art, New York), and from Düsseldorf he then traveled to Switzerland and Rome, where he developed friendships with Sanford Gifford and Albert Bierstadt.*

Whittredge abruptly left Europe in May 1859 and returned to the United States, where he rented a studio in New York's Tenth Street Studio Building. He spent the summer sketching in Newport, Rhode Island, and in January 1860 he moved to New York and worked alongside Jervis McEntee, Gifford, Church, David Johnson, and John F. Kensett. It was also after his European sojourn that the artist dropped his given first name and adopted an alternate spelling of his surname, using "Worthington Whittredge" to sign his work. Following his time in New York, Whittredge made several trips to Colorado and New Mexico, first with General John Pope in 1866 and again in 1870 with Gifford and Kensett. Whittredge also served two terms as president of the National Academy of Design, first elected in 1875 and again in 1876.

Whittredge married Euphemia Foot in 1867, and in 1879 he bought land in Summit, New Jersey, where he spent the rest of his life. Between 1873 and 1886 Whittredge made several trips to the Catskills, both with his family and with Jervis McEntee, in 1883 and 1886. He retained his Tenth Street studio and continued working through 1904, when he exhibited one hundred and twenty-five paintings at The Century Association. He died at his home in Summit on February 25, 1910.

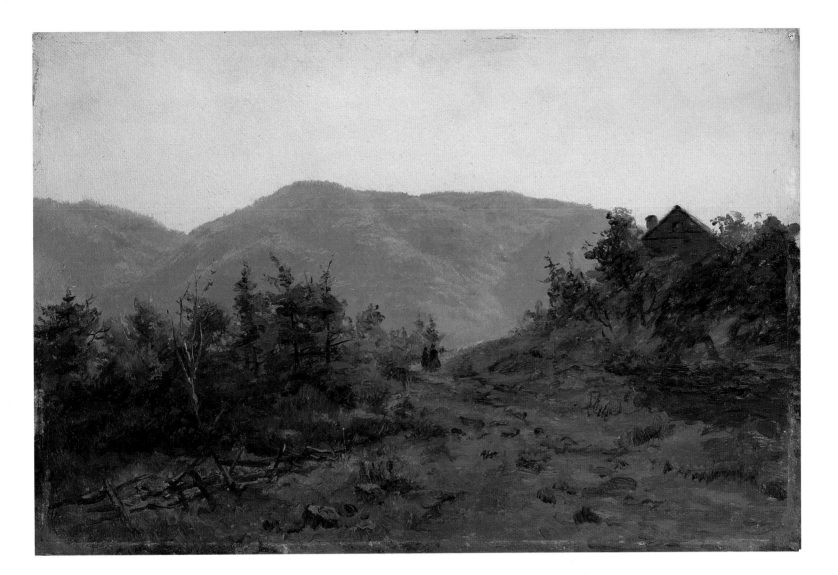

56 · *Mountain Landscape*

Oil on academy board, 21¼ × 27¼ in. (54 × 69.2 cm)
Signed on reverse: Worthington Whittredge
Ex coll.: Dorothy Clark Archibald
Gift of Dorothy Clark Archibald, 1999.16.4

After traveling extensively throughout Europe, Whittredge returned to the United States and struggled with the realities of the American wilderness. He recalls in his autobiography:

> *It was impossible for me to shut out from my eyes the works of the great landscape painters which I had so recently seen in Europe, while I knew well enough that if I was to succeed I must produce something new and which might claim to be inspired by my home surroundings. I was in despair. Sure, however, that if I returned to nature I should find a friend, I seized my sketch box and went to the first available outdoor place I could find. I hid myself for months in the recesses of the Catskills.*[272]

Mountain Landscape, which is signed on the reverse and inscribed "Catskill Mountains," illustrates a vista not uncommon in the works of the Hudson River School painters. In the early nineteenth century Thomas Cole established the Catskills as a mecca for American artists, and Whittredge's paintings in and of this region signify his association with the regional school following his repatriation.[273]

Whittredge made several trips to the Catskills later in life, first traveling to Shandaken Center in August 1873, and to the Catskills again in 1883, 1885, and 1886. On at least two of these trips, in 1883 and 1886, fellow painter Jervis McEntee joined Whittredge in upstate New York. In his autobiography,

Whittredge describes McEntee and their time together— "Jervis McEntee was one of my most intimate friends. Summer after summer we were together in the Catskills. His home had always been near them and he knew every nook and corner of them and every stepping-stone across their brooks."[274] With McEntee as companion and local guide, Whittredge spent several summers painting in the Catskills. It was during this time that he likely completed *Mountain Landscape*, which offers the viewer a more exterior view of the Catskill region, with the hills in the distance behind a foreground featuring a rustic house, a split-rail fence, and two figures walking along a rough trail.

ALEXANDER WYANT

Born 1836, Evans Creek, Ohio;
died 1892, New York City

ARCHIVES OF AMERICAN ART

Alexander Helwig Wyant was born in Ohio, the son of a carpenter. He began work as a sign painter, but in 1857 he visited Cincinnati, where he was impressed by paintings by George Inness, whom he sought out in New York City the following year. Inness became a lifelong friend and mentor, and he may have introduced Wyant to the Cincinnati collector and patron Nicholas Longworth. Longworth, who was patron to Robert S. Duncanson, among others, supported Wyant's study in New York City and Cincinnati from 1860 to 1863, during which time the artist absorbed the influence of the work of the Hudson River School painters.

In 1863 Wyant attended a New York exhibition of paintings by artists associated with Düsseldorf and was particularly taken with the work of the Norwegian artist Hans Friedrich Gude. Two years later, the artist took his first trip to Europe, and in Karlsruhe, Germany, he studied with Gude for nearly a year. He also made stops in England—where he studied the work of John Constable, in particular—and Ireland. He later painted several scenes of the Irish landscape.

Back in New York, Wyant joined the American Society of Painters of Water Colors in 1867, and in 1868 he was elected as an associate of the National Academy of Design; he was made an academician the following year. During this time, at the suggestion of Roswell M. Shurtleff (1838–1915), Wyant began sketching in the Keene valley in the Adirondacks.

In 1873, like many American artists before him, such as Albert Bierstadt and Thomas Moran (1837–1926), Wyant joined a government expedition to the West. A stroke forced him to return home in 1874, however. (The stroke paralyzed Wyant's painting arm, requiring him to learn to paint with his left.) Back in New York he took a studio at the YMCA building on Twenty-third Street, where he offered art lessons. Around this time he became a member of the Society of American Artists and the Century Club, both in New York City. In 1880 he married one of his students, the watercolorist Arabella Locke (d. 1919), and the couple began to spend an increasing amount of time in the Adirondacks, where they had built a house. Inness and Shurtleff made occasional visits to Wyant in the Adirondacks during this period.

Wyant's health was in decline by the mid-1880s, and paralysis spread to his entire right side. In 1889 he and his wife bought a home in Arkville in the Catskill Mountains, and there Wyant lived out the rest of his life, visiting New York City only occasionally.

57 · *Florida Sunset,* c. 1885–92

Oil on canvas, 10⅛ × 14⅛ in. (25.7 × 35.9 cm)
Signed at lower left (on beach): A H Wyant
Ex coll.: purchased by George H. Story, New York City, in 1897
Gallery Fund, 1898.5

A native of Ohio, Wyant traveled extensively throughout the United States, including Kentucky, New Mexico, Arizona, and West Virginia, yet there is no evidence of his traveling to Florida. However, George Inness, Wyant's mentor, visited Florida in 1891 and may have encouraged Wyant to do so as well. Furthermore, it is unlikely that Wyant would have produced paintings of the state without having seen it firsthand: a critic remarked in *Appleton's Art Journal* that "Mr. Wyant rarely composes. He studies and selects his views from Nature with the object of working them up at his leisure."[275] This comment strongly suggests Wyant's preference for, and habit of, selecting his subjects and views from his own experience and observation. In addition, because Wyant produced more than one painting of Florida—another oil is titled *A Creek Scene in Florida* (exhibited at the Yale School of Fine Arts in 1871)—it is likely that Wyant did indeed visit the state, possibly even before Inness.

Florida Sunset is an idyllic coast scene, featuring high-key orange clouds in a predominantly blue-gray sky. Although the trees drip with Spanish moss, their jagged, dark branches silhouetted against the sky emphasize the lack of leaves. The bright colors of the sun and sky might be compared to earlier paintings by Frederic Church, whose interest in atmosphere and cloud formations led to many examinations of the sunset as a subject. In contrast, Wyant's sunset theme, accompanied by the leafless trees and low tide of the water, may well have symbolized his approaching death.[276] (*Florida Sunset* is believed to have been painted within the last six or seven years of his life.)[277]

The July 1924 Wadsworth Atheneum *Bulletin* lists three Wyant paintings acquired by the museum, among them *Florida Sunset* and another, no longer in the collection, titled *The Last Glow,* purchased in 1900. The Atheneum purchased *Florida Sunset* in 1898 on the advice of George H. Story, then curator at The Metropolitan Museum of Art, who had bought the painting the year before.[278]

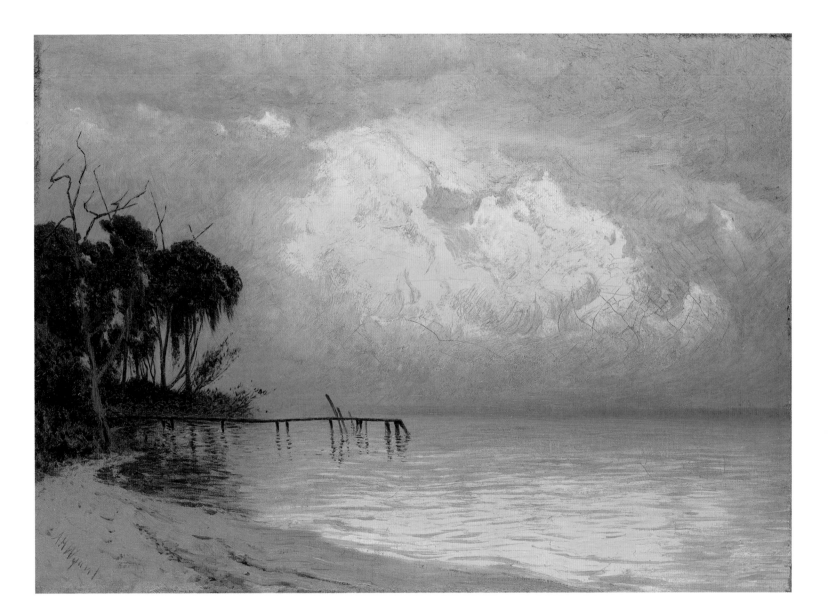

NOTES TO THE CATALOGUE

1. Mary Sayre Haverstock, "An American Bestiary," *Art in America* 58 (July–August 1970): 52, 57.

2. *The Crayon* 6 (September 1859): 287.

3. The trip is described in Theodore E. Stebbins, Jr., with William H. Gerdts, Erica E. Hirshler, Fred S. Licht, and William L. Vance, *The Lure of Italy: American Artists and the Italian Experience, 1760–1914*, exh. cat. (New York: Abrams, in association with the Museum of Fine Arts, Boston, 1992), 50, 213, 438; and Nancy K. Anderson and Linda S. Ferber, with Helena E. Wright, *Albert Bierstadt: Art and Enterprise*, exh. cat. (New York: Hudson Hills Press, in association with the Brooklyn Museum, 1990), 121.

4. Both related Capri oil sketches appear in Anderson and Ferber, *Albert Bierstadt*, 132, 133.

5. Ibid., 113.

6. Ibid., 151.

7. *Mercury*, New Bedford, January 7, 1859; reproduced in Anderson and Ferber, *Albert Bierstadt*, 143.

8. See *The Crayon* 6 (September 1859): 287.

9. Anderson and Ferber, *Albert Bierstadt*, 173.

10. His letters appear in the New York *Evening Post* and the San Francisco *Golden Era*, and his articles appear in the *Atlantic Monthly*, reproduced in Anderson and Ferber, *Albert Bierstadt*, appendix B, 306–22.

11. Albert Bierstadt to John Hay, August 22, 1863, *John Hay Collection*, John Hay Library, Brown University, Providence, Rhode Island, quoted in Anderson and Ferber, *Albert Bierstadt*, 178.

12. Anderson and Ferber, *Albert Bierstadt*, 180; and Gordon Hendricks, "Bierstadt and Church at the New York Sanitary Fair," *Antiques* 102 (November 1972): 893.

13. Anderson and Ferber, *Albert Bierstadt*, 45.

14. Gerald L. Carr, "Albert Bierstadt, Big Trees, and the British: A Log of Many Anglo-American Ties," *Arts Magazine* 60 (summer 1986): 64.

15. For a series of contemporary reviews of this work, see Anderson and Ferber, *Albert Bierstadt*, 208.

16. "Great Picture" was a contemporary term, originating in England, that described large paintings created for exhibition to the public. See Carr, "Albert Bierstadt," 60–71.

17. *Boston Morning Post*, October 11, 1869, quoted in Anderson and Ferber, *Albert Bierstadt*, 93–94.

18. Theodore E. Stebbins, Jr., *The Hudson River School: Nineteenth-Century American Landscapes in the Wadsworth Atheneum*, exh. cat. (Hartford: Wadsworth Atheneum, 1976), 72.

19. *San Francisco Bulletin*, October 24, 1867, 3; thanks to Nancy Anderson for supplying this reference.

20. For a description of the artist's trip west from 1871 to 1873 (but with negligible information on the trip to Hetch Hetchy valley), see Gordon Hendricks, "The First Three Western Journeys of Albert Bierstadt," *Art Bulletin* 46 (September 1964): 333–65.

21. Quoted in Anderson and Ferber, *Albert Bierstadt*, 227.

22. See Elizabeth Johns, "The 'Missouri Artist' as Historian," in Michael Edward Shapiro, Barbara Groseclose, Elizabeth Johns, Paul C. Nagel, and John Wilmerding, *George Caleb Bingham*, exh. cat. (New York: Abrams, in association with the Saint Louis Art Museum, 1990), 83–111.

23. Ibid., 103–4.

24. Richard Kluger, quoted in a letter from Mary Jean Blasdale, New Bedford Whaling Museum, to Jack Brin, October 2, 2000, curatorial painting file. Thanks to Jack Brin for sharing this information.

25. Aldrich, "Among the Studios," Our Young Folk (September 1865): 597, reproduced in Annette Blaugrund, *The Tenth Street Studio Building* (Ann Arbor, Mich.: University Microfilms, 1987), 176 n. 40.

26. "American Paintings-John Casilear," *Art Journal* 2 (1876): 16–17.

27. Sadakichi Hartmann, writing in 1901, said that Casilear was "known for his delicate finish" (*A History of American Art*, rev. ed. [1932; rpt., New York: Tudor, 1934], 58).

28. See Linda S. Ferber and William H. Gerdts, *The New Path: Ruskin and the American Pre-Raphaelites*, exh. cat. (New York: Schocken Books, in association with the Brooklyn Museum, 1985), for a full discussion of the origin and influence of the Pre-Raphaelite movement in America.

29. Henry T. Tuckerman, *Book of the Artists: American Artist Life* (New York: Putnam, 1867), 521–22, quoted in Barbara Ball Buff, s.v. "Lake George," in *American Paradise: The World of the Hudson River School*, ed. John K. Howat, exh. cat. (New York: The Metropolitan Museum of Art, 1987), 143.

30. The print source for Chambers's *Niagara Falls* was first noted in Howard Merritt, "Thomas Chambers—Artist," *New York History* 37 (April 1956): 219. The print is reproduced in Jeremy Elwell Adamson, with Elizabeth McKinsey, Alfred Runte, and John F. Sears, *Niagara: Two Centuries of Changing Attitudes, 1697–1901*, exh. cat. (Washington, D.C.: Corcoran Gallery of Art, 1985), 34.

31. Adamson et al., *Niagara*, 35, 47.

32. Louis L. Noble, *The Life and Works of Thomas Cole*, ed. Elliot S. Vesell (1853; rpt., Hensonville, N.Y.: Black Dome Press, 1997), 272.

33. When Church exhibited *Hooker and Company* (cat. 13) at the National Academy of Design in 1826, the catalogue gave his address as Hartford, as it did again in 1847. See Mary Bartlett Cowdrey, ed., *National Academy of Design Exhibition Record, 1826–1860*, vol. 1 (New York: New-York Historical Society, 1943), 80.

34. David Huntington first discovered the source for Church's landscape. See David C. Huntington to Charles Cunningham, May 15, 1957, curatorial painting file, Wadsworth Atheneum.

35. See Benjamin Silliman, *Remarks Made, on a Short Tour, Between Hartford and Quebec in the Autumn of 1819* (New Haven: S. Converse, 1820), ill. opp. 252.

36. Chandos Michael Brown, *Benjamin Silliman: A Life in the Young Republic* (Princeton, N.J.: Princeton University Press, 1989), 320.

37. Silliman, *Remarks Made*, 252–53.

38. See Matthew Baigell, "Frederic Church's 'Hooker and Company': Some Historic Considerations," *Arts Magazine* 56 (January 1982): 125.

39. Richard Saunders, with Helen Raye, *Daniel Wadsworth: Patron of the Arts* (Hartford: Wadsworth Atheneum, 1981), 104–5.

40. For a discussion of Wadsworth's efforts as an amateur landscape artist, see Saunders, with Raye, *Daniel Wadsworth*, 14–15, 27.

41. Roger Stein, *Susquehanna: Images of the Settled Landscape*, exh. cat. (Binghamton, N.Y.: Roberson Center for the Arts and Sciences, 1981), 18–20.

42. Thomas Cole to Robert Gilmor, May 21, 1828, quoted in Noble, *Life and Works*, 64.

43. Bartlett Cowdrey, *National Academy of Design Exhibition Record*, 80.

44. Howard S. Merritt, ed., *Annual II: Studies on Thomas Cole, an American Romanticist* (Baltimore: Baltimore Museum of Art, 1967), 90.

45. Perry Miller, *Errand into the Wilderness* (Cambridge: Harvard University Press, 1956), 23–24.

46. The painting bore an abbreviated title for its first showing at the Wadsworth Atheneum in 1850: *Journey of the Pilgrims Through the Wilderness*. See the *Catalogue of Paintings in Wadsworth Gallery, Hartford* (Hartford: E. Gleason, 1850).

47. The religious and national symbolism of this painting is discussed in Franklin Kelly, *Frederic Edwin Church and the National Landscape* (Washington, D.C.: Smithsonian Institution Press, 1988), 7–9.

48. Baigell, "Frederic Church's 'Hooker and Company,'" 124–25.

49. See Christopher Kent Wilson, "The Landscape of Democracy: Frederic Church's 'West Rock, New Haven,'" *American Art Journal* 18, no. 1 (1986): 21–39.

50. Gerald Carr, "Master and Pupil: Drawings by Thomas Cole and Frederic Church," *Bulletin of the Detroit Institute of Arts* 66, no. 1 (1990): 56–57, discusses a drawing of the Charter Oak by Church, dated August–September 1846 (Olana State Historic Site, OL. 1977.302).

51. Kelly, *Frederic Edwin Church*, 34.

52. See "Chronicles of Facts and Opinions: American Art and Artists," *Bulletin of the American Art-Union*, ser. (August 1850): 81, reproduced and discussed in Kelly, *Frederic Edwin Church*, 35.

53. Theodore E. Stebbins, Jr., *Close Observation: Selected Oil Sketches by Frederic E. Church*, exh. cat. (Washington, D.C.: Smithsonian Institution Press, in association with the Cooper-Hewitt Museum, 1978), 16–17, 58–59.

54. The details of Church's trip are discussed in David C. Huntington, *Frederic Edwin Church, 1826–1900: Painter of the Adamic New World Myth* (Ann Arbor, Mich.: University Microfilms, 1982), 39–49; and more recently in Katherine Emma Manthorne, *Creation and Renewal: Views of Cotapaxi by Frederic Church*, exh. cat. (Washington, D.C.: Smithsonian Institution Press, for the National Museum of American Art, 1985) and idem, *Tropical Renaissance: North American Artists Exploring Latin America, 1839–1879* (Washington, D.C.: Smithsonian Institution Press, 1989).

55. Alexander von Humboldt, *Cosmos: A Sketch of a Physical Description of the Universe*, vol. 1, trans. E. C. Otté (New York, 1850), 33.

56. See David C. Huntington, *The Landscapes of Frederic Edwin Church: Vision of an American Era* (New York: Braziller, 1966), 1–4, 64–71. The more recent and most thorough discussion appears in Jeremy Elwell Adamson, "Frederic Church's 'Niagara': The Sublime as Transcendence" (Ph.D. diss., University of Michigan, 1981). Also, see idem, "In Detail: Frederic Church and *Niagara*," *Portfolio* 3 (November/ December 1981): 53–59. The history of depictions of Niagara Falls including Church's work has been the subject of a major exhibition and a study: Jeremy Elwell Adamson, with Elizabeth McKinsey, Alfred Runte, and John F. Sears, *Niagara: Two Centuries of Changing Attitudes, 1697–1901*, exh. cat. (Washington, D.C.: Corcoran Gallery of Art, 1985); and Elizabeth McKinsey, *Niagara Falls: Icon of the American Sublime* (Cambridge: Cambridge University Press, 1985).

57. Quoted in Adamson, "In Detail," 53.

58. Church may have visited the falls as early as August 1851, joined by his friend Cyrus Field (Isabella Judson, *Cyrus Field, His Life and Work* [New York: Harper Brothers, 1896], 41; noted in Adamson et al., *Niagara*, 80 n. 191).

59. Ruskin quoted in Huntington, *Landscapes*, 65–66.

60. More than seventy sketches of Niagara Falls by Church are extant, most in the collection of the Cooper-Hewitt Museum and some at Olana State Historic Site, Hudson, New York.

61. Franklin Kelly, with Stephen Jay Gould, James Anthony Ryan, and Debora Rindge, *Frederic Edwin Church*, exh. cat. (Washington, D.C.: National Gallery of Art, 1989), 61.

62. The review is reproduced in Tuckerman, *Book of the Artists*, 372.

63. "Fine Arts. National Academy of Design," *Albion* (New York), May 2, 1863, 213–14. Of the frame, the writer observed: "That Mr. Church was quite right in preferring black walnut to gold for his 'Coast Scene' we have no doubt. . . . There is an elevated and gilded rim girdling it in the pattern . . . on the border of Greek and Roman togas. . . . The cool hue of the wood is grateful, but unfortunately the designer . . . has thought fit to chop [the frame] up into small sections by transverse bars, gaining . . . a series of dainty little squares wherein fanciful knobs and rosettes may disport themselves, but thrusting these needlessly in the way." *Coast Scene, Mount Desert*, which for many years had an inappropriate frame, likely put on in this century, has been put in a replica of the original frame based on the above description and study of other original frames designed by the artist, including the frame on *Vale of St. Thomas, Jamaica* (cat. 18).

64. Kelly et al., *Frederic Edwin Church*, 74 n. 140, cites the use of "yesty waves" in volume 1 of Ruskin's *Modern Painters* (New York: Wiley, 1882), ch. 3, "Of Water as Painted by Turner," sec. 5, "Of Truth of Water," 402–3). The term "yesty" was also used in a description of Achenbach's sea in *Clearing Up, Coast of Sicily*, in "Gallery of the Düsseldorf Artists," *Bulletin of the American Art-Union* 2 (June 1849): 12.

65. Theodore E. Stebbins, Jr., *Close Observation*, 21, 62.

66. Tuckerman, *Book of the Artists*, 386. See Elizabeth McClintock, "Horace Wolcott Robbins" (master's thesis, Trinity College, Hartford, 1990).

67. Horace Robbins to Mary Eldrege Hyde Robbins, May 18, 1865, Olana State Historic Site, Hudson, New York.

68. Huntington, *Landscapes*, 54–59; and Stebbins, Jr., *Close Observation*, 35–38.

69. Tuckerman, *Book of the Artists*, 387.

70. Robbins to Robbins, May 18, 1865.

71. Elizabeth Hart Jarvis Colt to Frederic E. Church, October 26, 1866, Frederic Church Archives, Olana State Historic Site, Hudson, New York.

72. Church wrote to his patron William H. Osborn: "I am progressing in the studio with Mrs. Colt's picture, although I find it harder to work since the Niagara is finished" (March 26, 1867, Frederic Church Archives, Olana State Historic Site, Hudson, New York). The reference is to *Niagara Falls, from the American Side* (1867, National Gallery of Scotland).

73. A number of titles were assigned to this painting. The *Hartford Daily Times*, April 11, 1870, announced: "A large new picture by the artist Church of this city, has just been put on exhibition at Goupil's art gallery. It is 'A Scene in Jamaica,' and is to grace the walls of Mrs. Col. Colt's gallery of paintings." See Elizabeth Mankin Kornhauser, entry for Church's *Vale of St. Thomas, Jamaica*, in Elizabeth Mankin Kornhauser, with Elizabeth R. McClintock and Amy Ellis, *American Paintings Before 1945 in the Wadsworth Atheneum*, vol. 1 (New Haven and London: Yale University Press, in association with the Wadsworth Atheneum, 1996), 206–10, for a discussion of the painting's political context and its relation to the title of this work.

74. "A New Tropical Landscape," *Evening Post* (New York), September 10, 1870, quoted in Kelly et al., *Frederic Edwin Church*, 65. Thanks to J. Gray Sweeney for pointing out this review.

75. Last Will and Testament of Elizabeth H. Colt (Hartford, 1905), 16, Connecticut State Library, Hartford (copy in curatorial painting file, Wadsworth Atheneum).

76. Stebbins, Jr., *Hudson River School*, 51–52.

77. Robin W. Winks, *Frederick Billings: A Life* (New York and Oxford: Oxford University Press, 1991), is a definitive biography of Billings.

78. Correspondence from April 13, 1879, to January 11, 1882, between Frederic Church and Frederick and Julia Parmly Billings is in the Billings Mansion Archives, Woodstock, Vermont, and the Frederic Church Archives, Olana State Historic Site, Hudson, New York. The sale of Cole paintings is discussed in Frederic Church to Frederick Billings, April 13, 1879, Billings Mansion Archives. There is a photocopy of the letter in the curatorial painting file, Wadsworth Atheneum. Thanks to Laura Kent and Jane S. M. Smith.

79. Frederic Church to Frederick Billings, February 14, 1880, Billings Mansion Archives, Woodstock, Vermont. There is a photocopy of the letter in the curatorial painting file, Wadsworth Atheneum. Thanks to Laura Kent and Jane S. M. Smith.

80. Frederick Billings to Frederic Church, February 20, 1880, Frederic Church Archives, Olana State Historic Site, Hudson, New York.

81. Frederic Church to Frederick Billings, November 9, 1881, Frederic Church Archives, Olana State Historic Site, Hudson, New York.

82. Frederic Church to Frederick Billings, February 10, 1881, Billings Mansion Archives, Woodstock, Vermont.

83. Diaries of Frederick Billings, provided by Janet R. Houghton, Billings Mansion Archives, Woodstock, Vermont.

84. Kelly, *Frederic Edwin Church and the National Landscape*, 67.

85. Winks, *Frederick Billings*, 31–35.

86. Kelly et al., *Frederic Edwin Church*, 168.

87. Frank Bonnelle, "In Summertime on Olana," *Boston Sunday Herald*, September 7, 1890, 17, quoted in Kelly et al., *Frederic Edwin Church*, 149.

88. Frederic E. Church to Charles Dudley Warner, August 16, 1884, Frederic Church Archives, Olana State Historic Site, Hudson, New York.

89. Frederic E. Church to Charles Dudley Warner, December 27, 1884, Frederic Church Archives, Olana State Historic Site, Hudson, New York.

90. A typescript of Warner's *An Unfinished Biography of the Artist* is in the Frederic Church Archives, Olana State Historic Site, Hudson, New York, and is reproduced with annotations by Debora Rindge in Kelly et al., *Frederic Edwin Church*, 174–99. The original manuscript is unlocated.

91. *Paintings by Frederic E. Church, N.A.*, exh. cat. (New York: The Metropolitan Museum of Art, 1900).

92. Frederic E. Church to Luigi DiCesnola, director, The Metropolitan Museum of Art, July 10, 1893. Archives, The Metropolitan Museum of Art, quoted in Katherine Emma Manthorne, *Tropical Renaissance*, 104.

93. Frederic E. Church to Luigi DiCesnola, September 5, 1893, Archives, The Metropolitan Museum of Art; quoted in Manthorne, *Tropical Renaissance*, 105.

94. For the best-known account of Cole's discovery by New York artists and patrons, see William Dunlap, *History of the Rise and Progress of the Arts of Design in the United States*, vol. 2 (1834; rpt., New York: Dover, 1969), 359–60. For an updated and more accurate version of the events of Cole's early years, see Ellwood C. Parry III, *The Art of Thomas Cole: Ambition and Imagination* (Newark: University of Delaware Press, 1988), 36–47.

95. J. Bard McNulty, ed., *The Correspondence of Thomas Cole and Daniel Wadsworth* (Hartford: Connecticut Historical Society, 1983), 1–6.

96. Ibid., 1.

97. Ibid., 4.

98. For a recent comprehensive study of the picturesque in America, see John Conron, *American Picturesque* (University Park: Pennsylvania State University Press, 2000).

99. Thomas Cole to Robert Gilmor, December 25, 1826, reprinted in "Correspondence Between Thomas Cole and Robert Gilmor, Jr.," appendix 1 in Merritt, *Annual II*, 47.

100. Matthew 3:1–3.

101. J. Gray Sweeney, "The Nude of Landscape Painting: Emblematic Personification in the Art of the Hudson River School," *Smithsonian Studies in American Art* 3, no. 4 (fall 1989): 47–48.

102. Parry, *Art of Thomas Cole*, 53.

103. See McNulty, *Correspondence*, 7–9.

104. Ibid., 10–12.

105. Catherine H. Campbell, "Two's Company: The Diaries of Thomas Cole and Henry Cheever Pratt on Their Walk Through Crawford Notch, 1828," *Historical New Hampshire* 23 (winter 1978): 312–16. A transcription from Cole's journal of his "Sketch of My Tour to the White Mountains with Mr. Pratt" appears in *Bulletin of the Detroit Institute of Arts* 66, no. 1 (1990): 27–35.

106. McNulty, *Correspondence*, 58–59 n. 4.

107. See ibid., 26. The drawing is in the collection of the Detroit Institute of Arts, Sketchbook No. 2, 39.559.

108. Theodore E. Stebbins, Jr., and Galina Gorokhoff, *A Checklist of American Paintings at Yale University* (New Haven: Yale University Art Gallery, 1982), 30–31.

109. Nicolai Cikovsky, Jr., "'The Ravages of the Axe': The Meaning of the Tree Stump in Nineteenth-Century American Art," *Art Bulletin* 61 (December 1979): 611–26.

110. McNulty, *Correspondence*, 22–23.

111. Ibid., 26.

112. Ibid., 27–28.

113. Ellwood C. Parry III, "Thomas Cole's Early Career, 1818–1829," in *Views and Visions: American Landscape Before 1830*, ed. Edward Nygren, with Bruce Robertson, exh. cat. (Washington, D.C.: Corcoran Gallery of Art, 1986), 172. See Ellwood C. Parry III, "Cooper, Cole, and *The Last of the Mohicans*," in *Art and the Native American: Perceptions, Reality, and Influences*, vol. 10, ed. Mary Louise Krumrine and Susan Clare Scott (University Park: Pennsylvania State University, 2001), for a full discussion of the group of *Last of the Mohicans* paintings by Cole.

114. Appendix 1 in Merritt, *Annual II*, 44.

115. James Fenimore Cooper, *The Last of the Mohicans* (1826; rpt., Cambridge, Mass.: Riverside Press, 1958), 324.

116. McNulty, *Correspondence*, 17.

117. Gilmor wrote to Cole on December 5, 1827: "I can see no objection to your going anywhere for a part of your scenery though the tale is located near Lake George, so all that is necessary is that it should be appropriate." When Gilmor's version was shown in Philadelphia in 1828, the title included the following description: "A composition of real scenes—The mountain is Corroway Peak, and the Lake is Winisioge Lake with Rattlesnake Island, in N. Hampshire." Both quotations from Parry, *Art of Thomas Cole*, 65.

118. Parry, "Cole's Early Career," 178–79.

119. Thomas Cole to Daniel Wadsworth, August 4, 1827, in McNulty, *Correspondence*, 12.

120. Ibid., 22–23.

121. Ibid., 25.

122. Ellwood C. Parry III, "Acts of God, Acts of Man: Geological Ideas and the Imaginary Landscapes of Thomas Cole," in *Two Hundred Years of Geology in America*, ed. Cecil J. Schneer (Hanover: University of New Hampshire, 1979), 53–71; and Barbara Novak, *Nature and Culture:*

American Landscape Painting, 1825–1875 (New York: Oxford University Press, 1980), 54–57. See also Rebecca Bailey Bedell, *The Anatomy of Nature: Geology and the American Landscape Painting, 1825–1877* (Princeton, N.J.: Princeton University Press, 2002).

123. Parry, "Acts of God," 57 n. 10.

124. Parry, *The Art of Thomas Cole*, 64–65.

125. Richard Slotkin, introduction to James Fenimore Cooper, *The Last of the Mohicans* (New York: Penguin, 1988), ix–xxviii.

126. Although Wadsworth left no explanation for his choice of name for his country estate, it was highly appropriate for his intentions. In Latin *monte* means "mountain" and *video* means "having the power to see."

127. Richard Saunders, with Helen Raye, *Daniel Wadsworth: Patron of the Arts* (Hartford: Wadsworth Atheneum, 1981), 18–19, reproduces the newspaper advertisement that appeared in the *Connecticut Courant*, August 19, 1848, announcing the sale of Monte Video after Wadsworth's death and describing the estate in detail.

128. Benjamin Silliman, *Remarks Made, on a Short Tour, Between Hartford and Quebec* (New Haven: S. Converse, 1820), 15.

129. McNulty, *Correspondence*, 50.

130. For a discussion of Cole's use of this vantage point from above in his landscapes, see Albert Boime, *The Magisterial Gaze: Manifest Destiny and American Landscape Painting, c. 1830–1865* (Washington, D.C., and London: Smithsonian Institution Press, 1991), 48–57. For a discussion of the importance of the viewing tower at Monte Video, see Alan Wallach, "Wadsworth's Tower: An Episode in the History of American Landscape Vision," *American Art* 10 (fall 1996): 8–27.

131. McNulty, *Correspondence*, 31–32, was the first to suggest that these two paintings were conceived as a pair. A list of the paintings in Wadsworth's collection at Monte Video appears in "Probate Inventory of the Estate of Daniel Wadsworth," September 30, 1848, Connecticut State Library, Hartford.

132. Thomas Cole to Daniel Wadsworth, Florence, Italy, July 13, 1832, quoted in McNulty, *Correspondence*, 56–57. The engraving of Monte Video appears in John Howard Hinton, *The History and Topography of the United States*, vol. 2 (1832), facing 481. The engraving is dated 1831 and shows a view of the estate from south to north.

133. See McNulty, *Correspondence*, 7–9.

134. Ibid., 31–32. McNulty notes that *View on Lake Winnipiseogee* and a painting referred to as a view of Squam Lake are one and the same and are discussed in Thomas Cole to Daniel Wadsworth, New York, January 9, 1828, 31–32.

135. Ibid., 40.

136. For a discussion of Cole's landscapes as signifying Manifest Destiny, see Albert Boime, *The Magisterial Gaze*, 48–57.

137. Ellwood C. Parry III to Amy Ellis, July 7, 1992; curatorial painting file, Wadsworth Atheneum. Parry suggested a date of 1832 to 1838, a time when Cole was exploring architectural elements in preparation for *The Course of Empire*.

138. Thomas Cole to Charles M. Parker, New York, January 8, 1844, Thomas Cole Papers, New York State Library, cited in Noble, *Life and Works*, 266. This letter contains the first reference to the original owner, whose identity is otherwise unspecified. The name "Miss Sarah Hicks" appears in Stebbins, Jr., *Hudson River School*, 27, though the source for the first name is not provided and remains unknown.

139. William L. Vance, *America's Rome: Classical Rome*, vol. 1 (New Haven and London: Yale University Press, 1989), 69.

140. Tuckerman, *Book of the Artists*, 232.

141. William Cullen Bryant, *A Funeral Oration, Occasioned by the Death of Thomas Cole, Delivered Before the National Academy of Design, New-York, May 4, 1848* (pamphlet) (New York, 1848), 21.

142. Trevor J. Fairbrother, entry for Thomas Cole, *Evening in Arcady*, in Theodore Stebbins, Jr., Carol Troyen, and Trevor J. Fairbrother, *A New World: Masterpieces of American Painting, 1760–1910*, French ed. (Boston: Museum of Fine Arts, 1983), 360.

143. "Thomas Cole, N York, 1827," Thomas Cole Papers, New York State Library, Albany, New York, reproduced in Merritt, *Annual II*, 98.

144. Thomas Cole, "Sicilian Scenery and Antiquities," *Knickerbocker* 13 (February and March 1844): 112.

145. For a discussion of Cole's Mount Etna paintings, see Franklin W. Kelly, "Myth, Allegory, and Science: Thomas Cole's Paintings of Mount Etna," *Arts in Virginia* 23 (November 1983): 2–18.

146. As Ellwood Parry points out, Cole's biographer, Louis L. Noble, erroneously wrote that the artist's solo exhibition was held in the old quarters of the National Academy of Design in Clinton Hall. See Noble, *Life and Works*, 264; and Parry, *Art of Thomas Cole*, 291–92.

147. Quoted in Noble, *Life and Works*, 264.

148. Copies of the brochure, titled *Catalogue of Pictures by Thomas Cole, A.N.A. [sic] Now Exhibiting in the Rooms of the National Academy, Corner of Broadway and Leonard Street. Open from 9 A.M. until 10 P.M.*, are in the collections of the Cole Papers, New York State Library, Albany, New York, and the Detroit Institute of Arts Library.

149. For a discussion of this drawing, see the entry for this painting by Eleanor Jones in Stebbins, Jr., et al., *Lure of Italy*, 262. For Noble's discussion of the importance of this painting, see his *Life and Works*, 264–65.

150. Thomas Cole, *Thomas Cole's Poetry*, ed. Marshall B. Tymn (York, Pa.: Liberty Cap Books, 1972), 134–35. Cole's two-part article "Sicilian Scenery and Antiquities" recounts his experiences in Sicily; the poem appears on page 34.

151. Noble, *Life and Works*, 265.

152. Thomas Cole to Alfred Smith, January 29 to March 11, 1844, archives, Wadsworth Atheneum.

153. Alfred Smith to Thomas Cole, January 29, 1844, archives, Wadsworth Atheneum.

154. McNulty, *Correspondence*, 69. The receipt for Wadsworth's contribution of fifty dollars, dated March 7, 1844, is annotated "to pay in part for the M. Aetna" ("Receipts of Wadsworth Atheneum Gallery," archives, Wadsworth Atheneum).

155. Thomas Cole to Alfred Smith, February 24, 1844, archives, Wadsworth Atheneum.

156. Sadakichi Hartmann, *A History of American Art*, vol. 1, rev. ed. (1932; rpt., New York: Tudor, 1934), 77.

157. G. W. Sheldon, *American Painters*, rev. ed. (New York: D. Appleton, 1881), 73, quoted in Wayne Craven, "Samuel Colman (1832–1920): Rediscovered Painter of Far-Away Places," *American Art Journal* 8, no. 1 (1976): 18.

158. Based on her research and travel, M. Elizabeth Boone has determined that *Gibraltar from the Neutral Ground* is not an accurate view, despite the specificity of the title. See M. Elizabeth Boone to Amy Ellis, January 29, 1995, curatorial painting file, Wadsworth Atheneum.

159. See A. Gallenga, *Iberian Reminiscences: Fifteen Years' Travelling Impressions of Spain and Portugal*, vol. 2 (London: Chapman and Hall, 1883). Thanks to M. Elizabeth Boone for this reference and for sharing her research on Samuel Colman in Spain.

160. The season can be identified by the rock, which appears barren in summer and green with foliage in spring and fall. See Richard Ford, *A Hand-Book for Travellers in Spain, and Readers at Home* 2:517, photocopy of pertinent section in curatorial painting file, Wadsworth Atheneum. Thanks to M. Elizabeth Boone for this reference.

161. Craven, "Samuel Colman," 22.

162. See Gloria-Gilda Deák, *The Romantic Landscapes of Samuel Colman*, exh. cat. (New York: Kennedy Galleries, 1983), cat. no. 42. An undated

Saw Mill Valley, Ashford was in the collection of Colman's descendants until 1983, when it was placed with Kennedy Galleries. The painting measures 8 by 6⅜ inches, and so is smaller than the Atheneum's *Saw Mill Valley*. Another painting is listed in James L. Yarnall and William H. Gerdts, *The National Museum of American Art's Index to American Art Exhibition Catalogues from the Beginning Through the 1876 Centennial Year*, vol. 1 (Boston: Hall, 1986), 789.

163. Ibid. *Saw-Mill River* was in the collection of Robert Hoe, New York City, when it was exhibited in 1875.

164. "The Arts," *Appleton's* (1875), 763, photocopy in curatorial painting file, Wadsworth Atheneum. Thanks to M. Elizabeth Boone for this reference.

165. Craven, "Samuel Colman," 22.

166. At least one of Colman's studies or sketches was comparable in size to the Atheneum's painting, however. See Yarnall and Gerdts, *Index*, 787–93. On 789, Yarnall and Gerdts list *Study at Irvington*, owned by Robert Hoe, New York City, and measuring 18 by 9 inches (45.7 × 22.9 cm).

167. The entry in the *Dictionary of American Biography* on Colman reads, in part, "At one time he lived at Irvington-on-Hudson, where he painted some charming river views" (*Dictionary of American Biography, Published Under the Auspices of American Council of Learned Societies . . .*, vol. 4 [New York: Scribner's, 1943], 314). For a list of works by Colman exhibited between 1866 and 1875, see Yarnall and Gerdts, *Index*, 789, 790, 793.

168. See J. Gray Sweeney, "The Advantages of Genius and Virtue: Thomas Cole's Influence, 1848–58," in *Thomas Cole: Landscape into History*, ed. William H. Truettner and Alan Wallach, with Christine Stansell, Sean Wilentz, and J. Gray Sweeney, exh. cat. (New Haven and London: Yale University Press, for the National Museum of American Art, Smithsonian Institution, Washington, D.C., 1994), 113–35.

169. Cole's paintings are not about settling the West, or any particular frontier, but speak generally about a stage in the rise of human civilization. Crocker's painting has these mythic overtones because of its allusion to Cole's. See Alan Wallach, "Thomas Cole: Landscape and the Course of Empire," in Truettner and Wallach, *Thomas Cole*, esp. 64–67.

170. George H. Durrie was another artist who treated the winter landscape (cat. 40). Peter Bermingham suggests that the Hudson River School painters neglected winter as a subject partly because winters were generally spent in the studio, painting from sketches made during the spring and summer months, and he adds that winter landscapes were not popular as "escapist decorations for the American home," for obvious reasons (*Jasper F. Cropsey, 1823–1900: A Retrospective View of America's Painter of Autumn*, exh. cat. [College Park: University of Maryland Art Gallery, 1968], 19 and 19–20 n. 21). Articles dealing specifically with nineteenth-century winter pictures are: Helen Comstock, "The American Scene in Winter," *Panorama* 2 (December 1946): 38–42; idem, "Wintering Up—With Currier and Ives," *Portfolio* 5 (December 1945): 75–80; and Martha Young Hutson, "The American Winter Landscape, 1830–1870," *American Art Review* 2 (January–February 1975): 60–78.

171. Tuckerman, *Book of the Artists*, 538–39. For a discussion of Cropsey's paintings of Torne Mountain, which is visible in the background of *Winter Scene—Ramapo Valley*, see Kenneth W. Maddox, "Cropsey's Paintings of Torne: A Legendary Mountain Worthy of the Painter's Pencil," *OCHS Journal* 30, no. 1 (2001): 37–53.

172. Martha Young Hutson discusses Cropsey's *Ramapo Valley* in her monograph *George Henry Durrie (1820–1863), American Landscapist: Renowned Through Currier and Ives*, exh. cat. (Laguna Beach, Calif.: Santa Barbara Museum of Art and American Art Review Press, 1977), 78–82.

173. Bermingham, *Jasper F. Cropsey*, 19–20 n. 21.

174. Ibid., 25.

175. William Forman, "Jasper F. Cropsey, N.A.," *Manhattan Magazine* (1884): 375, quoted in Bermingham, *Jasper F. Cropsey*, 22. In the nineteenth century, autumn carried a nationalistic and religious meaning as a beautiful and particularly American season and as a symbol of spiritual illumination after physical vitality is diminished. See Edward Hitchcock, "The Euthanasia of Autumn," in *Religious Lectures on Peculiar Phenomena in the Four Seasons* (Boston, 1853). See also Charles Eldredge and Barbara Millhouse, with Robert Workman, *American Originals: Selections from Reynolda House, Museum of American Art*, exh. cat. (New York: Abbeville and American Federations of Arts, 1990).

176. In *Jasper F. Cropsey, 1823–1900*, exh. cat. (Washington, D.C.: Smithsonian Institution Press, 1970), cat. no. 71, William Talbot lists a painting with the title "Susquehanna River" (1880, oil on canvas, 12 × 20 in. [30.5 × 50.8 cm]), private collection.

177. Roger B. Stein, *Susquehanna: Images of the Settled Landscape*, exh. cat. (Binghamton, N.Y.: Roberson Center for the Arts and Sciences, 1981), 64.

178. William S. Talbot, "Jasper F. Cropsey, Child of the Hudson River School," *Antiques* 92 (November 1967): 713–17.

179. For a complete discussion of the works inspired by literary themes, see Joseph D. Ketner II, "Robert S. Duncanson (1821–1871): The Late Literary Landscape Paintings," *American Art Journal* 15, no. 1 (1983): 35–47. For a detailed account of Duncanson's years in Canada and the influence of Canadian artists on his work, see Allan Pringle, "Robert S. Duncanson in Montreal, 1863–1865," *American Art Journal* 17, no. 4 (1985): 28–50.

180. See K. Quinn's entry on the Atheneum's painting in Stebbins, Jr., et al., *Lure of Italy*, 186–88.

181. American miniaturist William Miller, a friend of Duncanson, to Isaac Strohm, n.d., quoted in Guy McElroy, *Robert S. Duncanson: A Centennial Exhibition*, exh. cat. (Cincinnati: Cincinnati Art Museum, 1972), 12–13.

182. Joseph D. Ketner II, "Robert S. Duncanson (1821–1872)," in *Artists of Michigan from the Nineteenth Century*, exh. cat. (Muskegon and Detroit, Mich.: Muskegon Museum of Art and Detroit Historical Museum, 1987), 64.

183. Asher B. Durand, from "Letters on Landscape Painting," *The Crayon*, 1855, letter 2, reprinted in John W. McCoubrey, *American Art, 1700–1960: Sources and Documents* (Englewood Cliffs, N.J.: Prentice-Hall, 1965), 110–11. Thanks to Franklin Kelly, Smithsonian American Art Museum, who generously reviewed an earlier version of this entry and offered comments and criticism.

184. David B. Lawall, *Asher B. Durand: A Documentary Catalogue of the Narrative and Landscape Paintings* (New York and London: Garland, 1978), 90.

185. David B. Lawall, *Asher Brown Durand: His Art and Art Theory in Relation to His Times* (New York and London: Garland, 1977), 378.

186. From Durand, "Letters on Landscape Painting," 110.

187. These paintings include *View Toward the Hudson River, Dover Plains, Dutchess County, New York* (1848, Smithsonian American Art Museum), *Kindred Spirits* (1849, New York Public Library), and *Progress* (1853, Warner Collection, Gulf States Paper Corporation, Tuscaloosa, Alabama). See Lawall, *Asher Brown Durand: His Art*, 411–27.

188. Ann J. Adams speculates about the identities of the figures in her entry for *View Toward the Hudson Valley* in Stebbins, Jr., *Hudson River School*, 57.

189. See Albert Boime, *The Magisterial Gaze: Manifest Destiny and American Landscape Painting c. 1830–1865* (Washington, D.C., and London: Smithsonian Institution Press, 1991), especially 75–76 for Durand.

190. See Carol Troyen, "Retreat to Arcadia: American Landscape and The American Art-Union," *American Art Journal* 23, no. 1 (1991): 20–37.

191. See Boime, *Magisterial Gaze*.

Notes

192. According to his daughter, snow did not deter Durrie. See Mary Clarissa Durrie, "George Henry Durrie: Artist," *Antiques* 24 (July 1933): 13–14. For further discussion of winter landscape painting in America, see Martha Hutson, "The American Winter Landscape, 1830–1870," *American Art Review* 2 (January–February 1975): 60–78.

193. As quoted in Colin Simkin, *An Exhibition of Paintings by Durrie, Connecticut Artist*, exh. cat. (New Haven: New Haven Colony Historical Society, 1966), 12.

194. Hutson, *George Henry Durrie*, 52.

195. See Bartlett Cowdrey, *George Henry Durrie, 1820–1863: Connecticut Painter of American Life*, exh. cat. (Hartford: Wadsworth Atheneum, 1947), n.p.

196. *Winter in the Country: "Frozen Up"* was published in the month of April in the Travelers Insurance Company (Hartford) 1964 Currier and Ives calendar. See curatorial painting file, Wadsworth Atheneum.

197. William Dunlap, *History of the Rise and Progress of the Arts of Design in the United States*, vol. 2 (1834; rpt., New York: Dover, 1969), 264.

198. Ibid., 265.

199. It was generally thought that Fisher first traveled to Niagara in 1818, but this has proven erroneous. See Fred Barry Adelson, *Alvan Fisher (1792–1863): Pioneer in American Landscape Painting*, vol. 1 (Ann Arbor, Mich: University Microfilms International, 1985), 167–88.

200. Adamson et al., *Niagara*, 35–36, 139.

201. See Adelson, *Alvan Fisher*, 171.

202. Adamson et al., *Niagara*, 35 n. 90.

203. Century Association, *Gifford Memorial Meeting of the Century, November 19, 1880*, with addresses by John F. Weir, Worthington Whittredge, and Jervis McEntee (New York: Century Association, 1880), 20–21.

204. Ila Weiss, *Poetic Landscape: The Art and Experience of Sanford R. Gifford* (Newark: University of Delaware Press, 1987), 260.

205. G.W. Sheldon, *American Painters*, rev. ed. (New York: D. Appleton, 1881), 16.

206. Sanford Gifford to Mrs. Samuel Colt, June 15(?), 1866, archives, Wadsworth Atheneum.

207. The drawings were first discussed in Ila Joyce Weiss, *Sanford Robinson Gifford (1823–1880)* (Ann Arbor, Mich.: University Microfilms International, 1968), 248; and Ila Weiss, "Two Paintings by Sanford R. Gifford," *Bulletin of the Wadsworth Atheneum* 4 (spring/fall, 1968): 49.

208. Century Association, *Gifford*, 45.

209. Weiss, *Poetic Landscape*, 237.

210. A "List of Some of My Chief Pictures" was attached to Gifford's autobiographical letter of November 6, 1874, to Octavius Brooks Frothingham and updated in 1880, reproduced as "Adirondack Mtns." in appendix B of Weiss, *Poetic Landscape*, 328.

211. The series of paintings is discussed in Weiss, *Poetic Landscape*, 304–6.

212. G. W. Sheldon, "How One Landscape-Painter Paints," *Art Journal* 3 (1877): 285, quoted in Nicolai Cikovsky, Jr., *Sanford Robinson Gifford, 1823–1880*, exh. cat. (Austin: University of Texas, University Art Museum, 1970), 16.

213. Weiss, "Two Paintings by Sanford R. Gifford," 50.

214. S.G.W. Benjamin, *Art in America: A Critical and Historical Sketch* (New York: Harper and Brothers, 1880), 80.

215. Curatorial painting file, Wadsworth Atheneum.

216. Patricia Mandel, *Homer Dodge Martin: American Landscape Painter, 1836–1897* (Ann Arbor, Mich.: University Microfilms International, 1978), esp. ch. 8, "Homer Martin: Post Mortem, 1897–1917; High Prices, a Book, Fake Martins and a Follower," which discusses issues of authenticity.

217. Weiss, *Poetic Landscape*, 148. See The Metropolitan Museum of Art, *A Memorial Catalogue of the Paintings of Sanford Robinson Gifford, N.A.*, with an essay by John F. Weir (New York: The Metropolitan Museum of Art, 1881), 44, which lists *A Rainy Day on Lake Kenogamy* as no. 679, dated 1878, 8½ × 16 in. (21.6 × 40.6 cm), owned by F.N. Otis, M.D.

218. Thanks to Nicolai Cikovsky, Jr., and Franklin Kelly, National Gallery of Art, Washington, D.C., for their opinions on this work. See Nicolai Cikovsky, Jr., to Elizabeth Mankin Kornhauser, December 14, 1992, curatorial painting file, Wadsworth Atheneum.

219. John Sartain, "James Hamilton," *Sartain's Union Magazine of Literature and Art* 10 (1852): 331–33.

220. Inventory and Appraisement of the Estate of the Late Colonel Samuel Colt of Hartford, Connecticut (1862), Connecticut State Library, Hartford.

221. *Catalogue of Paintings: From the Studio of James Hamilton, P.A., James S. Earle & Sons*, with essay by Emily Sartain, "Remarks on the Collection" (Philadelphia: James S. Earle, 1875), no. 49.

222. Theodore E. Stebbins, Jr., *The Life and Works of Martin J. Heade* (New Haven and London: Yale University Press, 1975), 50.

223. Ibid., 49–50.

224. James Jackson Jarves, *The Art-Idea*, ed. Benjamin Rowland, Jr. (1864; rpt. Cambridge: Harvard University Press, 1960), 193.

225. Barbara Novak compares Heade's paintings of haystacks to the haystack paintings from the 1890s by Claude Monet, but she notes that, although both artists painted the haystack as seen in different degrees and qualities of light, the painters had different objectives. See *American Painting of the Nineteenth Century: Realism, Idealism, and the American Experience*, 2nd ed. (New York: Harper and Row, 1979), 128–30. See also Stebbins, *Life and Works*, 54–55, and John Wilmerding's discussion of a series of charcoal drawings of the marshes at Newburyport, Massachusetts, in Kynaston McShine, ed., *The Natural Paradise: Painting in America, 1800–1950*, exh. cat. (New York: Museum of Modern Art, 1976), 47–49. Wilmerding suggests that Heade achieves an "air of timelessness" akin to spirituality.

226. Stebbins, Jr., *Hudson River School*, 67.

227. This information is drawn from Teresa A. Carbone's catalogue entry for Heade's *Summer Showers*, c. 1865–70, in the collection of the Brooklyn Museum of Art. See Carbone et al., *Masterpieces of American Painting from the Brooklyn Museum*, exh. cat. (New York: Jordan-Volpe Gallery, 1996), 70–71.

228. Theodore E. Stebbins, Jr., *The Life and Work of Martin Johnson Heade: A Critical Analysis and Catalogue Raisonné* (New Haven and London: Yale University Press, 2000), 116.

229. Elizabeth Mankin Kornhauser, "'All Nature Here Is New to Art': Painting the American Landscape 1800–1900," in Elizabeth Johns, Andrew Sayers, and Elizabeth Mankin Kornhauser, with Amy Ellis, *New Worlds from Old: Nineteenth-Century Australian and American Landscapes*, exh. cat. (Canberra: National Gallery of Australia, and Hartford: Wadsworth Atheneum, 1998), 74.

230. See Nancy K. Anderson, "'Wondrously Full of Invention': The Western Landscapes of Albert Bierstadt," in Anderson and Ferber, *Albert Bierstadt*, 69–107.

231. Kenneth W. Maddox to Amy Ellis, April 30, 1993, curatorial painting file, Wadsworth Atheneum.

232. Thanks to Michael Quick, who examined the painting for the Atheneum on August 10, 1993, and suggested that it was painted en plein air. Quick also confirmed the painting's authenticity and attributed it to the late 1860s, when Inness was still painting in the style of the Hudson River School.

233. Much of the historical information in this entry was gleaned from the wall labels for the exhibition *Westchester Landscapes: Pastoral Visions, 1840–1920*, held February 5– June 13, 1993, at the Hudson River Museum of Westchester in Yonkers, New York, Kenneth W. Maddox,

guest curator. As William Oedel has pointed out, Inness painted images of rural and agrarian America more often than the signs of industrial progress. See Oedel entry for Inness's *Hudson River Valley* (1867) in *American Paintings in the Detroit Institute of Arts: Works by Artists Born 1816–1847*, ed. Nancy Rivard Shaw (New York: Hudson Hills Press, 1998).

234. See Kenneth W. Maddox to Elizabeth Mankin Kornhauser, October 23, 1991, curatorial painting file, Wadsworth Atheneum.

235. John I. H. Baur, "'. . . the exact brush work of Mr. David Johnson,' an American Landscape Painter," *American Art Journal* 12, no. 4 (1980): 37–38; and Ferber and Gerdts, *New Path*, 270.

236. Donald Keyes, with Catherine H. Campbell, Robert L. McGrath, and R. Stuart Wallace, *The White Mountains: Place and Perceptions*, exh. cat. (Hanover, N.H., and London: University Press of New England, for the University Art Galleries, University of New Hampshire, 1980), 103–5.

237. See ibid., 105, which compares the Atheneum's painting to Durand's *Franconia, White Mountains* (c. 1857, New-York Historical Society), finding that certain elements were so similar as to suggest a date of about 1860 for the Atheneum's work. However, Johnson visited the New Hampshire area only once between 1856 and 1863, and that was sometime in 1861 (see John I. H. Baur and Margaret C. Conrads, *Meditations on Nature: The Drawings of David Johnson*, exh. cat. [Yonkers, N.Y.: Hudson River Museum of Westchester, 1987], 14–16), which, in conjunction with Johnson's use of a monogram to sign the painting, suggests a possible date of 1861–63 for the Atheneum's picture.

238. See Gwendolyn Owens, *Nature Transcribed: The Landscapes and Still Lifes of David Johnson (1827–1908)*, exh. cat. (Ithaca, N.Y.: Herbert F. Johnson Museum of Art), esp. 33.

239. See Gwendolyn Owens, "David Johnson," in Howat, *American Paradise*, 270–76.

240. The small size of the canvas is in keeping with many White Mountain School paintings, which were sold as souvenirs, primarily to middle-class tourists who hung the pictures on the walls of their small urban homes. See Keyes et al., *White Mountains*, 55.

241. See Ferber and Gerdts, *New Path*, for a complete discussion of the American Pre-Raphaelite movement. See also Owens, *Nature Transcribed;* and Roger B. Stein, *John Ruskin and Aesthetic Thought in America, 1840–1900* (Cambridge: Harvard University Press, 1967).

242. See Elizabeth McKinsey, "'Trying to Paint a Soul'—Church and His Contemporaries," in her *Niagara Falls*, 236.

243. Identified by Jeremy Elwell Adamson, organizer of the exhibition *Niagara* at the Corcoran Gallery of Art in Washington, D.C., in 1985. See "Collectors' Notes," Eleanor H. Gustafson, ed., *Antiques Magazine* 142 (November 1992): 658.

244. Curatorial painting file, Wadsworth Atheneum.

245. Curatorial painting file, Wadsworth Atheneum. Kensett's *Niagara Falls* was originally found hanging in an office in Eno Memorial Hall in Simsbury, Connecticut. Former assistant curator Elizabeth McClintock identified the painting as a Kensett while doing research in 1991, and Elizabeth Kornhauser, the curator of American art, secured the work for a two-year loan, enabling the Atheneum's conservation staff to conduct an extensive restoration of the painting. The Wadsworth Atheneum acquired *Niagara Falls* in 2002, following a settlement with the Abigail Phelps Chapter of the Daughters of the American Revolution in Simsbury and the Town of Simsbury, and the painting is now part of the museum's permanent collection.

246. Kathleen Motes Bennewitz, "John F. Kensett at Beverly, Massachusetts," *American Art Journal* 21, no. 4 (1989): 46–65.

247. Ibid., 54.

248. Ibid., 60–61.

249. The series of Mingo Beach paintings is identified and discussed in ibid., 59–63.

250. The term is first used in John I. H. Baur, "American Luminism: A Neglected Aspect of the Realist Movement in Nineteenth-Century American Painting," *Perspectives USA* 9 (autumn 1954): 90–98, and later further defined in Novak, *American Painting*, esp. ch. 5, "Luminism: An Alternative Tradition"; and in John Wilmerding, ed., *American Light: The Luminist Movement: 1850–1875*, exh. cat. (Washington, D.C.: National Gallery of Art, 1980).

251. John Trumbull, *The Autobiography of Colonel John Trumbull*, ed. Theodore Sizer (1841; rpt., New Haven: Yale University Press, 1953), 15.

252. See John Trumbull, "More Recent Sketches," Beinecke Rare Book and Manuscript Library, Yale University, New Haven.

253. John Trumbull to Samuel Williams, November 11, 1808, Beinecke Rare Book and Manuscript Library, Yale University, New Haven, quoted in Bryan Wolf, "Revolution in the Landscape: John Trumbull and Picturesque Painting," in *John Trumbull: The Hand and Spirit of a Painter*, ed. Helen Cooper, exh. cat. (New Haven: Yale University Press, 1982), 225.

254. "Account of articles & packages to be taken with us to London," New York City, June 23, 1808, John Trumbull Papers, New-York Historical Society, New York.

255. See Adamson et al., *Niagara*, 30; and Wolf, "Revolution in the Landscape," 225.

256. "More Recent Sketches," no. 16, cited in Adamson et al., *Niagara*, 30, 77 n. 75.

257. William Gilpin, *Observations, Relative Chiefly to Picturesque Beauty, Made in the Year 1772, on Several Parts of England: Particularly the Mountains and Lakes of Cumberland, and Westmoreland* (London, 1786).

258. "More Recent Sketches," no. 29; cited in Adamson et al., *Niagara*, 31, 77 n.76.

259. John Trumbull to Daniel Wadsworth, New York City, May 9, 1828, Wadsworth Atheneum Loan Collection, Connecticut Historical Society, Hartford.

260. For a discussion of Vanderlyn's activities in Paris, see Lois Marie Fink, *American Art at the Nineteenth-Century Paris Salons* (Washington, D.C.: National Museum of American Art, Smithsonian Institution; Cambridge: Cambridge University Press, 1990), 10–23; and H. Barbara Weinberg, *The Lure of Paris: Nineteenth Century American Painters and Their French Teachers* (New York: Abbeville Press, 1991), 30–38.

261. Written at the end of the eighteenth century, *The Columbiad* was not actually published until 1807.

262. Carrie Rebora, "Robert Fulton's Art Collection," *American Art Journal* 22, no. 3 (1990): 40–64.

263. For a detailed account of the actual event and the story's alteration over time, see Samuel Y. Edgerton, Jr., "The Murder of Jane McCrea: The Tragedy of an American Tableau d'Histoire," *Art Bulletin* 47 (December 1965): 481–92. See, also, Kathleen H. Pritchard, "John Vanderlyn and the Massacre of Jane McCrea," *Art Quarterly* 12 (fall 1949): 361–66.

264. For a discussion of gender and ethnicity in this image, see June Namais, *White Captives: Gender and Ethnicity on the American Frontier* (Chapel Hill and London: University of North Carolina Press, 1993), 117–45.

265. For a detailed discussion of the painting's sources, see William Townsend Oedel, *John Vanderlyn: French Neoclassicism and the Search for an American Art* (Ann Arbor, Mich.: University Microfilms International, 1981), 228–38.

266. Oedel, *Vanderlyn*, 223–24. The source for Fulton's involvement is an unpublished manuscript of anecdotes dating from the mid- to late 1840s in the Remensnyder Collection, item no. 44, Senate House, Kingston, New York. A letter from Vanderlyn to Robert James Livingston, treasurer of the American Academy, dated October 25, 1804, indicates that he shipped *Jane McCrea* along with a number of other items via Nantes

to New York in 1804 (American Academy of the Fine Arts Papers, vol. 1, leaf 8, New-York Historical Society, New York).

267. Mary Bartlett Cowdrey, *American Academy of the Fine Arts and American Art-Union Exhibition Record 1816–1852* (New York: New-York Historical Society, 1953), 423. The copy after the original has a canvas stamp on the back from the firm of Edward Dechaux in a configuration used by the company from 1835 to 1841, which helps to place it between 1835 and 1839.

268. Daniel Wadsworth took a sketch of the site in 1825: *Natural Bridge, Virginia*, wash on paper, Wadsworth Atheneum, 1931.53.

269. The painting, which descended in the family of Benjamin Silliman, Jr., was given to the Wadsworth Atheneum as a work by Thomas Cole in 1956; see donor correspondence, curatorial painting file, Wadsworth Atheneum. It was published as a Cole in Stebbins, Jr., *Hudson River School*, no. 4. In 1980 Ellwood C. Parry questioned the painting's authenticity as a Cole, indicating that it contained "crudities in the execution" and lacked Cole's "mannerism in the trees, foliage, stumps, and rocks—not to mention the more dramatic use of lighting effects" (Ellwood C. Parry III to Richard Saunders, December 4, 1980, curatorial painting file, Wadsworth Atheneum). Eventually, Howard Merritt first suggested and later proved that the painting is by Jacob C. Ward; see Howard Merritt to Elizabeth Kornhauser, July 1, 1985, curatorial painting file, Wadsworth Atheneum.

270. "American Academy of Fine Arts," *American Monthly* 1 (July 1833): 330. Thanks to Howard Merritt for uncovering this review attributing the painting to Ward.

271. Benjamin Silliman, Jr., to Alfred Smith, New Haven, February 28, 1844, archives, Wadsworth Atheneum.

272. John I. H. Baur, ed., *The Autobiography of Worthington Whittredge 1820–1910* (New York: Arno Press, 1969), 42.

273. Anthony F. Janson, *Worthington Whittredge* (Cambridge: Cambridge University Press, 1989), 92.

274. Baur, *Autobiography*, 60.

275. "American Painters: Alexander H. Wyant, N.A.," *Art Journal* (December 1876): 354. David Brigham, a former intern at the Wadsworth Atheneum, originally made this observation.

276. See Franklin Kelly, "The Stillness of Twilight and the Solemnity of Undisturbed Primeval Nature: Twilight in the Wilderness," in *Frederic Edwin Church and the National Landscape*, exh. cat. (Washington, D.C., and London: Smithsonian Institution Press, 1988), 102–22.

277. Robert Olpin dated the painting at around 1892 based on its title. See Robert Olpin, *Alexander Helwig Wyant (1836–1892), American Landscape Painter: An Investigation of His Life and Fame and a Critical Analysis of His Work with a Catalogue Raisonné of Wyant Paintings* (Ann Arbor, Mich.: University Microfilms International, 1985), 427.

278. *Bulletin of the Wadsworth Atheneum* 2 (July 1924): 10. A letter from George H. Story to Mr. Gay, January 7, 1904, notes that "the Wyant was purchased at the auction sale of R. Bonner's things at Chickering Hall for $1000. 1897.22 'Afterglow' by Wyant." See curatorial painting file, Wadsworth Atheneum.

SELECTED BIBLIOGRAPHY

Adamson, Jeremy Elwell. *Niagara: Two Centuries of Changing Attitudes, 1697–1901*. Washington, D.C.: Corcoran Gallery of Art, 1985.

Adelson, Fred B. *Alvan Fisher (1792–1863): Pioneer in American Landscape Painting*. Ann Arbor, Mich.: University Microfilms International, 1984.

Anderson, Nancy K., and Linda S. Ferber, with Helena E. Wright. *Albert Bierstadt: Art and Enterprise*. New York: Hudson Hills Press, in association with the Brooklyn Museum, 1990.

Bedell, Rebecca. *The Anatomy of Nature: Geology and American Landscape Painting, 1825–1875*. Princeton and Oxford: Princeton University Press, 2001.

Benjamin, S.G.W. *Our American Artists*. Boston: D. Lothrop, 1886.

Blaugrund, Annette. *The Tenth Street Studio Building*. Ann Arbor, Mich.: University Microfilms International, 1992.

Boime, Albert. *The Magisterial Gaze: Manifest Destiny and American Painting, c. 1830–1865*. Washington, D.C.: Smithsonian Institution Press, 1991.

Burns, Sarah. *Pastoral Inventions: Rural Life in Nineteenth-Century American Art and Culture*. Philadelphia: Temple University Press, 1989.

Carr, Gerald L. *Frederic Edwin Church: Catalogue Raisonné of Works of Art at Olana State Historic Site*. 2 vols. New York: Cambridge University Press, 1994.

Cikovsky, Nicolai, Jr., and Michael Quick. *George Inness*. New York: Harper and Row, for the Los Angeles County Museum of Art, 1985.

Cole, Thomas. *The Collected Essays and Prose Sketches*. Edited by Marshall Tymn. St. Paul, Minn.: John Colet Press, 1980.

Conron, John. *American Picturesque*. University Park: Pennsylvania State University Press, 2000.

Cooper, Helen A., ed. *John Trumbull: The Hand and Spirit of a Painter*. New Haven: Yale University Press, 1982.

The Crayon: A Journal Devoted to the Graphic Arts and the Literature Related to Them. 8 vols. New York, 1855–61.

Driscoll, John Paul, and John K. Howat. *John Frederick Kensett: An American Master*. New York: Norton, in association with the Worcester Art Museum, 1985.

French, H. W. *Art and Artists in Connecticut*. Boston: Lee and Shepard; New York: Charles T. Dillingham, 1879.

Dunlap, William. *History of the Rise and Progress of the Arts of Design in the United States*. 3 vols. 1834; rpt., New York: Dover, 1969.

Ferber, Linda S., and William H. Gerdts. *The New Path: Ruskin and the American Pre-Raphaelites*. New York: Schocken Books, for the Brooklyn Museum, 1985.

Gerdts, William H. *William Holbrook Beard: Animals in Fantasy*. New York: Alexander Gallery, 1981.

Goetzmann, William H. *Exploration and Empire: The Explorer and the Scientist in the Winning of the American West*. New York: Norton, 1978.

Harvey, Eleanor Jones. *The Painted Sketch: American Impressions from Nature, 1830–1880*. Dallas, Tex.: Dallas Museum of Art, in association with Harry N. Abrams, 1998.

Howat, John K., ed. *American Paradise: The World of the Hudson River School*. New York: The Metropolitan Museum of Art, 1987.

Hutson, Martha Young. *George Henry Durrie (1820–1863), American Winter Landscapist: Renowned Through Currier and Ives*. Santa Barbara, Calif.: Santa Barbara Museum of Art and American Art Review Press, 1977.

Jacobowitz, Arlene. *James Hamilton, 1819–1878: American Marine Painter*. Brooklyn, N.Y.: Brooklyn Museum, 1966.

Janson, Anthony F. *Worthington Whittredge*. Cambridge: Cambridge University Press, 1989.

Johns, Elizabeth et al. *New Worlds from Old: 19th Century Australian and American Landscapes*. Canberra: National Gallery of Australia, and Hartford: Wadsworth Atheneum, 1998.

Kelly, Franklin, with Stephen Jay Gould, James Anthony Ryan, and Debora Rindge. *Frederic Edwin Church*. Washington, D.C.: National Gallery of Art, 1989.

Ketner, Joseph D. *The Emergence of the African-American Artist: Robert S. Duncanson 1821–1872*. Columbia: University of Missouri Press, 1993.

Keyes, Donald, ed. *The White Mountains: Place and Perceptions*. Durham, N.C.: Art Galleries of the University of New Hampshire, 1980.

Kornhauser, Elizabeth Mankin et al. *American Paintings Before 1945 in the Wadsworth Atheneum*. 2 vols. New Haven and London: Yale University Press, and Hartford: Wadsworth Atheneum, 1996.

Lawall, David B. *Asher Brown Durand: His Art and Art Theory in Relation to His Times*. New York and London: Garland, 1977.

Lubin, David M. *Picturing a Nation: Art and Social Change in Nineteenth-Century America*. New Haven and London: Yale University Press, 1994.

McKinsey, Elizabeth. *Niagara Falls: Icon of the American Sublime*. New York: Cambridge University Press, 1985.

Manthorne, Katherine, Richard S. Fiske, and Elizabeth Nielson. *Creation and Renewal: Views of 'Cotopaxi' by Frederic Edwin Church*. Washington, D.C.: National Museum of American Art, 1985.

Miller, Angela. *Empire of the Eye: Landscape Representation and American Cultural Politics, 1825–1875*. Ithaca, N.Y.: Cornell University Press, 1993.

Miller, David, ed. *American Iconology: New Approaches to Nineteenth-Century Art and Literature*. New Haven: Yale University Press, 1993.

Myers, Kenneth. *The Catskills: Painters, Writers, and Tourists in the Mountains, 1820–1895*. Hanover, N.H.: University Press of New England, 1987.

Novak, Barbara. *Nature and Culture*. Rev. ed. New York: Oxford University Press, 1995.

Nygren, Edward J. *Views and Visions: American Landscape Before 1830*. Washington, D.C.: Corcoran Gallery of Art, 1986.

Oedel, William Townsend. *John Vanderlyn: French Neoclassicism and the Search for an American Art*. Ann Arbor, Mich.: University Microfilms International, 1981.

Olpin, Robert S. *Alexander Helwig Wyant (1836–1892), American Landscape Painter: An Investigation of His Life and Fame and a Critical Analysis of His Work with a Catalogue Raisonné of Wyant Paintings*. Ann Arbor, Mich.: University Microfilms International, 1985.

Parry, Ellwood C., III. *The Art of Thomas Cole: Ambition and Imagination*. Newark: University of Delaware Press, 1988.

Prown, Jules David et al., eds. *Discovered Lands, Invented Pasts: Transforming Visions of the American West*. New Haven: Yale University Press, 1992.

Rash, Nancy. *The Paintings and Politics of George Caleb Bingham*. New Haven: Yale University Press, 1991.

Rumford, Beatrix T., ed. *American Folk Paintings: Paintings and Drawings Other Than Portraits from the Abby Aldrich Rockefeller Folk Art Center*. Boston: Little, Brown, with the Colonial Williamsburg Foundation, 1988.

Sears, John F. *Sacred Places: American Tourist Attractions in the Nineteenth Century*. Amherst: University of Massachusetts Press, 1989.

Shapiro, Michael Edward, Barbara Groseclose, Elizabeth Johns, Paul C. Nagel, and John Wilmerding. *George Caleb Bingham.*

New York: Abrams, in association with the Saint Louis Art Museum, 1990.

Sheldon, George W. *American Painters*. Rev. ed. New York: D. Appleton, 1881.

Stebbins, Theodore E., Jr., and Janet L. Comey, with Karen E. Quinn and Jim Wright. *Martin Johnson Heade*. New Haven and London: Yale University Press, 1999.

Stebbins, Theodore E., Jr., Janet L. Comey, and Karen E. Quinn. *The Life and Works of Martin Johnson Heade: A Critical Analysis and Catalogue Raisonné*. New Haven and London: Yale University Press, 2000.

Truettner, William H. *The West As America: Reinterpreting Images of the Frontier, 1820–1920*. Washington, D.C.: Smithsonian Institution Press, 1991.

Truettner, William, and Alan Wallach, eds. *Thomas Cole: Landscape into History*. New Haven: Yale University Press, for the National Museum of American Art, 1994.

Trumbull, John. *The Autobiography of Colonel John Trumbull*. Edited by Theodore Sizer. 1841; rpt., New Haven: Yale University Press, 1953.

Tuckerman, Henry T. *Book of the Artists: American Artist Life*. New York: Putnam, 1867.

Weiss, Ila. *Poetic Landscape: The Art and Experience of Sanford R. Gifford*. Newark: University of Delaware Press, 1988.

Wilmerding, John. *American Light: The Luminist Movement, 1850–1875*. Washington, D.C.: National Gallery of Art, 1980.

———. *William Bradford, 1823–1892*. Lincoln, Mass.: DeCordova Museum; New Bedford, Mass.: Whaling Museum of New Bedford, 1969.

Wilton, Andrew, and Tim Barringer. *American Sublime: Landscape Painting in the United States, 1820–1880*. London: Tate Gallery, 2002.

Wolf, Bryan Jay. *Romantic Re-vision: Culture and Consciousness in Nineteenth-Century American Painting and Literature*. Chicago: University of Chicago Press, 1982.

INDEX

PHOTO CREDITS

The following photographic credits identify the portrait images reproduced in the catalogue section of this book. This list is organized alphabetically using the last name of the artist; the page number of the reproduction is also provided.

Patania, *William H. Beard with Three Bears* (detail), 1866. Charcoal on paper, 19¾ × 25½ in. (50.2 × 64.8 cm). Courtesy of The Century Association, New York (p. 21); Napoleon Sarony, *Albert Bierstadt* (detail), c. 1870. Albumen silver print, 3½ × 2⅜ in. (8.9 × 6 cm). National Portrait Gallery, Smithsonian Institution (p. 24); George Caleb Bingham, *Self-Portrait* (detail), 1849–50. Oil on copper, 3 × 2½ in. (7.6 × 6.4 cm). National Portrait Gallery, Smithsonian Institution (p. 34); William Holbrook Beard, *William Bradford* (detail), [n.d.]. Oil on canvas, 27 × 22 in. (68.6 × 55.9 cm). National Academy of Design, New York (66-P) (p. 37); *John W. Casilear* (detail), 1860–69. Carte-de-visite (from Mrs. Vincent Coyler's Album). Photographed by Johnston Brothers, New York City [dim. unknown]. The Metropolitan Museum of Art, David Hunter McAlpin Fund, 1952 (52.605). © All Rights Reserved, The Metropolitan Museum of Art (p. 40); *Frederic E. Church* (detail), 1864. Carte-de-visite. Photographic emulsion on paper, mounted to card [dim. unknown]. Olana State Historic Site, New York State Office of Parks, Recreation and Historic Preservation (p. 45); Attributed to Mathew Brady, *Thomas Cole* (detail), c. 1845. Daguerreotype, 5⅜ × 4 in. (13.7 × 10.2 cm). National Portrait Gallery, Smithsonian Institution, Gift of Edith Cole Silberstein (p. 69); *Samuel Colman* (detail), 1860–69. Carte-de-visite (from Mrs. Vincent Coyler's Album). Photograph by George C. Rockwood, New York City [dim. unknown]. The Metropolitan Museum of Art, David Hunter McAlpin

Fund, 1952 (52.605). © All Rights Reserved, The Metropolitan Museum of Art (p. 91); *Jasper F. Cropsey* (detail), c. 1865. Carte-de-visite. Photograph by George C. Rockwood, New York City [dim. unknown]. The Metropolitan Museum of Art, The Albert Ten Eyck Gardner Collection, Gift of the Centennial Committee, 1970 (1970.659.175). © All Rights Reserved, The Metropolitan Museum of Art (p. 98); W. A. Notman, *Robert S. Duncanson* (detail), 1864. Albumen silver print, 3¼ × 2⅛ in. (8.3 × 5.4 cm). Notman Photographic Archives, McCord Museum of Canadian History, Montreal, I-11978.1. © Musée McCord Museum (p. 102); Charles DeForest Fredricks, *Asher Brown Durand* (detail), c. 1858. Albumenized salted paper print, 7⅛ × 5¼ in. (18.1 × 13.3 cm). National Portrait Gallery, Smithsonian Institution (p. 105); George Henry Durrie, *Self-Portrait* (detail), 1843. Oil on canvas, 30 × 25 in. (76.2 × 63.5 cm). National Portrait Gallery, Smithsonian Institution (p. 108); Alvan Fisher, *The Hunter, A Self-Portrait* (detail), 1837. Watercolor over graphite pencil on wove paper, 13 × 9¾ in. (33 × 24.8 cm). Museum of Fine Arts, Boston, The M. and M. Karolik Collection of American Watercolors, Drawings and Prints, 1800–1875 (61.276). Photograph © 2003 Museum of Fine Arts, Boston (p. 111); *Sanford R. Gifford* (detail), 1868. Carte-de-visite (from Mrs. Vincent Coyler's Album). Photographer unknown [dim. unknown]. The Metropolitan Museum of Art, David Hunter McAlpin Fund, 1952 (52.605). © All Rights Reserved, The Metropolitan Museum of Art (p. 114); *Martin Johnson Heade*, 1860. Carte-de-visite photoprint, 2½ × 3¾ in. (6.5 × 9.5 cm). Photographs of Artists, Collection I, Archives of American Art, Smithsonian Institution. Reel 439, fr.1058–1059. Photograph by Lee Ewing (p. 124); Unidentified Photographer, *George Inness* (detail), c. 1860. Silver albumen

print, 3⅞ × 3 in. (9.8 × 7.6 cm). National Portrait Gallery, Smithsonian Institution (p. 128); *David Johnson* (detail), 1860–69. Carte-de-visite (from Mrs. Vincent Coyler's Album). Photographer unknown [dim. unknown]. The Metropolitan Museum of Art, David Hunter McAlpin Fund, 1952 (52.605). © All Rights Reserved, The Metropolitan Museum of Art (p. 130); Charles DeForest Fredricks, *John Frederick Kensett* (detail), c. 1860. Albumenized salted paper print, 7¼ × 5¼ in. (18.4 × 13.3 cm). National Portrait Gallery, Smithsonian Institution (p. 132); John Trumbull, *Self-Portrait* (detail), c. 1802. Oil on canvas, 29¾ × 24½ in. (75.6 × 62.2 cm). Yale University Art Gallery, Gift of Marshall H. Clyde, Jr. (p. 137); John Vanderlyn, *Self-Portrait* (detail), [n.d.]. Oil on canvas, 25¼ × 20⅞ in. (64.1 × 53 cm). The Metropolitan Museum of Art, Bequest of Ann S. Stephens in the name of her mother, Mrs. Ann S. Stephens, 1918 (18.118). © All Rights Reserved, The Metropolitan Museum of Art (p. 141); *Worthington Whittredge*, c. 1870. Photograph by George G. Rockwood, New York City. Photographic print with carte-de-visite mount, 4 × 2⅜ in. (10 × 6 cm). Photographs of Artists, Collection I, Archives of American Art, Smithsonian Institution. Reel 440, fr.1317. Photograph by Lee Ewing (p. 148); *Alexander H. Wyant*, c. 1890. Photographic print, 8⅝ × 7⅛ in. (22 × 18 cm). Photographs of Artists, Collection I, Archives of American Art, Smithsonian Institution. Reel 440, fr.1366–1368. Photograph by Lee Ewing (p. 151).

The following photo credit is for figure illustrations in the introductory essay.

© Collection of the New-York Historical Society (figs. 7, 8, 9 10, 11)